THE COMPLETE GUIDE TO DRAWING
MANGA & ANIME

Date Naoto

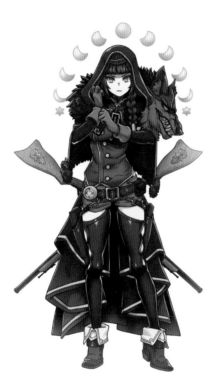

TUTTLE Publishing

Tokyo | Rutland, Vermont | Singapore

Contents

Beginner Level

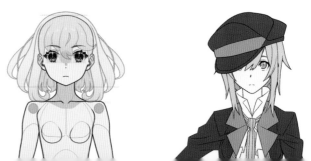

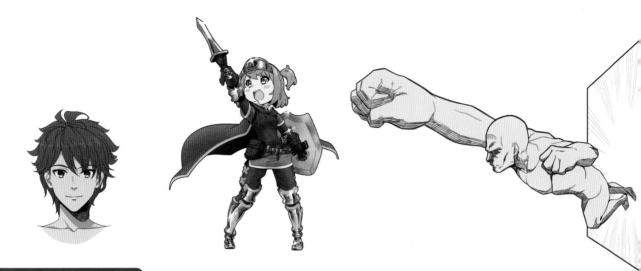

Intermediate Level

To Download Bonus Materials

1. You must have an internet connection.

2. Type the URL below into your web browser:

https://www.tuttlepublishing.com/the-complete-guide-to-drawing-manga-and-anime

For support email us at **info@tuttlepublishing.com**

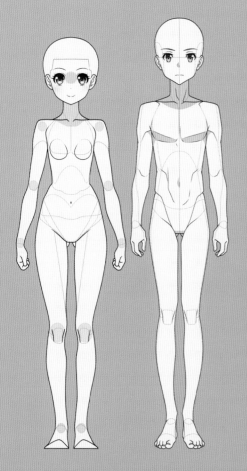

Why I Wrote This Book

Drawing is a skill that anyone can learn. Natural talent must certainly exist. But if we take 10,000 artists, how many geniuses would there be among them? I think there would be very few, perhaps just one person, or even none.

In other words, all the other great artists out there are just ordinary people who have learned a skill. If you think about it in that way, it's easier to imagine learning to draw yourself. So what should you learn?

There are a few important skills you should master when learning how to draw: the basic proportions of the human body, dimensions, silhouettes, and the proper use of color. If you can learn the right balance of these skills it is possible to dramatically improve your drawing ability. This book can teach you that balance.

You should know that a drawing that is technically correct is not necessarily a good picture. Of course, artistic skill is a necessary element, but as the Japanese concepts of *shuhari* (gaining mastery, then innovating, and finally transcending) and *katayaburi* (breaking the mold or being unconventional) tell us, the essence is in "how to break the foundation" after mastering the basics. in other words, you should add your own personal touch to your drawings after you have mastered the basics.

So it is very important for your artistic growth to first create that foundation. However, I understand the desire to learn quickly, of wanting to get better as fast as you can. Therefore, I have developed a 90-day course that aims to teach the basics of drawing effectively. By using this book, you will be able to improve your drawing skills while learning at a comfortable, yet brisk, pace. Most important, have fun!

— **Date Naoto**
March 2021

How to Use This Book

This book teaches you how to draw characters using a step-by-step course of about 90 days. The Introductory sections explain how to draw a picture, the Beginner Level shows you how to draw a person, and the Intermediate Level explains how to create more advanced illustrations.

Each week, the program consists of five lessons providing ways of thinking followed by two days off. That way you won't feel forced to draw every day. Take some time off!

The Purpose of this Book

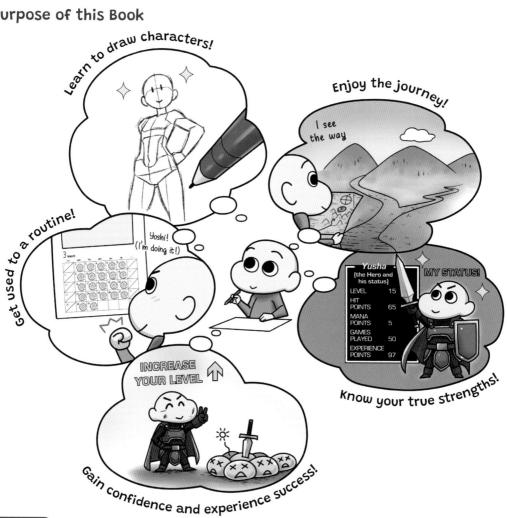

Introduction

I will explain what it means to draw a picture, how to solve problems, and how to improve your drawing if you keep at it.

Beginner Level

Focusing on how to draw people, you will learn everything from the basics of illustration to drawing full body poses.

Intermediate Level

You will learn advanced techniques, such as how to make attractive poses, compositions, and productions.

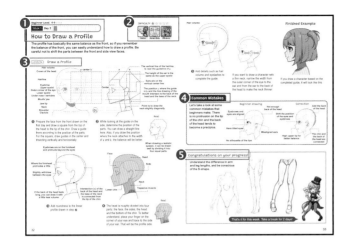

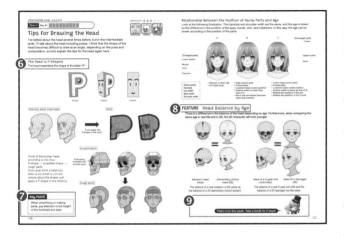

Your progress
①

The ◆ symbol indicates the day of the week. The bar below that shows how far you've progressed through the 13-week course.

② Difficulty levels and icons
Each lesson is assigned a difficulty level from 1 to 5 stars (from easiest to most difficult). The icons show the material that will be covered (see the bottom of this page for more information).

③ Lessons
These are the hands-on elements you will learn to master.

④ Common mistakes
Common drawing mistakes made by beginners and how to correct them.

⑤ Beginner overviews
For the Beginner levels, each week ends with a 2-day break and a basic overview of what you learned.

⑥ Commentaries
This is content that you can refer to, such as useful tips and tricks, when you are drawing.

⑦ Key points
This section explains points to which you should pay particular attention.

⑧ FEATURE
These are important details that will help you progress even further.

⑨ You're done!
The Intermediate levels also end each week with a 2-day break (there are no overviews in the Intermediate levels).

Icons

Drawing Techniques
Techniques necessary for drawing

Knowledge
Knowledge necessary for drawing

Basics
Techniques and knowledge that form the basis of all drawing

Permanence
Skills and knowledge necessary for lifelong drawing

Anatomy
Knowledge of human anatomy

Design Ability
Knowledge used for character design, etc.

Efficiency
Technologies and knowledge that enable efficient growth

Applications
Applications using the basics

3D
Knowledge to grasp three-dimensional objects, such as understanding surfaces and 3D effects

Human Body
Knowledge of anatomy for the fine arts

The OK icon indicates an acceptable example, the △ icon indicates a so-so example, and the ✕ icon a very bad example.

The DL icon indicates that free practice materials are available to download (see page 3 for instructions).

Getting Started

Basics Knowledge Permanence

Why Do We Draw?

Why do you draw in the first place? It is worthwhile to take a moment to consider this basic question before we start.

The purpose of drawing is self-expression. It is a way to communicate your thoughts and ideas to others.

By making a list of likes and dislikes, you can find out what your preferences are. This is the source of an artist's style, so be conscious of it.

By imagining in advance what you want to draw and the results you want to achieve, you can proceed without hesitation.

You Can't Draw What You Don't Know

Are you trying to imagine a picture? If you draw something you don't know or don't understand well, it won't work. Professionals collect reference materials they can study when preparing for a project. Look carefully at the materials and draw.

You imagine the picture you want to draw and start drawing, but...

If you don't know the shape and structure of the costume, you can't draw it.

Studying reference material in advance gives you an idea of how to draw something correctly. Don't be afraid to draw while referring to an example.

What Is Practice?

Your rate of improvement will advance greatly if you understand how to practice effectively.

Take notes when you have ideas about what you'd like to draw. Regularly referring to your notes will give you artistic inspiration.

Failure is not a bad thing. We grow by learning from our mistakes. Instead of worrying about them, keep track of any problems you have and keep drawing. Learning how to deal with your difficulties will ensure you don't fail next time.

No matter how much you draw, your personality will always shine through. By learning basic drawing techniques first, your individual style will flourish later. It won't work if you force things by actively trying to create a unique style. "Break the mold" by mastering the basics.

Always set your hurdles (your goals) low. By clearing many small hurdles, you will gain confidence.

Don't be tentative when you practice. You should try to practice with the same rhythm and confidence you express with your actual drawing.

The best way to learn is by having fun. Don't take the lessons too seriously and learn while being entertained.

Key Point

"See" and "Watch"
In this book, I intentionally differentiate between the words "see" and "watch."
"Watch" is used when concentrating on something and looking at it consciously.

Preparation Before Drawing

Preparation is required before drawing. Most of our worries, such as not being able to sit at a desk for a long time, not knowing what to draw, and getting bored halfway through, are due to **lack of preparation**.

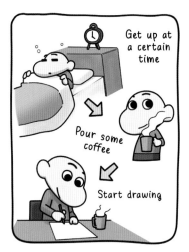

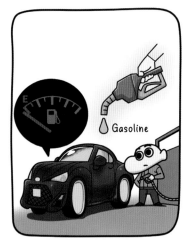

Get into a rhythm. It's a common motivational switch. By deciding what to do before drawing, you can mentally prepare yourself. This varies from person to person, so please try to find the action that makes this switch the easiest for you.

Professionals are serious about their drawing. That's why they are careful to prepare before any project. Start by thinking about what kind of picture you want to draw, what kind of materials you will need, what kind of process you will use, and so on.

In this example of what it means to draw, the input is gasoline (knowledge) and the output is a car (the artist). A car without gasoline is useless. So learn as much as you can before you draw.

Memory Tips

I'm sure everyone has experienced the difficulties you can have when trying to remember something important. Here are some tips on how to make it easier to remember.

When you see something you want to draw, think about what it can be used for.

Think about explaining what the thing is to other people.

Try to visualize something that will help you remember what the object is.

Drawing is Knowledge and Experience

Drawing and cooking are very similar. Of course, it takes a lot of time and effort to become a top chef, but it doesn't take a special talent to be good at it. Knowledge and experience are of the utmost importance.

Themes and drawings = cooking and recipes	Imitation = knowing the taste	Good technique = exquisite taste
You can't make anything if you don't know what you want to make and how to make it. First you need knowledge.	If you don't know the taste (patterns and techniques), you can't reproduce it. The taste can be replicated through experience.	If you understand how to make something taste better, you can make more delicious dishes. This leads to growth.

Cooking

Type (food name)	If you don't know the type of food and the name of the food, you can't make it.
Recipe	You can't make it without knowing the recipe.
The taste	If you don't know the taste, you can't reproduce it.
Delicious taste	You can't cook good food if you don't know good taste
Dexterity	Can you accurately measure the amount and cook smoothly?

Picture

Theme	I can't start unless I know what to draw.
Drawing ability	You can't draw if you don't understand the human body.
Reproduction	You can't draw well if you don't know how to draw.
Imitation of a good person (artistic role model)	You can't draw a beautiful picture if you don't possess an understanding of effective drawing techniques.
Power of observation	Can you accurately reproduce the example in your drawing?

Learning and Experience

Skills that can be learned can be acquired through experience, but they require a lot of time and effort. What can be learned quickly can take years of experience. Let's do it efficiently by understanding the techniques you can learn and the techniques gained from experience.

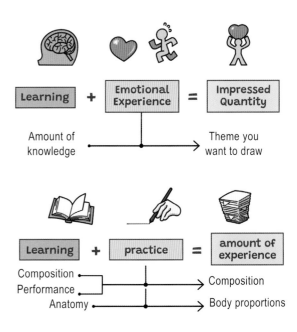

| Learning | + | Emotional Experience | = | Impressed Quantity |

Amount of knowledge → Theme you want to draw

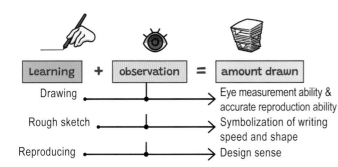

| Learning | + | observation | = | amount drawn |

Drawing → Eye measurement ability & accurate reproduction ability
Rough sketch → Symbolization of writing speed and shape
Reproducing → Design sense

| Learning | + | practice | = | amount of experience |

Composition
Performance → Composition
Anatomy → Body proportions

How Do I Improve My Drawing Skills?

Dig Deeper Into What Interests You

In order to be good at drawing, it is important to find exactly what you want to draw. First, write down what you are interested (brainstorming). Any interest, no matter how trivial, is fine.

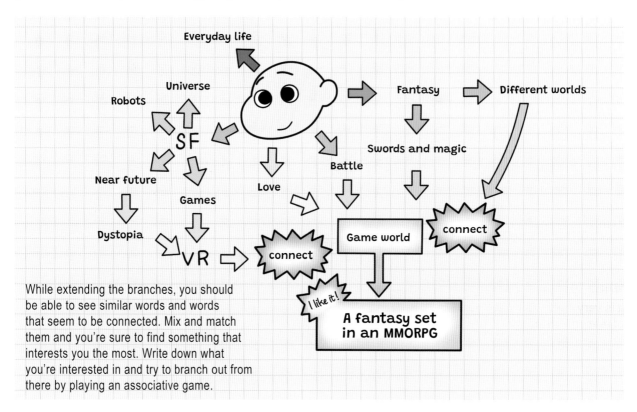

While extending the branches, you should be able to see similar words and words that seem to be connected. Mix and match them and you're sure to find something that interests you the most. Write down what you're interested in and try to branch out from there by playing an associative game.

Growth Cycle

Growth has a unique cycle. When I continue to draw, there is a dramatic moment when my understanding deepens, not unlike an epiphany. When you broaden your horizons and compare your work with that of other artists, you will become aware of your weaknesses. As long as you continue to draw, you will grow. This is true no matter how good of an artist you are.

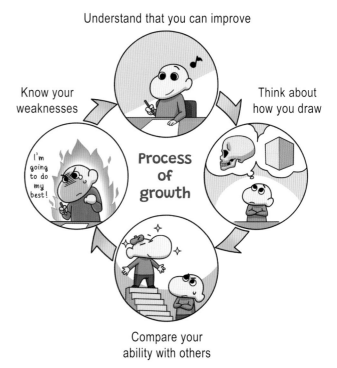

Quantity Over Quality? Quality Over Quantity?

I often see arguments about whether practice should be **quantity over quality** or **quality over quantity**. Actually, **both** answers are correct.

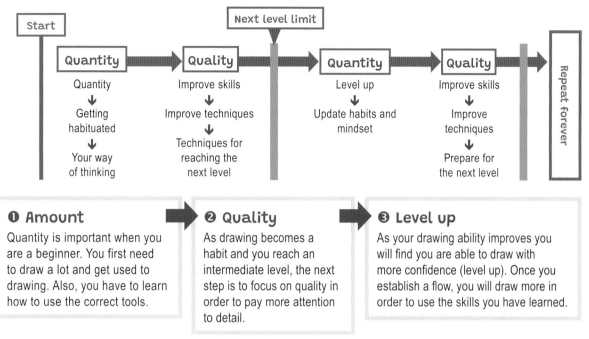

❶ Amount

Quantity is important when you are a beginner. You first need to draw a lot and get used to drawing. Also, you have to learn how to use the correct tools.

❷ Quality

As drawing becomes a habit and you reach an intermediate level, the next step is to focus on quality in order to pay more attention to detail.

❸ Level up

As your drawing ability improves you will find you are able to draw with more confidence (level up). Once you establish a flow, you will draw more in order to use the skills you have learned.

What is Practice?

It is very inefficient if you draw carelessly. You can grow efficiently by drawing with a clear understanding of reason and logic.

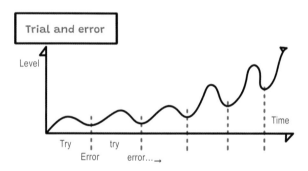

If you draw without a clear purpose, you will grow only through trial and error and your growth will come in waves. If you don't understand what you are doing you will learn haphazardly, so it becomes inefficient.

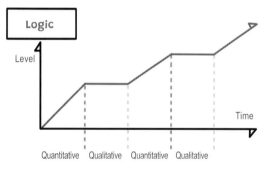

By drawing with an understanding of theory and logic, you can grow without wasting time and effort. When you level up, new challenges will appear, so you can grow efficiently.

In RPGs, there are skills that can only be learned at low levels. By learning these skills early, you can progress quicker as you level up.

A Shortcut to Growth

Think practice is hard? Practice is meant to be enjoyed. Whether you find it difficult or fun to do the same thing over and over, the experience you gain will benefit you many times over. It can help if you approach it as a game.

Have fun! If you can think of practice as entertainment, you won't dread the hard work.

Read the rules! Understanding what you are practicing is like knowing the rules of the game.

Find a strategy! If you can find an efficient strategy, you can clear the goal in the shortest amount of time.

Make Small Goals

If you set a major goal at the beginning, the road will be long and steep and you can become frustrated along the way. So set a series of smaller goals and try to clear them one by one, starting with the first one. After completing this small goal, you can check the pathway to success and find a better route to reach your main goal without difficulty.

Set small goals! A long-distance goal can feel unrealistic.So first of all, set a short-term goal.

For now, let's draw! If you check your surroundings again after reaching your immediate goal, problems that you couldn't see at the starting point will come to light. It is effective to accumulate small goals to avoid risks.

Compare what you drew with your goal, and fix the problem! If you only look at the goal from the beginning and move forward, you will notice a big mistake halfway through and you will not be able to turn back. The objective is to reach the goal, so try to fix the problem and then aim for the goal.

How Should I Practice?

What's so Great about Drawing?

There are three elements to developing a drawing skill: drawing ability, knowledge, and empirical rules. How many of these skills you master and how well you balance them will determine the quality of your drawing, so take the initiative and gain experience.

Drawing ability refers to pure artistic skill. Being able to effectively depict human anatomy, colors, 3D grasping ability, etc. are reflected in your drawing ability.

An understanding of comics, novels, movies, music, science, literature, history, etc., and knowledge gained from conversations with people are included in the amount of knowledge you acquire.

Empirical rules refer to your personal experiences, for example, using things that you have seen, knowledge you have acquired and things you have felt to create your art.

Key Point

Observation is **an important** technique you use to accurately portray an object in your drawing. If you are not careful in your observation, you can miss important details. First, take a close look at the details of various objects and see if you've overlooked anything. The power of observation grows only by repeating through trial and error.

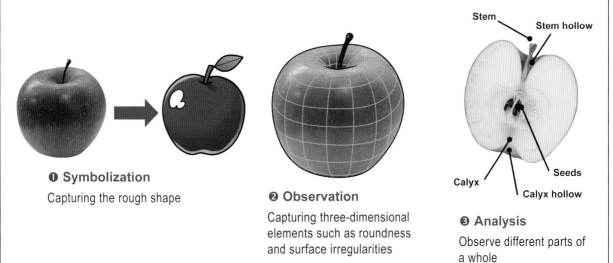

❶ Symbolization

Capturing the rough shape

❷ Observation

Capturing three-dimensional elements such as roundness and surface irregularities

❸ Analysis

Observe different parts of a whole

What Kind of Drawing Practice Do You Have?

Drawing practice includes design, drawing, reproduction, and two-dimensional drawing. There is not one technique that is most effective, as the techniques that can be obtained through practice are different. Choose what you are lacking now.

Sketching

Reproduce the skeleton and muscles of the human body, and the shadows created by three-dimensional objects.

‖

Understanding of structure

Drawing

Quickly capture only the silhouette and reproduce it with a few lines.

‖

Grasping/simplification/ insight of shapes

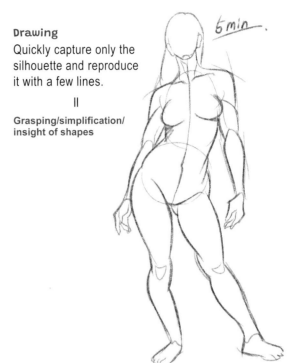

Reproduction

Reproduction is more like dissection than copying. Analyze the drawing's structure and determine the technique that was used to draw the picture.

‖

Technical analysis/ reproduction

2D Drawing

The poses and features of the human body and objects are extracted and reproduced in a two-dimensional picture.

‖

Exaggeration and symbolization

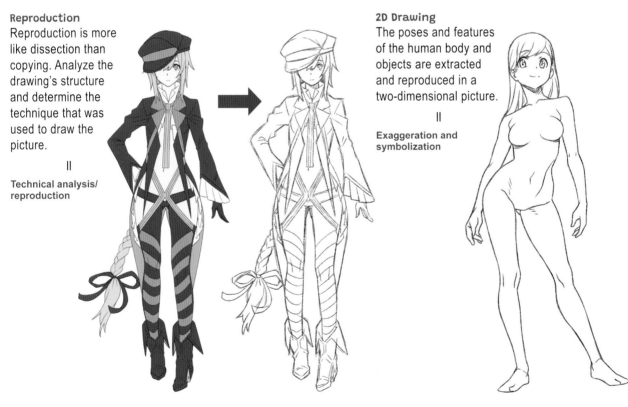

The Role of Drawing and Reproducing

Imagine a map application that shows map data, current location, and bearing. Reproduction is a route search function. A skilled drawing ability will give you more detailed map data and a more accurate current location. When you try to reproduce a picture, think of it as trying to find a route from beginning to end. As with a map, if you are observant, you can find many routes, and through knowledge and experience, you can choose the route that best suits your purpose. **Which picture you choose to reproduce** is important. By the way, drawing speeds up your search, and 2D drawing helps you find a pattern that suits you best.

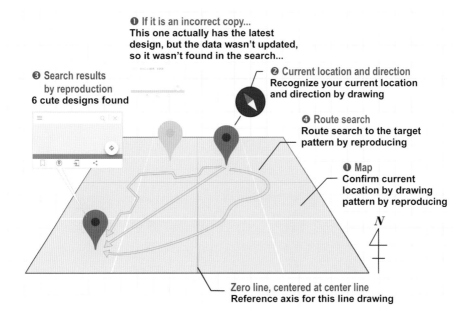

❶ If it is an incorrect copy...
This one actually has the latest design, but the data wasn't updated, so it wasn't found in the search...

❸ Search results by reproduction
6 cute designs found

❷ Current location and direction
Recognize your current location and direction by drawing

❹ Route search
Route search to the target pattern by reproducing

❶ Map
Confirm current location by drawing pattern by reproducing

N

Zero line, centered at center line
Reference axis for this line drawing

How to Set Goals

There are two main ways to reach your goal: the long-distance staircase method and the skill point method. Neither method is better than the other, so choose the one that suits you best.

Long-distance staircase method

A method of deciding a goal in advance for several months to a year and practicing earnestly to achieve it. With the staircase method, it is easy to set clear so you can expect rapid growth, but the path is long and steep. There's always a danger you may get tired and give up halfway through.

Skill point method

A way to set small daily goals and stack them up. It's easy and enjoyable but on the other hand, it's more difficult to see any growth. However, you tend to experience a natural, more steady growth mainly in your specialty field.

How Should I Draw?

Basics Knowledge Permanence

The Three Basics

Exaggeration, transformation, and omission are key points when turning 3D objects into 2D. How you exaggerate, transform, or omit depends on how you compare your drawing to your source. The ideal becomes clear by repeatedly reproducing and analyzing your favorite pattern.

Exaggeration
When 3D information is reduced to 2D, it is exaggerated to compensate for the reduced information.

Transformation
Match the head and body in 2D, or change the parts you don't like.

Omission
Reduce unnecessary information in 2D, and keep it simple.

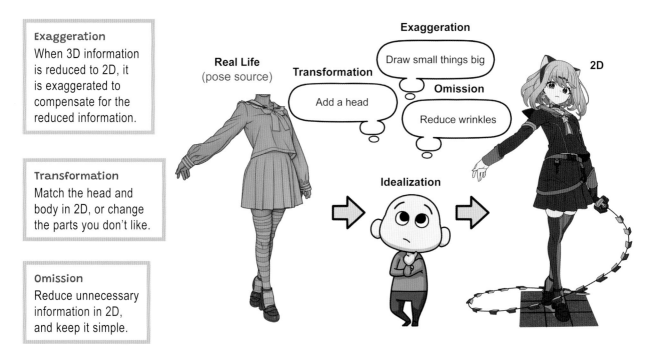

Real Life
(pose source)

Transformation
Add a head

Exaggeration
Draw small things big

Omission
Reduce wrinkles

2D

Idealization

Check by Pulling Back

When I'm drawing, I tend to focus on the part I'm drawing now, so when I step back and look at it, the overall balance often changes. It's a good idea to look at your work from a distance periodically, or display a navigator if it's digital, so you can always check the whole while drawing.

I tend to focus only on what I'm drawing now.

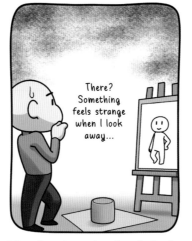

Therefore, in analog, I periodically step away from the drawing and check the overall balance.

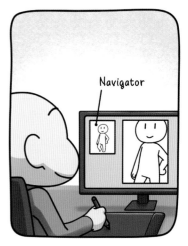

In the case of digital, it is also good to always display a navigator that allows you to check the overall balance.

Lines are Connected

Lines that appear to be separate are actually connected. By being conscious of the invisible connections, the picture will look dramatically better, so let's be conscious of it.

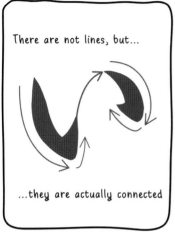

A beautiful shape is made up of connections that flow.

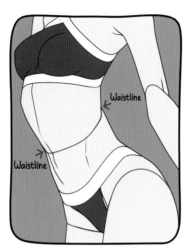

Each joint part, such as the waistline and elbows, is also connected around the other side.

Similarly, the left and right shoulders are joined behind the neck.

Sharp Lines

Look at the illustration on the right. When comparing **A** and **B**, which one looks more three-dimensional? In **A**, there is no indentation and all the lines are the same thickness and look rough. **B** looks like one lump as a cube, doesn't it? You can make it look more three-dimensional by thinning the ridgeline where the surface changes and cutting it in the middle.

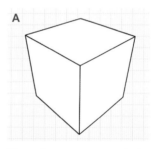

Three faces are separated by lines, so each face can be seen independently.

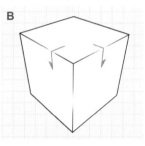

Three faces are connected, so it looks like one mass.

Now compare C and D.
Which lines look better?

I think everyone probably answered **D**. In **C**, the lines are all the same thickness, while in **D**, the silhouette is thicker and the lines inside the person are thinner. As a result, the person and the background are clearly separated, so the eye only goes to the person. Also, details such as hair lines and wrinkles can be sharpened by drawing with thinner lines, and it feels more three-dimensional.

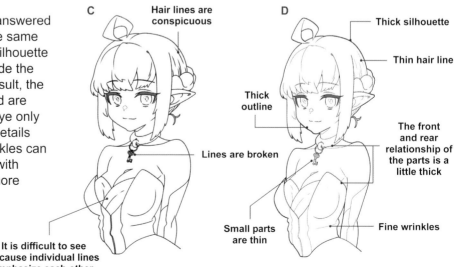

C Hair lines are conspicuous

Lines are broken

It is difficult to see because individual lines emphasize each other.

D Thick silhouette

Thin hair line

Thick outline

The front and rear relationship of the parts is a little thick

Small parts are thin

Fine wrinkles

Long-Distance Staircase Method

A method of deciding a goal in advance for several months to a year and practicing earnestly toward it. With the staircase method, it is easy to set goals and have clear goals, so you can expect rapid growth, but the path is long and steep, so you may get exhausted and give up halfway through.

Human Body Balance Guide

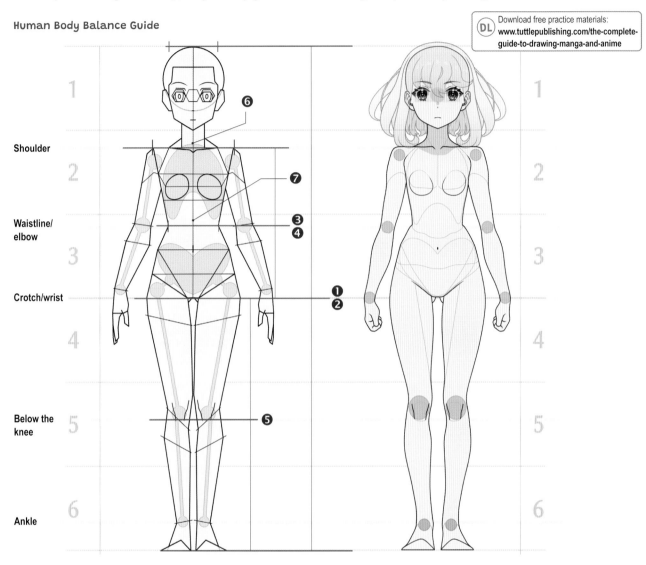

- Shoulder
- Waistline/elbow
- Crotch/wrist
- Below the knee
- Ankle

Front view basic ratio guide

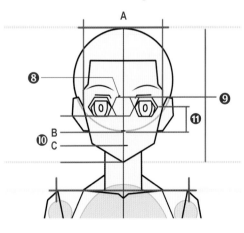

Body proportions

❶ Half of the head and body is the position of the crotch
❷ The position of the crotch is equal to the position of the wrist
❸ Halfway between the shoulder and crotch is the position of the waist
❹ The position of the waistline is equal to the position of the elbow
❺ Also, half of the ankle should be directly below the knee
❻ Shoulder width is 1.5 times the face width A (average)
❼ The width of the waistline is the width that one head can enter (average)

Head ratio

❽ Leave a gap of 1 eye between eyes
❾ Half of the head is the position of the upper eyelid
❿ Divide the lower eyelid and the tip of the chin into three equal parts, where B is under the nose and C is the mouth
⓫ The position where the ears are located is between the outer corner of the eye and the bottom of the nose

Identifying Problems

Basics Permanence Efficiency

How People Appreciate Drawings

How do people evaluate a drawing? People get their first impression from the thumbnail size and trimmed size. Since you can't see the details in the picture, people have to click on a thumbnail to see more. Therefore, we have to be interested in the silhouette, the human body, and the balance of colors.

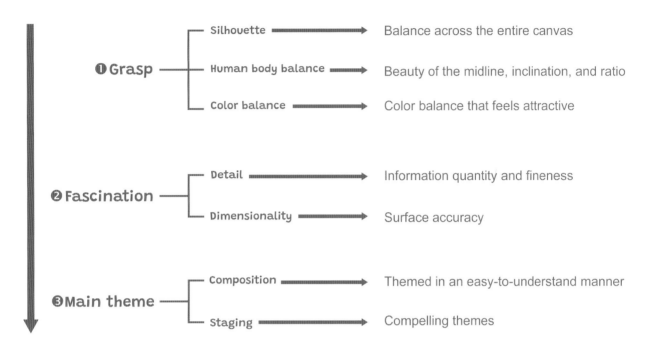

❶ Grasp
- Silhouette ⟶ Balance across the entire canvas
- Human body balance ⟶ Beauty of the midline, inclination, and ratio
- Color balance ⟶ Color balance that feels attractive

❷ Fascination
- Detail ⟶ Information quantity and fineness
- Dimensionality ⟶ Surface accuracy

❸ Main theme
- Composition ⟶ Themed in an easy-to-understand manner
- Staging ⟶ Compelling themes

Click on the image to enlarge it and see the details. Once people are interested in the details and dimensionality, they will pay attention to the compositional and staging aspects of the drawings. However, depending on the situation, you may skip ❷ and go to ❸, so it is important to think about what kind of process will draw you into the picture.

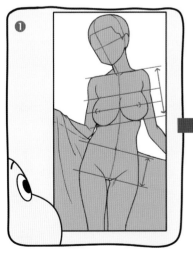

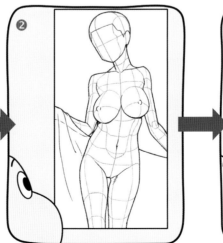

❶ Look at the silhouette, the balance of the human body, and the balance of colors.

❷ Look at details and three-dimensional objects.

❸ Look at the composition and staging.

The Creative Process

The creative process is mainly divided into **theme**, **touch**, **feel**, **reconstruction**, and **output**. If you get stuck, revisit the problem through that process.

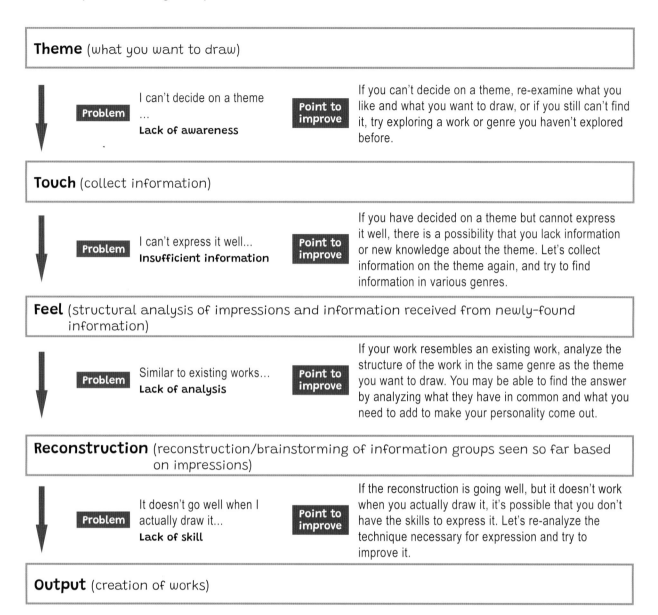

Theme (what you want to draw)

Problem
I can't decide on a theme ...
Lack of awareness

Point to improve
If you can't decide on a theme, re-examine what you like and what you want to draw, or if you still can't find it, try exploring a work or genre you haven't explored before.

Touch (collect information)

Problem
I can't express it well...
Insufficient information

Point to improve
If you have decided on a theme but cannot express it well, there is a possibility that you lack information or new knowledge about the theme. Let's collect information on the theme again, and try to find information in various genres.

Feel (structural analysis of impressions and information received from newly-found information)

Problem
Similar to existing works...
Lack of analysis

Point to improve
If your work resembles an existing work, analyze the structure of the work in the same genre as the theme you want to draw. You may be able to find the answer by analyzing what they have in common and what you need to add to make your personality come out.

Reconstruction (reconstruction/brainstorming of information groups seen so far based on impressions)

Problem
It doesn't go well when I actually draw it...
Lack of skill

Point to improve
If the reconstruction is going well, but it doesn't work when you actually draw it, it's possible that you don't have the skills to express it. Let's re-analyze the technique necessary for expression and try to improve it.

Output (creation of works)

The perception of time spent in this process

First, do what you want to do as soon as possible. Then improve the quality and move on.

Tricks to Find inconsistencies

When you feel something is wrong with the picture but you don't know why, try hiding various parts. If it's digital, you can create a layer that fills a part with white. Stare at the hidden place and imagine what kind of picture it should be. And what if you open the hidden part, you will surely notice any problems.

　　If you look at the character below with one eye hidden, you can see that the direction she is looking in with her left and right eyes is different. This is the epitome of an inconsistency.

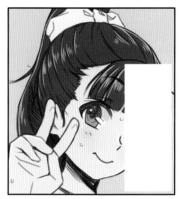

When you cover her left eye with white, her right eye is looking at you...

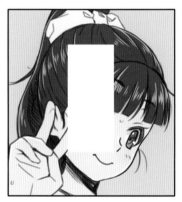

If you hide her left eye, you can see that her right eye is not looking at you.

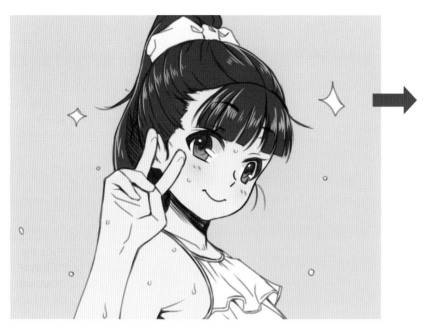

If You Can't Draw Symmetrically, Close One Eye and Draw

When a person sees an object, the brain combines the information from both eyes into a single image, and you may notice problems if your vision is less than perfect. Also, each eye sees an object a little differently. When you're drawing and you're worried about misalignment, closing one eye will help.

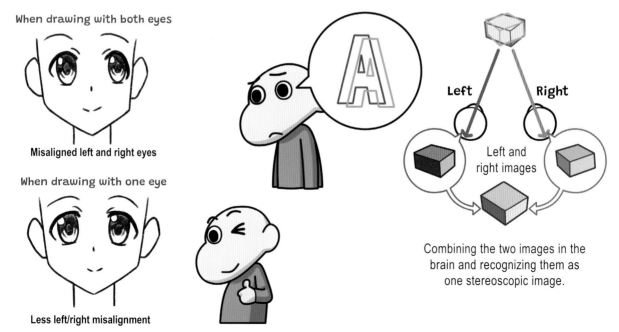

When drawing with both eyes

Misaligned left and right eyes

When drawing with one eye

Less left/right misalignment

Left
Right

Left and right images

Combining the two images in the brain and recognizing them as one stereoscopic image.

Silhouette Confirmation

One of the points that makes the picture look good is the beauty of the silhouette. When you're drawing a picture, you're looking at it subjectively, so it's hard to notice the difference.

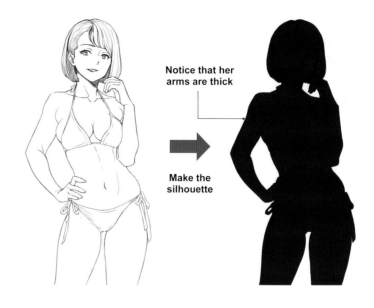

Notice that her arms are thick

Make the silhouette

Blurry Eyes

If there is still an inconsistency, narrowing your eyes when reviewing your work can be an effective method. Just stare at the drawing with narrowed eyes. The idea is to stare at the drawing without trying to look at it closely.

Upside-Down Confirmation

Another way to eliminate subjectivity is by turning the canvas upside down. This method is a confirmation method taught at art colleges. By turning it upside down, you can see an illustration with new eyes, and you can check it in a state where subjectivity is erased.

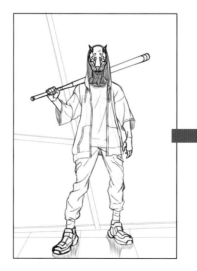
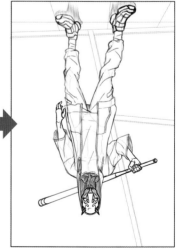

Vertical and Horizontal Balance

One of the first things people see when they look at a drawing is the balance. In particular, if the horizontal or vertical tilt is off, it will look odd. How to correct the balance is explained in detail on page 30.

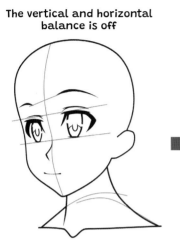

The vertical and horizontal balance is off

Even if you pay attention to the details, it will look strange if the balance is broken.

If you correct the placement...

I corrected the left picture to the correct size and placement for each part. I think it looks good just by correcting the balance.

...you will see the beauty of balance!

Especially for the eyes and eyebrows, draw auxiliary lines in advance so that the two parts are not misaligned.

FEATURE How Do I Find Out What is Trending in Design?

Design trends are constantly changing. So how can we see the flow of the designs? One way is to **observe *doujinshi* (manga) sales events**. At the direct sales areas, the placement position varies depending on the size of the circle (i.e., its fan base).

In front of the shutters, the wall circle groups are the circles called the *Ote*, then the cushion wall groups, then the fake wall groups, and the center stage groups.

I have worked as a staff member for several years, and have also participated in *doujin* circles for many **years**. In other words, there is a possibility that the **cushion wall artists will become a major company in 3 to 5 years, and if you observe the elements common to the cushion wall designs, you will get a hint for the next design.**

In addition, if you analyze the intermediate class popularity rankings, download sales sites, *doujinshi* store sites, etc., you can speculate to some extent what the most popular designs will be.

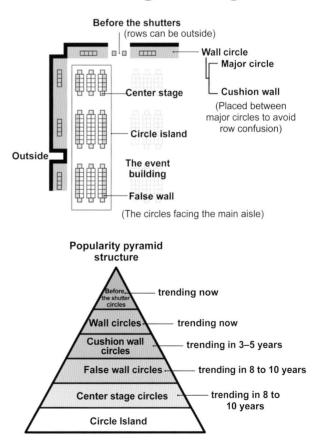

Before the shutters (rows can be outside)

Wall circle
Major circle
Cushion wall
(Placed between major circles to avoid row confusion)

Center stage

Circle island

Outside

The event building

False wall

(The circles facing the main aisle)

Popularity pyramid structure

- Before the shutter circles — trending now
- Wall circles — trending now
- Cushion wall circles — trending in 3–5 years
- False wall circles — trending in 8 to 10 years
- Center stage circles — trending in 8 to 10 years
- Circle Island

How Do I Track My Growth?

Don't you wish you could see your current status like in a video game? Especially when you recreate the same motif or picture you drew in the past, you can see your personal growth and what you have become able to do unconsciously. By making these comparisons regularly, you can actually see your advancement, so please try it.

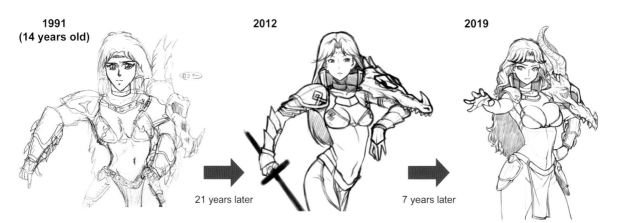

1991
(14 years old)

2012

21 years later

2019

7 years later

Try Some Self-Correction

When comparing your current work with your past work, analyze the points that have improved or the points that have not, and write them down in a journal.

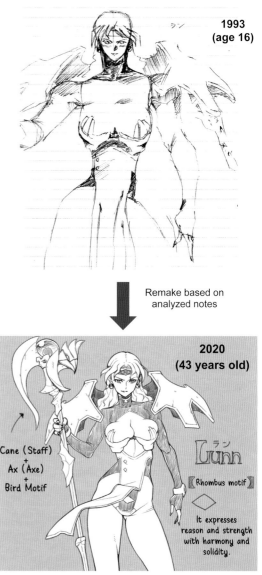

1993
(age 16)

① Think about the points you want to present (the theme)
- A belligerent magic-caster?
- Did you want to express a strong woman?
- Did you want to guide the gaze in the order of facial expression → the shoulder armor → the chest design → the hands?

② Think about what you are doing well (self-praise)
- Contraposto stance is taken
- The hand looks good

③ Think about what wasn't done well (problems in presentation)
- Right hand is cut off
- The legs are only halfway drawn

④ Think about ambiguous points (problems related to drawing)
- The clavicle design in the costume is ambiguous

Remake based on analyzed notes

2020
(43 years old)

Cane (Staff)
+
Ax (Axe)
+
Bird Motif

Lunn

〖Rhombus motif〗

It expresses reason and strength with harmony and solidity.

Beginner Level

Basic Skills for Artists

A 90-Day Course to Improve Your Drawing Skills

In the Beginner Level, we will explain how to draw each part of the body such as the head, torso, limbs, etc. In addition to a lesson that is described according to the method, it explains how to draw and how to think. Five days out of the week, you will be reading the text, and the remaining two days will be rest days, so let's proceed without overdoing things.

Basics Human Body Efficiency

How to Draw a Face from the Front

For everyone who picks up this book, I think that drawing a character is synonymous with drawing a character's face. In the first week, I will explain how to draw from the face to the collarbone, so on the first day, start with how to draw the front of the character using the Basic Proportion Guide for the front view.

(LESSON) **Draw a Face from the Front**

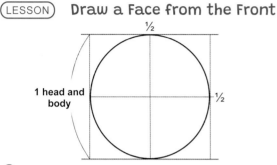

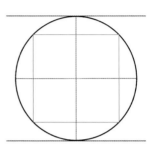

❶ Draw a circle. You can use either drawing software or physical templates. Draw a crosshair to through the center.

❷ Draw a square inside the circle. This process is for memorizing the proportions, so once you get used to it, you will be able to draw even if you skip this process.

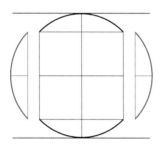

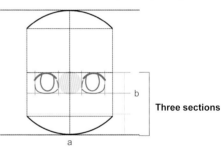

❸ Cut out the left and right red parts that protrude from the square. This remaining part will be the head. The top is the top of the head and the bottom is the tip of the chin.

❹ The horizontal center line is the position of the upper eyelid. From here to the tip of the chin, **a** is divided into three equal parts. This **b** will be the lower eyelid. If you leave a gap of one eye between the eyes, the balance will be better.

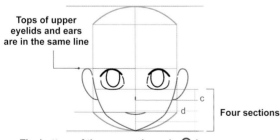

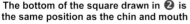

The bottom of the square drawn in ❷ is the same position as the chin and mouth

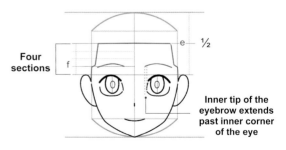

❺ One-quarter **c** from the lower eyelid to the tip of the chin is the position of the bottom of the nose, and half of that is **d**, the position of the mouth. Draw a contour to bend at the level of the mouth. Then draw ears between the upper eyelid and the nose. Now the lower half of the face is done.

❻ The hairline is located at the top of the head and halfway between the upper eyelids **e**. From the hairline, divide the upper eyelid into four equal parts **f**, and the space between the eyebrows will come. When drawing the eyebrows, make sure that the inner corner of the eyebrow is longer than the inner corner of the eye.

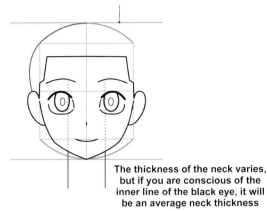

This line becomes the line of the head

The thickness of the neck varies, but if you are conscious of the inner line of the black eye, it will be an average neck thickness

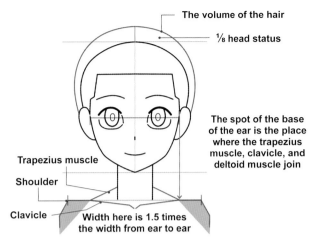

The volume of the hair

⅛ head status

The spot of the base of the ear is the place where the trapezius muscle, clavicle, and deltoid muscle join

Trapezius muscle

Shoulder

Clavicle

Width here is 1.5 times the width from ear to ear

7 Draw the head so that the top of the circle drawn in step **1** and the top of the ear are connected. If you draw the neck so that the inside of the black part of the eyes is wide, it will be an average neck width. The length of the neck varies depending on the head and body, but if you have a 6-head-sized body, it's a good idea to draw it about ¼ the length of the first circle (head).

8 The average shoulder width is about 1.5 times the ear width from the base of the ear. A straight line down from the base of the ear is the confluence of the trapezius, clavicle, and deltoid muscles. The volume of the hair should be drawn about ⅛ the width of the head and body for a better balance.

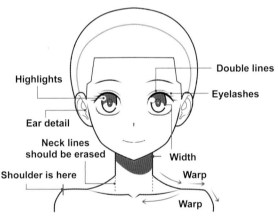

Highlights

Ear detail

Neck lines should be erased

Shoulder is here

Double lines

Eyelashes

Width

Warp

Warp

Finished Example

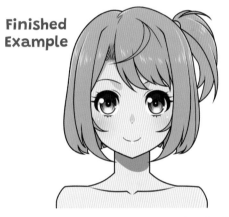

9 Finally, add details such as eyelashes and highlights to complete the front view of the face.

This is an example following the completed guide. You can imitate the drawings of your favorite artist, such as the shape of the eyes and the presence or absence of eyelashes. No matter how good an artist is, they start by imitating the drawings of their favorite artists.

Key Point

The balance of the face drawn in this lesson will be the "basic ratio guide for the front face." First of all, remember this as a basic balance, such as the position of the eyes, nose, and mouth relative to the face, the size of the head, and the width of the shoulders. Since it is basic, you can customize it to your favorite balance once you can see your own pattern.

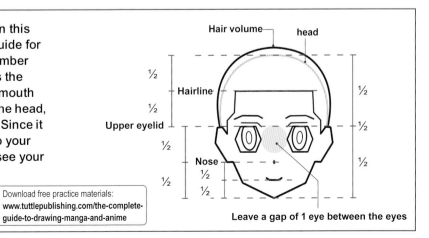

Hair volume head

½

Hairline

½

Upper eyelid

½

Nose ½

½

½

½

½

½

Leave a gap of 1 eye between the eyes

Drawing Better with a Basic Proportions Guide

Here is a picture of a novice pencil artist. Let's try to see how well we can use the Basic Proportions Guide for the front view for this picture. If you are worried that the picture looks distorted, it may be because of a misalignment of the median line, a tilt, or a mistake in the proportion of the parts. These three things are very important for understanding how to draw the whole body.

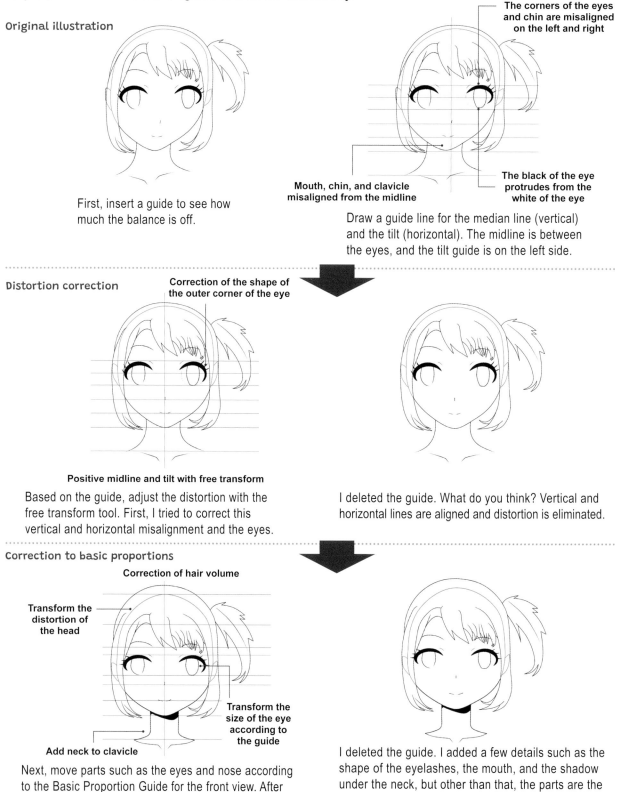

Original illustration

First, insert a guide to see how much the balance is off.

The corners of the eyes and chin are misaligned on the left and right

Mouth, chin, and clavicle misaligned from the midline

The black of the eye protrudes from the white of the eye

Draw a guide line for the median line (vertical) and the tilt (horizontal). The midline is between the eyes, and the tilt guide is on the left side.

Distortion correction

Correction of the shape of the outer corner of the eye

Positive midline and tilt with free transform

Based on the guide, adjust the distortion with the free transform tool. First, I tried to correct this vertical and horizontal misalignment and the eyes.

I deleted the guide. What do you think? Vertical and horizontal lines are aligned and distortion is eliminated.

Correction to basic proportions

Correction of hair volume

Transform the distortion of the head

Transform the size of the eye according to the guide

Add neck to clavicle

Next, move parts such as the eyes and nose according to the Basic Proportion Guide for the front view. After that, adjust the distortion and position of the lines.

I deleted the guide. I added a few details such as the shape of the eyelashes, the mouth, and the shadow under the neck, but other than that, the parts are the same. If you compare these three, it looks much better.

Drawing the Back of the Head

The back of the head is made up of the same silhouette as the front. The most important point is the trapezius muscle. If you draw the trapezius muscle line in front of the neck, it will look like the back.

The silhouette is the same as the front

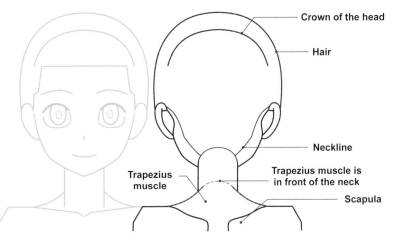

Crown of the head

Hair

Neckline

Trapezius muscle

Trapezius muscle is in front of the neck

Scapula

Common Mistakes

Have you ever felt that your face looks too big for some reason, even though you intended to draw it correctly? This is because you drew the outline and the back of the head by connecting them. There is a space between the contour and the back of the head, so the face (contour) should be smaller than the back of the head. If you are interested, after drawing the outline, draw the back of the head slightly larger than that.

OK!

Here is the back of the head

NO!

If you draw by connecting the outline and the back of the head, the face will look bigger

Outline line

Visible occipital line

How to Draw a Profile

The profile has basically the same balance as the front, so if you remember the balance of the front, you can easily understand how to draw a profile. Be careful not to shift the parts between the front and side view faces.

LESSON Draw a Profile

DL Download free practice materials:
www.tuttlepublishing.com/the-complete-guide-to-drawing-manga-and-anime

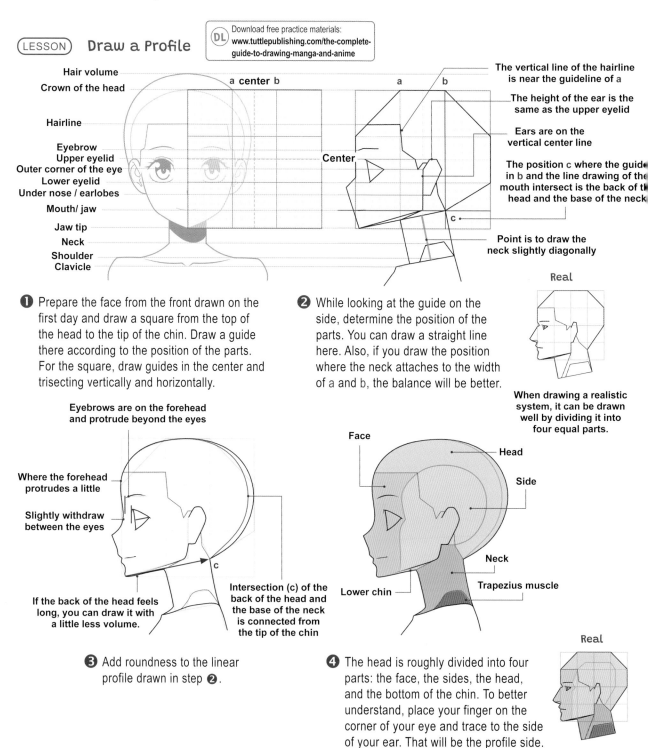

Hair volume
Crown of the head
Hairline
Eyebrow
Upper eyelid
Outer corner of the eye
Lower eyelid
Under nose / earlobes
Mouth/ jaw
Jaw tip
Neck
Shoulder
Clavicle

a center b

a b

Center

The vertical line of the hairline is near the guideline of a

The height of the ear is the same as the upper eyelid

Ears are on the vertical center line

The position c where the guide in b and the line drawing of the mouth intersect is the back of the head and the base of the neck

c

Point is to draw the neck slightly diagonally

Real

❶ Prepare the face from the front drawn on the first day and draw a square from the top of the head to the tip of the chin. Draw a guide there according to the position of the parts. For the square, draw guides in the center and trisecting vertically and horizontally.

❷ While looking at the guide on the side, determine the position of the parts. You can draw a straight line here. Also, if you draw the position where the neck attaches to the width of a and b, the balance will be better.

When drawing a realistic system, it can be drawn well by dividing it into four equal parts.

Eyebrows are on the forehead and protrude beyond the eyes

Where the forehead protrudes a little

Slightly withdraw between the eyes

c

If the back of the head feels long, you can draw it with a little less volume.

Intersection (c) of the back of the head and the base of the neck is connected from the tip of the chin

Face

Head

Side

Neck

Trapezius muscle

Lower chin

Real

❸ Add roundness to the linear profile drawn in step ❷.

❹ The head is roughly divided into four parts: the face, the sides, the head, and the bottom of the chin. To better understand, place your finger on the corner of your eye and trace to the side of your ear. That will be the profile side.

Hair volume

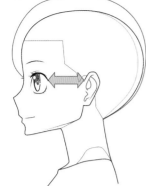

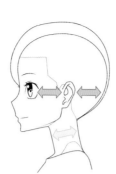

5 Add details such as hair volume and eyelashes to complete the guide.

If you want to draw a character with a thin neck, narrow the width from the outer corner of the eye to the ear and from the ear to the back of the head to make the neck thinner.

Finished Example

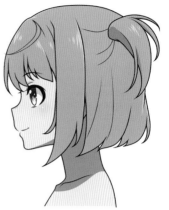

If you draw a character based on the completed guide, it will look like this.

Lips in Profile

First, take a look at a realistic lip shape.

Real

The upper lip protrudes from the lower lip

The line of the mouth is the line of the upper lip

There is also a pattern that does not use a silhouette of the lips. Some people use this animation technique to make it easier to lip-sync.

Profile Symbolization

There are various patterns for showing the profile. Here are some examples.

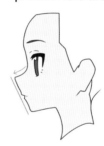

A straight line from nose to chin

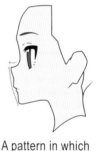

A pattern in which the nose rises and the lips protrude

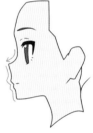

A pattern with a lip silhouette but isn't connected to the mouth line

No lip silhouette

Even if they open their mouth, the shape of the silhouette does not change, so you can reduce the work of drawing.

Common Mistakes

Let's take a look at some common mistakes that beginners make. There is no protrusion on the tip of the chin and the back of the head tends to become a precipice.

Beginner drawing

Eyebrows and eyes are aligned

Not enough back of the head

Have tilted eyes

Misaligned ears

No silhouette of the lips

Correction

Add the back of the head

Shift the position of the eyes and eyebrows

High upper lip for better balance

The chin and the back of the head are connected

How to Draw a Face from an Angle

An angled face is a little more complicated because you have to draw both the front and the side. If you can't figure it out, or if you can draw to some extent but feel something is strange, we have prepared a simple drawing method as a bonus, so try using that.

(LESSON) **Head to Clavicle**

(Preparation)

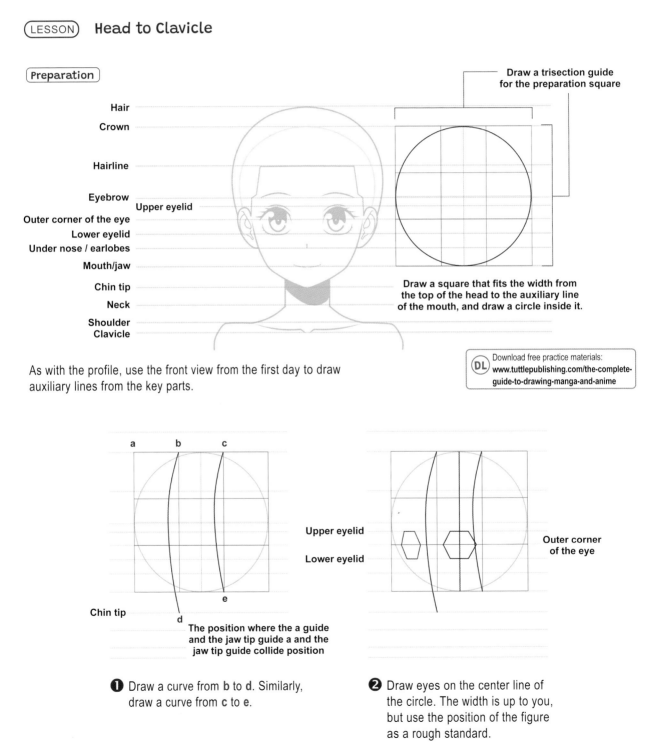

Draw a trisection guide for the preparation square

Draw a square that fits the width from the top of the head to the auxiliary line of the mouth, and draw a circle inside it.

Labels (top to bottom):
Hair
Crown
Hairline
Eyebrow — Upper eyelid
Outer corner of the eye
Lower eyelid
Under nose / earlobes
Mouth/jaw
Chin tip
Neck
Shoulder
Clavicle

As with the profile, use the front view from the first day to draw auxiliary lines from the key parts.

DL Download free practice materials:
www.tuttlepublishing.com/the-complete-guide-to-drawing-manga-and-anime

Upper eyelid
Lower eyelid
Outer corner of the eye

Chin tip
The position where the a guide and the jaw tip guide a and the jaw tip guide collide position

❶ Draw a curve from **b** to **d**. Similarly, draw a curve from **c** to **e**.

❷ Draw eyes on the center line of the circle. The width is up to you, but use the position of the figure as a rough standard.

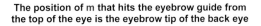

The position of **m** that hits the eyebrow guide from the top of the eye is the eyebrow tip of the back eye

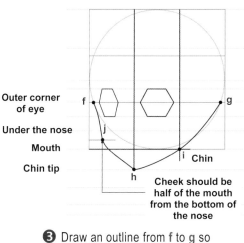

Outer corner of eye

Under the nose

Mouth

Chin tip

f

g

j

h

i **Chin**

Cheek should be half of the mouth from the bottom of the nose

❸ Draw an outline from **f** to **g** so as to pass through **h** and **i**.

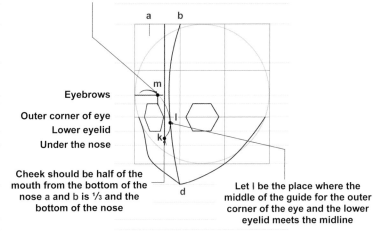

a b

m

Eyebrows

Outer corner of eye
Lower eyelid
Under the nose

l

k

d

Cheek should be half of the mouth from the bottom of the nose **a** and **b** is ⅓ and the bottom of the nose

Let **l** be the place where the middle of the guide for the outer corner of the eye and the lower eyelid meets the midline

❹ Draw the parts of the face. The line from **b** to **d** drawn in ❶ will be the midline of the face. The curve passing through the three points **k**, **l**, and **m** is the bridge of the nose.

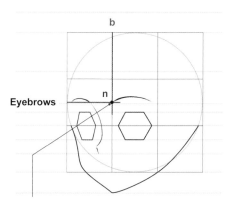

b

n

Eyebrows

The tip of the eyebrow in the foreground will be the **n** position where it hits the guide of the eyebrow when it is lowered from **b**.

❺ Draw the front eyebrows.

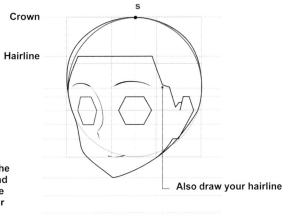

Mouth

o

The position where the median line and mouth guide collide is the mouth

❻ Draw the mouth to complete the facial parts.

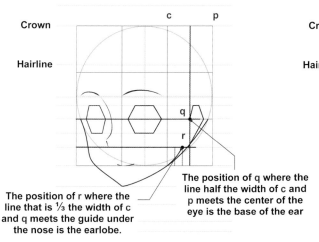

c p

Crown

Hairline

q

r

The position of **r** where the line that is ⅓ the width of **c** and **q** meets the guide under the nose is the earlobe.

The position of **q** where the line half the width of **c** and **p** meets the center of the eye is the base of the ear

❼ Draw the ears.

s

Crown

Hairline

Also draw your hairline

❽ Draw the head according to the roundness of the circle so that the vertex **s** of the circle is the top of the head.

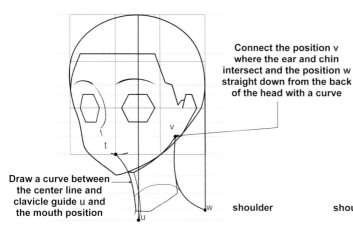

Connect the position v where the ear and chin intersect and the position w straight down from the back of the head with a curve

Draw a curve between the center line and clavicle guide u and the mouth position

shoulder

⑨ Draw the neck. At this time, be conscious that the lines on the left and right of the neck are roughly parallel.

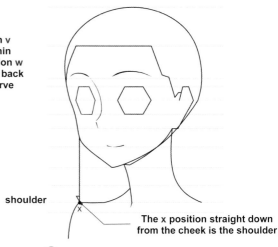

shoulder

The x position straight down from the cheek is the shoulder

⑩ Draw the back shoulder.

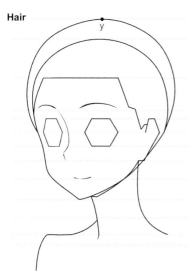

Hair

⑪ Draw the volume of the hair according to the position of the vertex y of the hair.

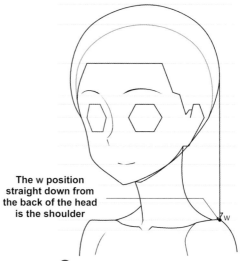

The w position straight down from the back of the head is the shoulder

⑫ Draw the shoulder and collarbone.

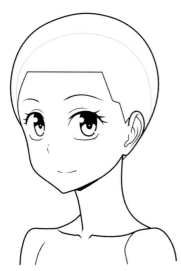

⑬ Finally, draw the eyelashes and details inside the eyes to complete the drawing.

Finished Example

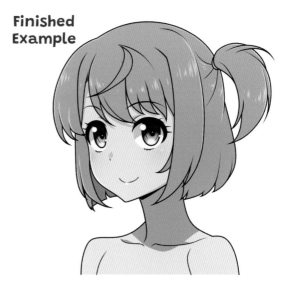

If you draw a character based on the completed guide, it will look like this.

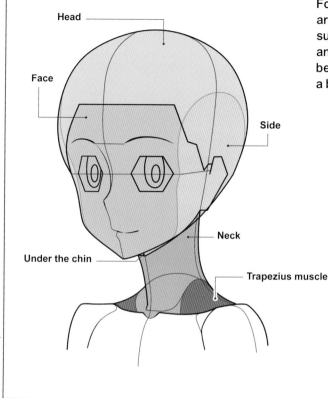

- Head
- Face
- Side
- Under the chin
- Neck
- Trapezius muscle

For angled faces, both the front and sides of faces are visible. Please remember well what kind of surface and parts are connected where. If the front and sides are difficult to understand, I think it will be easier to understand if you imagine the head in a box and draw it that way.

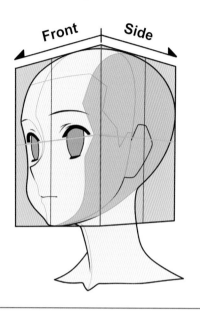

Front Side

FEATURE A Low-Angled Head isn't a Circle?

When drawing an angled face, the top of the head should be drawn as a circle taking into account the amount of tilt. In the case of head tilt, the top of the head can be made to look more natural by making the top of the head slightly flat and gently curved.

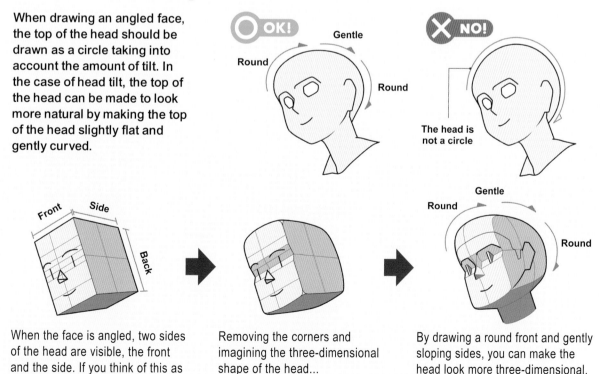

OK!
Gentle
Round
Round

NO!
The head is not a circle

Front Side Back

Gentle
Round
Round

When the face is angled, two sides of the head are visible, the front and the side. If you think of this as a cube, it will look like this.

Removing the corners and imagining the three-dimensional shape of the head...

By drawing a round front and gently sloping sides, you can make the head look more three-dimensional.

Eyebrows and Eyes Make a Gap

If you look at the profile, you can see that the forehead is protruding and the eyes are recessed from the forehead. There is a height difference between the eyes and the eyebrows. When you look at your face from an angle, it looks like your eyebrows and eyes are misaligned due to this height difference. Without this misalignment, the face will look flat.

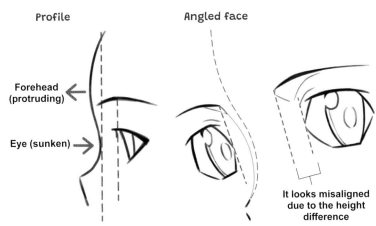

Profile

Angled face

Forehead (protruding) ←

Eye (sunken) →

It looks misaligned due to the height difference

The Curve of the Median Line Is the Same as the Contour Line

Look closely at the **A** line on the profile. This line will be the midline in the front and angled faces. In other words, when drawing an angled face with the same pattern, the lines **A** and **C** must be similar lines. Of course, this is not absolute, but the lines that are as similar as possible look beautiful. Also, since the **B** and **D** lines are also part of the three-dimensional face, if you keep in mind that the lines will be similar in the same way, you will be able to create a highly consistent picture.

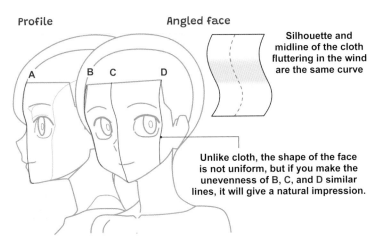

Profile

Angled face

A B C D

Silhouette and midline of the cloth fluttering in the wind are the same curve

Unlike cloth, the shape of the face is not uniform, but if you make the unevenness of B, C, and D similar lines, it will give a natural impression.

A Picture Is an Image of an Engraving

When drawing an angled face, it is important to be aware of the face. If you don't pay attention to at least two sides, the front and the side, the picture will be flat and the face will be too big for the head. It is a good idea to create the angled face with this in mind.

Using Our Guide to Fix Problems

Here are drawings of two novice pencil artists. If you draw the median line and the auxiliary line of the inclination according to the picture, you can see that the inclination is different for both. The figures below show this with the median line and slope corrected. Just like when I corrected the front view face on page 30, I used the original drawing to correct the parts using only free transformation (the neck has been redrawn). In this way, even if there is no deviation between the median line and the tilt, it will look quite good. If your face is unbalanced, try using a ruler or ruler tool to draw auxiliary lines instead of freehand when drawing the rough.

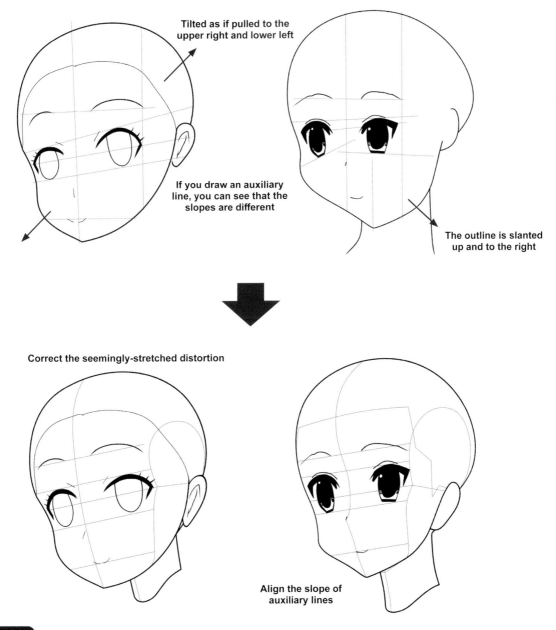

Tilted as if pulled to the upper right and lower left

If you draw an auxiliary line, you can see that the slopes are different

The outline is slanted up and to the right

Correct the seemingly-stretched distortion

Align the slope of auxiliary lines

Key Point

Right-handed people tend to lean to the upper right and lower left. Try writing on unlined paper. If your letters tend to slant up and to the right and to the right, the picture may also be up and to the right.

How to Connect the Head and Shoulders with the Neck

The neck is an important element in drawing the front face, profile face, and angled face. Here, I will explain how to connect from the neck to the shoulder.

Simplify the Head, Face, and Neck

I've drawn the front view face, side of the face, and the angled face so far, so you can see that the head is drawn as a sphere. Now imagine a face with a shield and a cylindrical neck merging. I think that a simplification like this makes it easier to imagine a roughly three-dimensional effect.

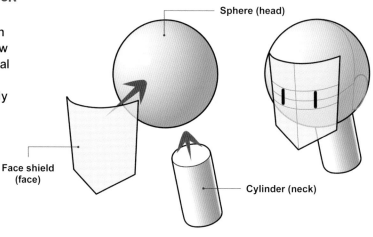

Sphere (head)

Face shield (face)

Cylinder (neck)

How to Draw the Chin

Humans have an area under the chin that connects the tip of the chin to the neck. It won't look right when this area under the chin is not drawn. Even if you have a slightly slanted face, you can see a little under the chin.

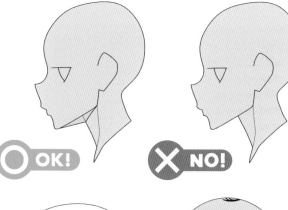

OK! NO!

Real

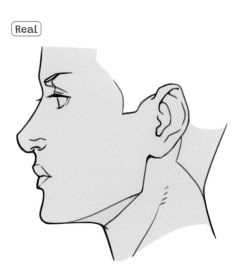

The technique of filling the neck with solid color, which is often seen in illustrations, forms the bottom of the chin.

How to Draw from the Neck to the Clavicle

The clavicle is shaped like a bow. The clavicle is connected to the shoulder blade on the back side and moves in conjunction with the arm bone (humerus) and the shoulder muscle (deltoid). Therefore, when you move your shoulder, your collarbone and scapula move at the same time. There is also a muscle called the trapezius muscle between the neck and the shoulder.

In the case of a real human body, the trapezius muscle bulges, but in the case of an illustration, drawing it with a dent makes it look slim and slender.

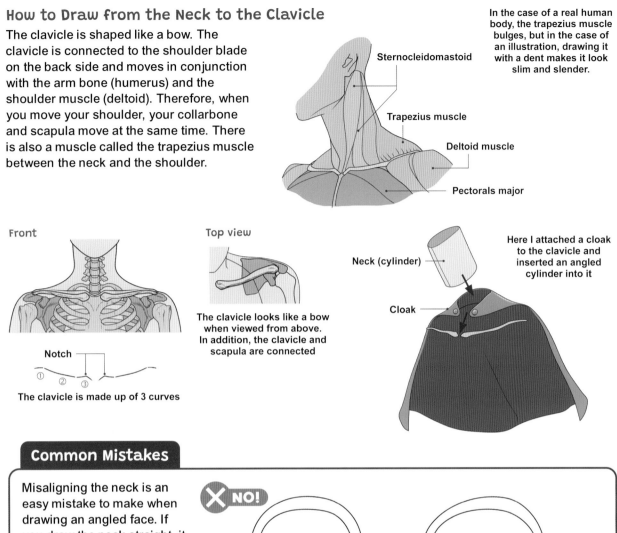

- Sternocleidomastoid
- Trapezius muscle
- Deltoid muscle
- Pectorals major

Front

Notch
① ② ③

The clavicle is made up of 3 curves

Top view

The clavicle looks like a bow when viewed from above. In addition, the clavicle and scapula are connected

Neck (cylinder)

Cloak

Here I attached a cloak to the clavicle and inserted an angled cylinder into it

Common Mistakes

Misaligning the neck is an easy mistake to make when drawing an angled face. If you draw the neck straight, it will look like the figure when viewed from the side. This will make the bottom of the chin disappear. Also, when drawing a face at an angle of 45 degrees, it works well to draw the neck from the base of the ear.

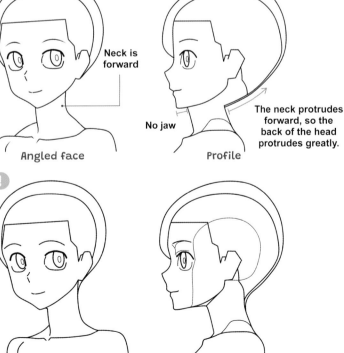

NO!

Neck is forward

No jaw

The neck protrudes forward, so the back of the head protrudes greatly.

Angled face

Profile

OK!

Angled face

Profile

Tips for Drawing the Parts of the Face

Now that you can draw the balance between the front view of the face, side face, and angled face, take a look at tips for drawing the parts of the face. The face can particularly express individuality, so it's important to understand the basics and try to find a way to draw the parts that suits you.

Eye Structure

The eye is made up of dark and white parts. The dark part of the eye is covered with a dome-shaped cornea, inside of which there is a mortar bowl-shaped iris and the pupil behind it.

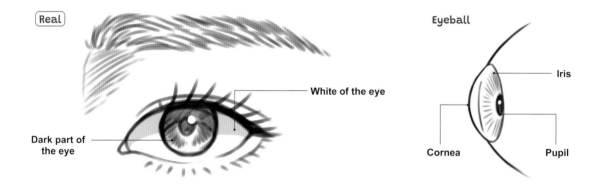

Real

White of the eye

Dark part of the eye

Eyeball

Iris

Cornea

Pupil

Pupil Position

When viewed from the front, the pupil has the shape of a perfect circle, but when the face is tilted, the eye is also tilted, so it gradually becomes an ellipse and the position of the pupil shifts.

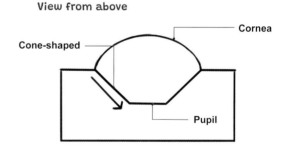

View from above

Cone-shaped

Cornea

Pupil

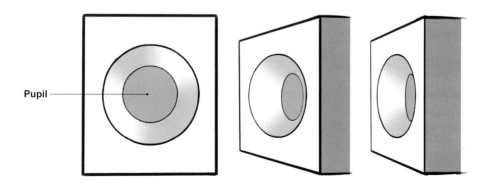

Pupil

A common mistake made by beginners is to draw a picture where the pupil is always in the center or the pupil is stuck to the cornea like a sticker.

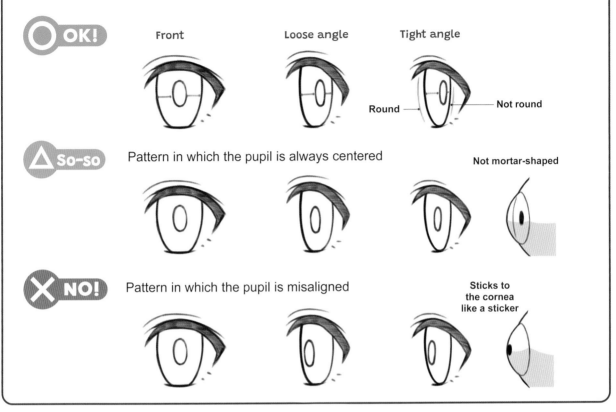

Drawing Eyelids with Different Patterns

Many people think that the eyelid is made up of a single line, but it is roughly divided into five blocks. The pattern is determined by which of these five pieces you leave out.

Angled Eyelids

When drawing the eyes in the back, the eyelids are a part that changes dramatically when the face is angled. This can be understood by understanding that the area around the eye is shaped like a hill.

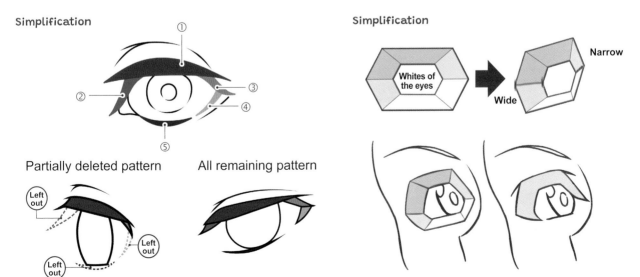

43

Profile Eyes

The profile eye pattern is very versatile. It also changes depending on the character. Carefully observe how the drawings of your favorite artists are transformed.

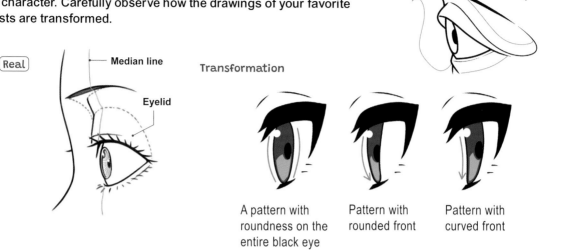

Super realistic

Real

Median line

Eyelid

Transformation

A pattern with roundness on the entire black eye

Pattern with rounded front

Pattern with curved front

Eye Changes by Angle

In the case of the front, both eyes will be mirror images. The inclination of the corners of the upper and lower eyelids is about 60 degrees (depending on the shape of the eye, such as slanting or drooping eyes), but if the angle increases slightly, the ratio and the width of the inner and outer corners of the eye will change. However, basically the vertical width of the eye does not change.

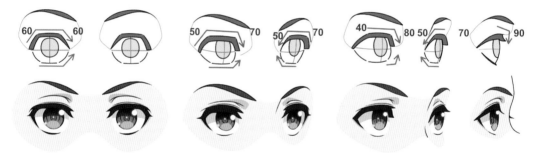

How Eyelashes Grow

Eyelashes grow from the edge of the eyelid. It grows in a radial pattern, so be careful not to stray in any direction.

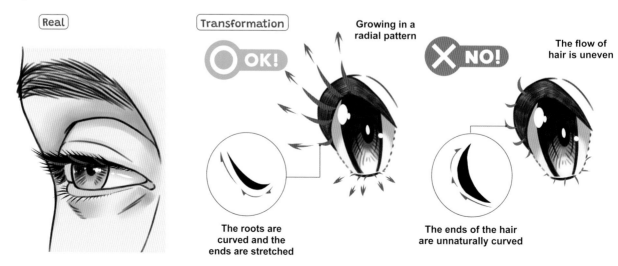

Real

Transformation

OK!

Growing in a radial pattern

The roots are curved and the ends are stretched

NO!

The flow of hair is uneven

The ends of the hair are unnaturally curved

Mouth Structure

The mouth consists of the upper and lower lips.

In the case of illustrations, it is rare to draw the lips firmly closed.

Also, depending on the design, you may see the mouth cut off in the middle.

More importantly, the position of the center of the mouth changes depending on the tilt of the face. Keep in mind that the cut position is always the center of the tilted state.

Also, by making tame on both ends of the mouth (mouth corners), the expression will be easier to understand.

Real

M-shaped upper lip
Drawing here gives a realistic impression

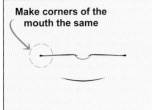

Front

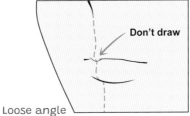

Loose angle

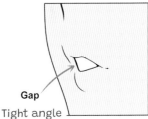

Tight angle

Transformation

Make corners of the mouth the same

Front

Don't draw

Loose angle

Gap

Tight angle

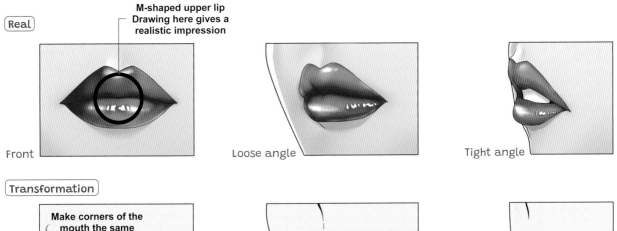

Key Point

It depends on the design, but a child's mouth should look rounded, and an adult's mouth should look straight.

Children's lips are round

Make them the same

Adult lips are straight

Loose S-shape

S-shaped

NO!

The line drawings are not connected on the left and right

The facial expression is clearly not the same if it is only a simple curve

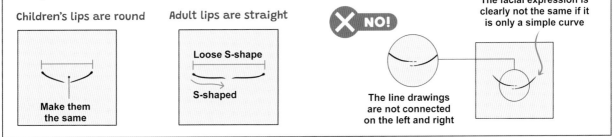

How to Draw an Open Mouth

When drawing an open mouth, draw from the line of the upper lip. It looks more realistic if you use this technique.

❶ Draw the upper lip

❷ Draw the lower lip so that it comes out from under the line of the upper lip

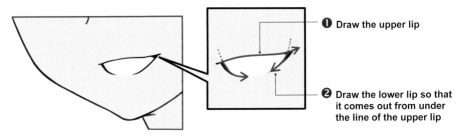

45

Various Ways to Open the Mouth

The expression changes greatly depending on how much the mouth is opened. When drawing an open mouth, adjust it according to the mood of the character you want to draw.

When you close your mouth, the lines will be thinner because they will stick together.

You can't see the tooth line when you open it a little.

If you open it a little, you can see the upper teeth.

If you open it well, you can see the lower teeth.

Slightly realistic

Transformation

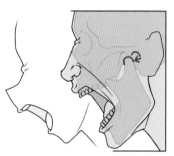

When you open your mouth wide, the jawbone shifts.

Structure and Coding of the Ear

There are various ways to draw ears, and there is no one correct answer. Also, since the ears are often hidden by the hair, they are also a part that does not get much attention. Even people who are reasonably good at it often have vague ears or can't draw well. In other words, many artists practice their ears at the end, so it can be said that good ears = good drawing. A good ear means that you are observant and attentive to details.

Real

Transformation

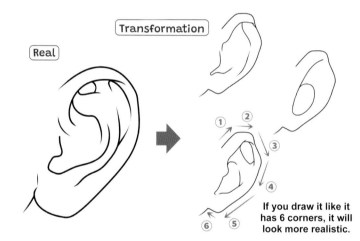

If you draw it like it has 6 corners, it will look more realistic.

Key Point

When you get confused about the position of the ears, use glasses as an example. The temple part of the glasses will be the position of the ear.

Nose Drawing Method

In real life, the bridge of the nose is treated as part of the face, so the cross section is trapezoidal. In the drawing, the bridge of the nose is regarded as a line, so it is better to consider the cross section as a triangle.

Real

Trapezoid

Transformation

Triangle

Various Depictions of the Nose

The shape of the nose varies depending on which face or line you draw. Let's look at a simplified pattern for clarity.

Guide to capture the nose

Tip of the nose

Center line

Nostril

Left side

Back of the nose

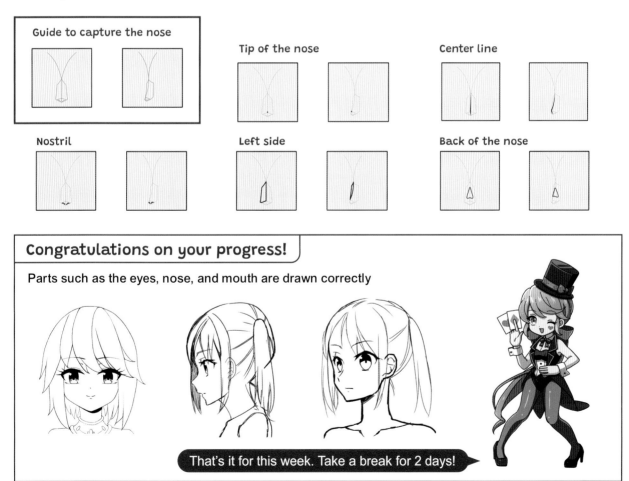

Congratulations on your progress!

Parts such as the eyes, nose, and mouth are drawn correctly

That's it for this week. Take a break for 2 days!

How to Draw the Torso from the Front

Once you have learned how to draw the face, the next step is to learn how to draw the body that connects to the head. First of all, let's start by understanding the balance as well as the face. I will explain the balance of the whole body on the 22nd day, so today I will explain how to draw the head and torso using a woman with a height of 6.5 heads as an example.

(LESSON) **Draw the Torso Front View**

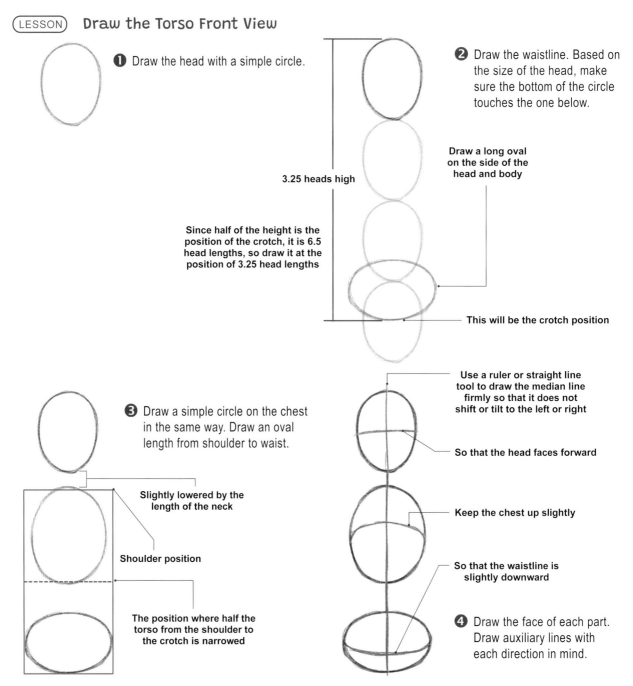

❶ Draw the head with a simple circle.

❷ Draw the waistline. Based on the size of the head, make sure the bottom of the circle touches the one below.

3.25 heads high

Draw a long oval on the side of the head and body

Since half of the height is the position of the crotch, it is 6.5 head lengths, so draw it at the position of 3.25 head lengths

This will be the crotch position

❸ Draw a simple circle on the chest in the same way. Draw an oval length from shoulder to waist.

Use a ruler or straight line tool to draw the median line firmly so that it does not shift or tilt to the left or right

So that the head faces forward

Slightly lowered by the length of the neck

Shoulder position

Keep the chest up slightly

The position where half the torso from the shoulder to the crotch is narrowed

So that the waistline is slightly downward

❹ Draw the face of each part. Draw auxiliary lines with each direction in mind.

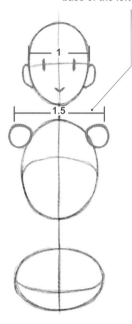

The basic shoulder width is 1.5 times the width of the base of the left and right ears

1

1.5

❺ Draw the shape of the face and the positions of the shoulder joints.

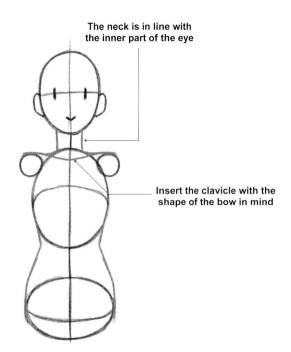

The neck is in line with the inner part of the eye

Insert the clavicle with the shape of the bow in mind

❻ Connect the chest and waist while narrowing the waist using the guide inserted in ❸ as a reference.

STEP UP Take a closer look at the front view

Pectoralis major

Sternum

Rectus abdominis

❼ Draw the line of the sternum and the shape of the rectus abdominis muscle. The chest starts from the bottom of the pectoralis major muscle, so if you are worried about the position of the chest, you may want to put in an overlap. Depicting overlap can be difficult for beginners, so practice it first.

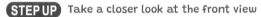

Make sure that the left and right trapezius muscles are connected

The shoulder is formed by the deltoid muscle on top of the round shoulder guide.

The pink part is the side of the torso

Front surface of the leg

Draw the surface of the body. When viewed from the front, not all torso silhouettes are frontal. In fact, the front part is narrow, and the other side is visible.

How to Draw the Torso from the Side

Today, I will explain how to draw a side view of the torso. The basic balance is the same as the front, but when facing sideways, the tilt of the chest and waist becomes important. Let's draw while being aware that the line from the waist to the buttocks will be an elegant S-shape.

(LESSON) **Draw the Torso from the Side**

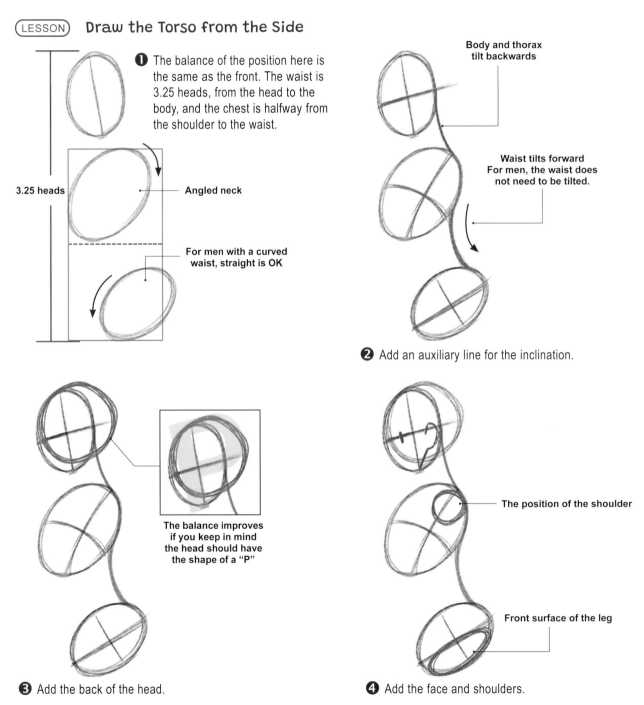

❶ The balance of the position here is the same as the front. The waist is 3.25 heads, from the head to the body, and the chest is halfway from the shoulder to the waist.

3.25 heads

Angled neck

For men with a curved waist, straight is OK

Body and thorax tilt backwards

Waist tilts forward
For men, the waist does not need to be tilted.

❷ Add an auxiliary line for the inclination.

The balance improves if you keep in mind the head should have the shape of a "P"

The position of the shoulder

Front surface of the leg

❸ Add the back of the head.

❹ Add the face and shoulders.

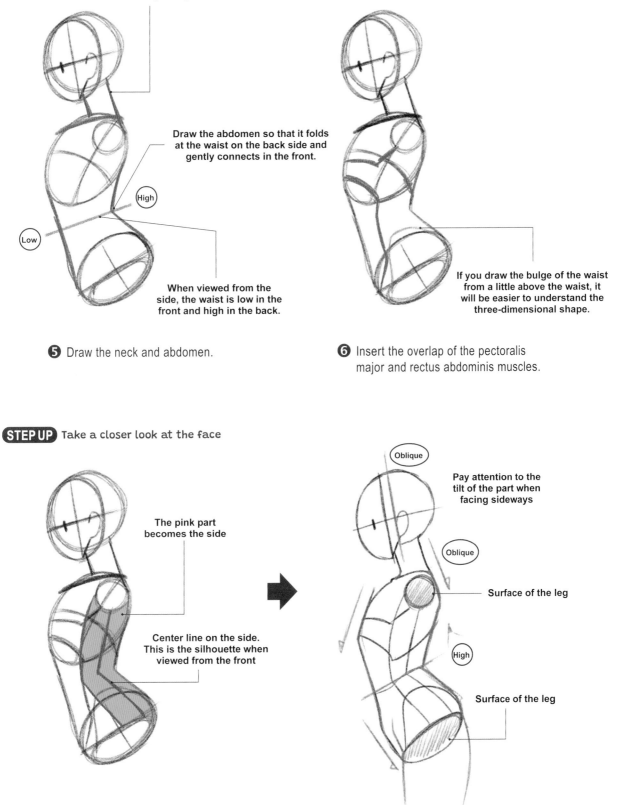

Draw the front and back lines parallel to each other at a slight angle for the neck

Draw the abdomen so that it folds at the waist on the back side and gently connects in the front.

High

Low

When viewed from the side, the waist is low in the front and high in the back.

❺ Draw the neck and abdomen.

If you draw the bulge of the waist from a little above the waist, it will be easier to understand the three-dimensional shape.

❻ Insert the overlap of the pectoralis major and rectus abdominis muscles.

STEP UP Take a closer look at the face

The pink part becomes the side

Center line on the side. This is the silhouette when viewed from the front

Oblique

Pay attention to the tilt of the part when facing sideways

Oblique

Surface of the leg

High

Surface of the leg

Draw lines that separate the front and sides and the center of the side. I think this makes it easier to grasp the solidity. It will look like this after removing the auxiliary lines and adjusting the shape.

How to Draw the Torso from an Angle

Today, I'm going to explain how to draw an angled torso. The diagonal is the same for the front as it is for the side view. I also explained how to draw an angled face with both the front and sides visible.

(LESSON) Draw the Torso from an Angle

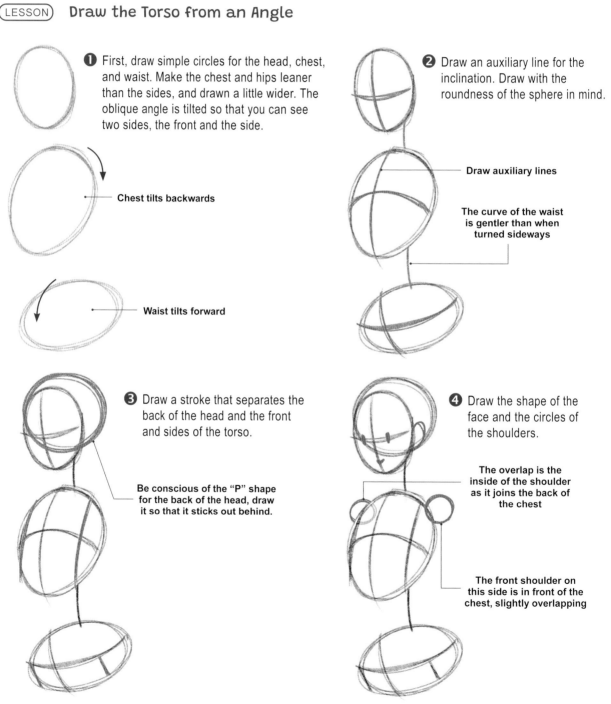

❶ First, draw simple circles for the head, chest, and waist. Make the chest and hips leaner than the sides, and drawn a little wider. The oblique angle is tilted so that you can see two sides, the front and the side.

Chest tilts backwards

Waist tilts forward

❷ Draw an auxiliary line for the inclination. Draw with the roundness of the sphere in mind.

Draw auxiliary lines

The curve of the waist is gentler than when turned sideways

❸ Draw a stroke that separates the back of the head and the front and sides of the torso.

Be conscious of the "P" shape for the back of the head, draw it so that it sticks out behind.

❹ Draw the shape of the face and the circles of the shoulders.

The overlap is the inside of the shoulder as it joins the back of the chest

The front shoulder on this side is in front of the chest, slightly overlapping

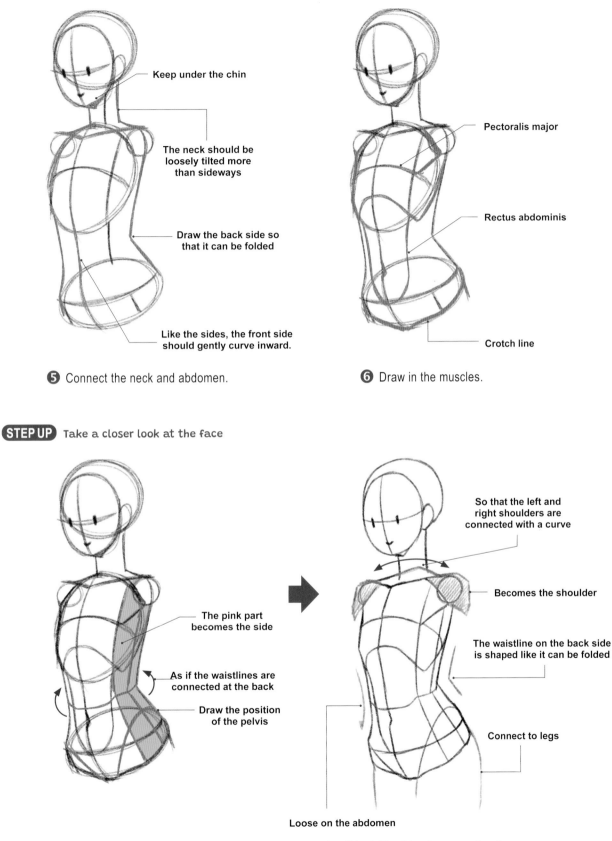

Keep under the chin

The neck should be loosely tilted more than sideways

Draw the back side so that it can be folded

Like the sides, the front side should gently curve inward.

5 Connect the neck and abdomen.

Pectoralis major

Rectus abdominis

Crotch line

6 Draw in the muscles.

STEP UP Take a closer look at the face

The pink part becomes the side

As if the waistlines are connected at the back

Draw the position of the pelvis

So that the left and right shoulders are connected with a curve

Becomes the shoulder

The waistline on the back side is shaped like it can be folded

Connect to legs

Loose on the abdomen

Draw the lines that separate the front and sides and the center of the side.

It will look like this after removing the auxiliary lines and adjusting the shape.

The Structure of the Torso

So far, I have explained how to draw the body from three perspectives: front, side, and diagonal. Today, I will explain the structure of the torso and the differences between males and females.

Trunk Simplification

The body is roughly made up of four sides: the front, left and right sides, and the back. In beginner drawings, the torso may look wide due to the absence of the sides, so try to imagine a simple square or simple shape first.

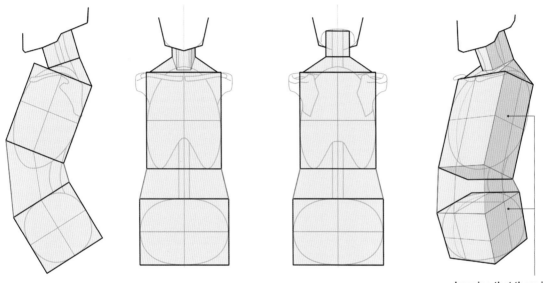

Imagine that there is a side even when drawing a circle

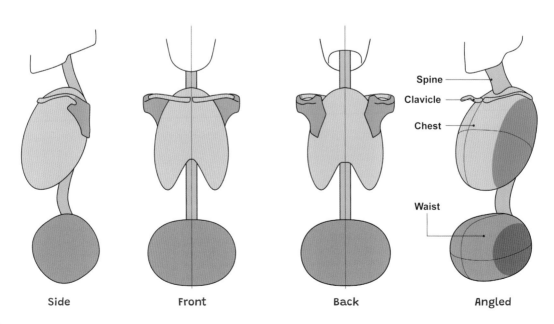

Spine
Clavicle
Chest

Waist

Side Front Back Angled

Differences Between Male and Female Skeletons

When comparing the physiques of men and women, the biggest difference is the torso. In fact, there is not much difference between the bones of the limbs. The difference in shoulder width and waist width, which is often raised as a difference between men and women, is related to the width of the sternum and pelvis. See the diagram below. Males have a wider central sternum, while females have an oval shape with a wider lower sternum and narrower upper sternum. The shoulders will be wider for men because of the wider sternum, and the shoulders will be narrower for women because the sternum is narrower. Similarly, women have a wide pelvis, giving the impression of a plump waist. The pelvis will be discussed in more detail on the next page.

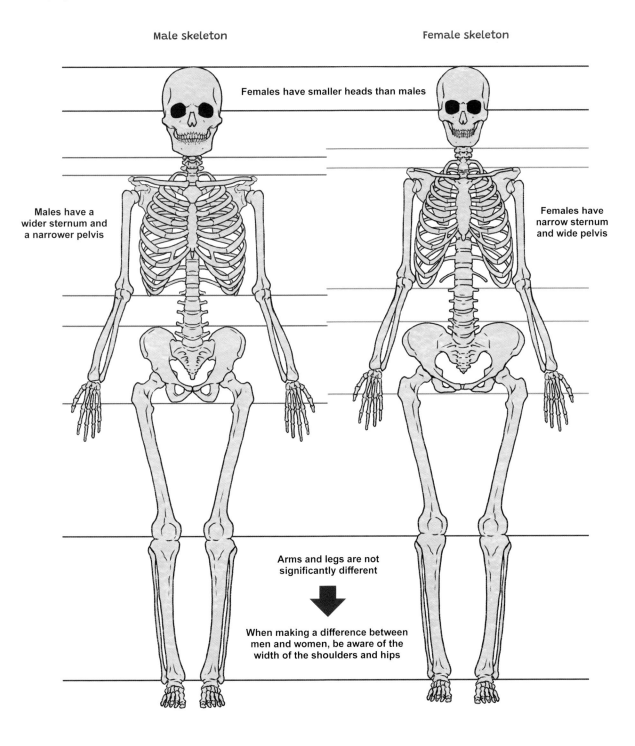

Male skeleton

Female skeleton

Females have smaller heads than males

Males have a wider sternum and a narrower pelvis

Females have narrow sternum and wide pelvis

Arms and legs are not significantly different

When making a difference between men and women, be aware of the width of the shoulders and hips

The Shape of the Pelvis Differs Between Men and Women

Another difference between men and women is the pelvis. When viewed from the front, the male pelvis is nearly square, running as wide as the chest. The female pelvis is much wider laterally than the chest. When viewed from the side, the spine is straight in men because the hips are vertical, and in women the spine is curved because it leans forward.

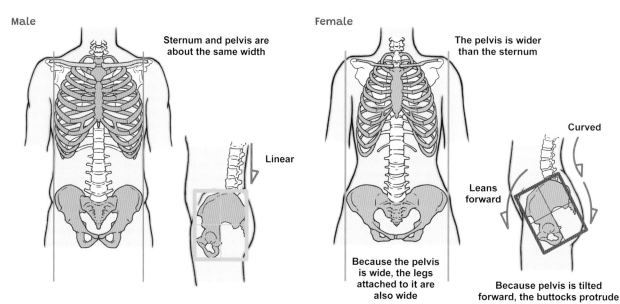

Male

Sternum and pelvis are about the same width

Linear

Female

The pelvis is wider than the sternum

Curved

Leans forward

Because the pelvis is wide, the legs attached to it are also wide

Because pelvis is tilted forward, the buttocks protrude

Chest Position

The chest is attached from the bottom of the pectoralis major muscle. The space between the collarbones and the upper chest is called the décolleté. You can see that the chest is attached to the bottom.

Boundary Between Shoulder and Chest

The shoulders are next to the chest (pectoralis major). If you draw the shoulders on the outside without being aware that they are attached to the chest, the shoulders will become too wide, so be careful. I will explain the shoulders tomorrow (Day 12).

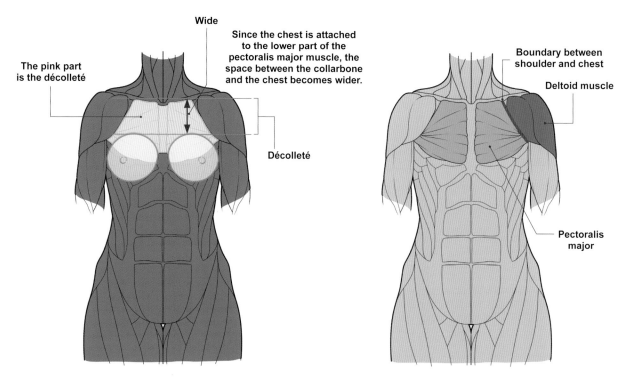

Wide

The pink part is the décolleté

Since the chest is attached to the lower part of the pectoralis major muscle, the space between the collarbone and the chest becomes wider.

Décolleté

Boundary between shoulder and chest

Deltoid muscle

Pectoralis major

Male and Female Skeletons

Here is the difference between men and women when replaced with a six heads-high character. It is important to remember this.

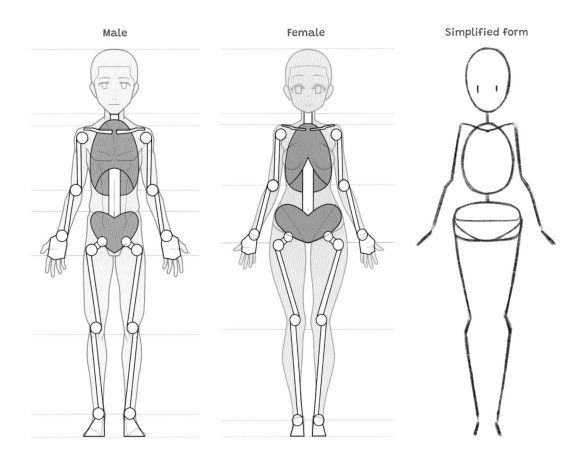

Male Female Simplified form

Instead of drawing a complex shape from the beginning, it is better to start with a simple shape and check the balance and then draw the details from there.

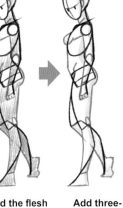

Simple shape Add the flesh Add three-dimensional effect

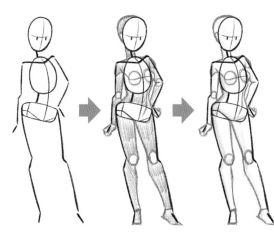

Simple shape Add the flesh Add three-dimensional effect

Shoulder and Torso Poses

Today we will be learning about shoulder and torso poses. The torso pose affects the movement of the torso as well as the shoulders. The shoulders can be moved up and down, and back and forth, so let's pose the torso while combining both elements.

Creating the Shoulder

In the case of an angled figure, the shoulders appear longer in the back and shorter in the front.

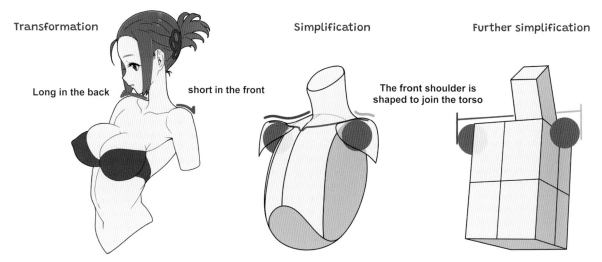

Transformation

Long in the back short in the front

Simplification

The front shoulder is shaped to join the torso

Further simplification

The appearance of the shoulder changes depending on the pose. In the case of a pose that arches the back and puffs out the chest, the shoulders rotate backward, so the back looks short and the front looks long.

When the back is rounded, the shoulders rotate forward, making the back look longer and the front shorter. The shoulders have a wide range of motion, so be sure to change them according to the picture you want to draw.

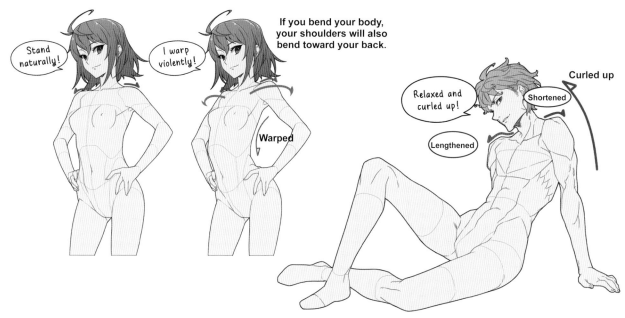

Stand naturally!

I warp violently!

If you bend your body, your shoulders will also bend toward your back.

Warped

Relaxed and curled up!

Curled up

Shortened

Lengthened

Standing Pose

When drawing a standing pose, there are roughly four patterns to follow: **leaning forward**, **normal**, **arching backward**, and **rounding the back**. Based on this, the pose is created by twisting the waist and moving the arms. I will explain twists in the Intermediate level (page 154).

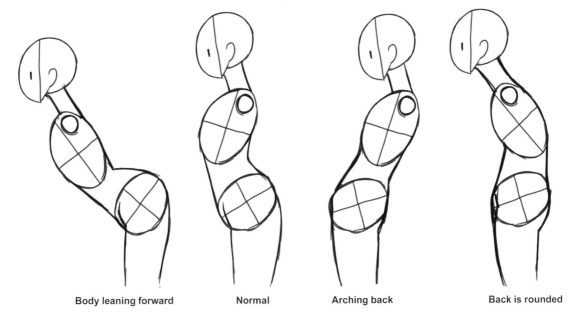

| Body leaning forward | Normal | Arching back | Back is rounded |

FEATURE Comparing Body Parts to Familiar Objects

In Week 1, I compared the collarbone to a bow, but you could also compare the shoulders to a clothes hanger, the chest to an egg, and the lower back to a heart. It doesn't matter what it is, as long as you find something that looks like this shape to you, you may be able to understand it better.

The hanger is made in the shape of a shoulder, so it's perfect as a reference.

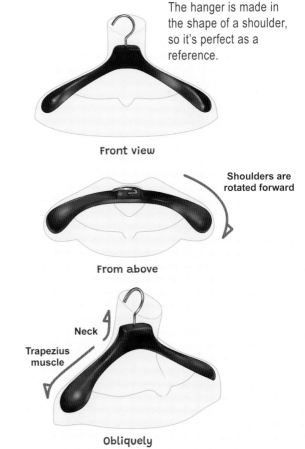

Front view

Shoulders are rotated forward

From above

Neck

Trapezius muscle

Obliquely

Shoulder: hanger

Chest: egg

Pelvis: heart

Female Body Types

Female body types can be roughly divided into three categories: **natural**, **curvy**, and **straight**. If you want to draw a narrow neck and chest, you should draw a straight body, so instead of drawing only the chest up, draw vertically from the clavicle to the crotch. Otherwise you will lose all balance. Also, when comparing the curvy and natural shapes, the natural shape has a thicker body. This is due to an illusion. When comparing a vertically long illustration with a short illustration with the same width, the short, straight figure actually looks wider. Therefore, if you want to draw a slender figure, the curvy figure is recommended.

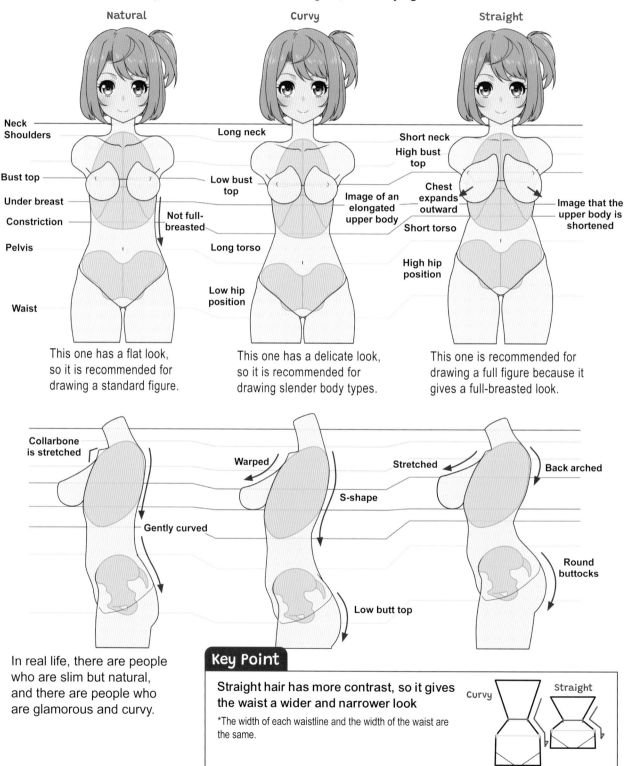

Natural

Neck
Shoulders

Bust top

Under breast

Constriction

Pelvis

Waist

This one has a flat look, so it is recommended for drawing a standard figure.

Curvy

Long neck

Low bust top

Not full-breasted

Long torso

Low hip position

This one has a delicate look, so it is recommended for drawing slender body types.

Straight

Short neck

High bust top

Chest expands outward

Short torso

High hip position

Image of an elongated upper body

Image that the upper body is shortened

This one is recommended for drawing a full figure because it gives a full-breasted look.

Collarbone is stretched

Gently curved

Warped

S-shape

Low butt top

Stretched

Back arched

Round buttocks

In real life, there are people who are slim but natural, and there are people who are glamorous and curvy.

Key Point

Straight hair has more contrast, so it gives the waist a wider and narrower look

*The width of each waistline and the width of the waist are the same.

Curvy

Straight

Various Poses

You can make various poses with just the torso. Here are some examples.

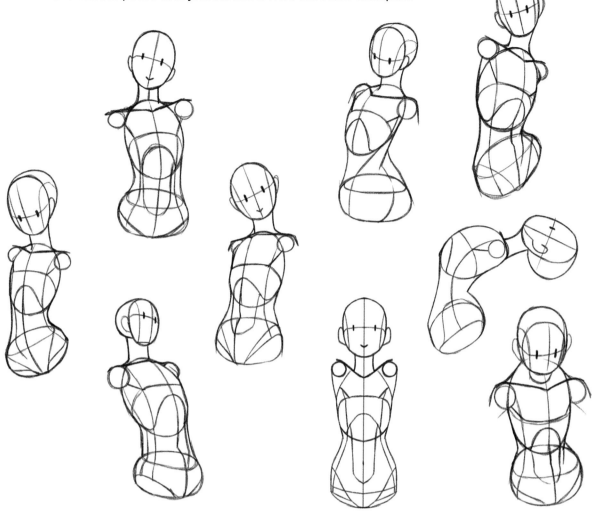

Congratulations on your progress!

Be aware of the position of the waistline, the thickness of the body, etc.

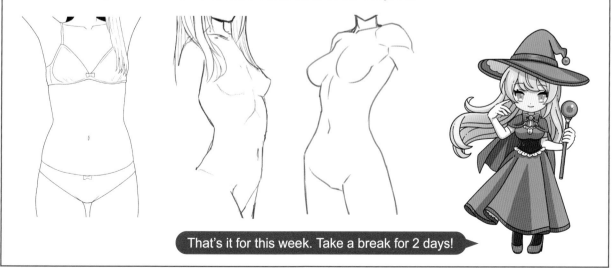

That's it for this week. Take a break for 2 days!

How to Draw the Arms

Once you have mastered drawing the torso, the next step is the limbs. Many people can draw great close-ups of faces and busts, but there are far fewer that they are good at drawing hands and feet as well as arms and legs. They can be difficult to master. Let's start by drawing the arms.

(LESSON 1) **Draw the Front Arm**

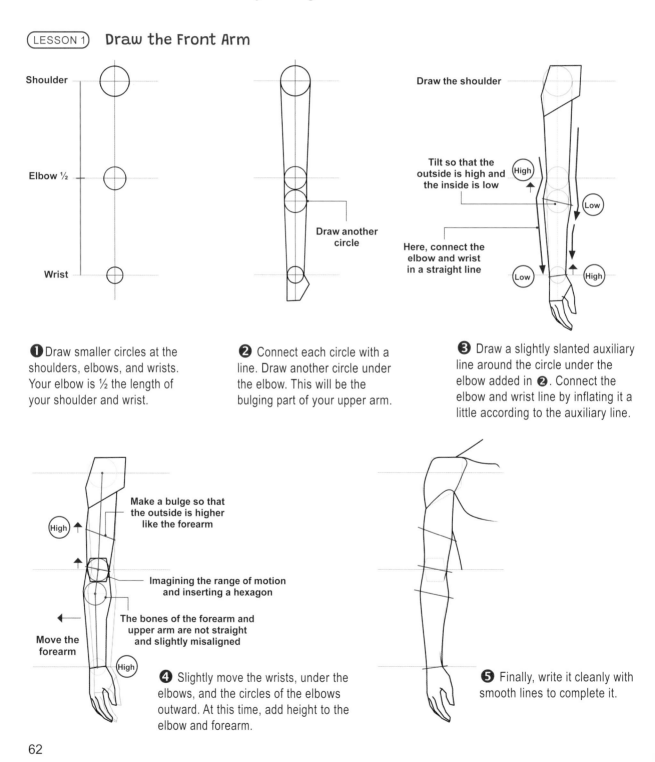

❶ Draw smaller circles at the shoulders, elbows, and wrists. Your elbow is ½ the length of your shoulder and wrist.

❷ Connect each circle with a line. Draw another circle under the elbow. This will be the bulging part of your upper arm.

❸ Draw a slightly slanted auxiliary line around the circle under the elbow added in ❷. Connect the elbow and wrist line by inflating it a little according to the auxiliary line.

❹ Slightly move the wrists, under the elbows, and the circles of the elbows outward. At this time, add height to the elbow and forearm.

❺ Finally, write it cleanly with smooth lines to complete it.

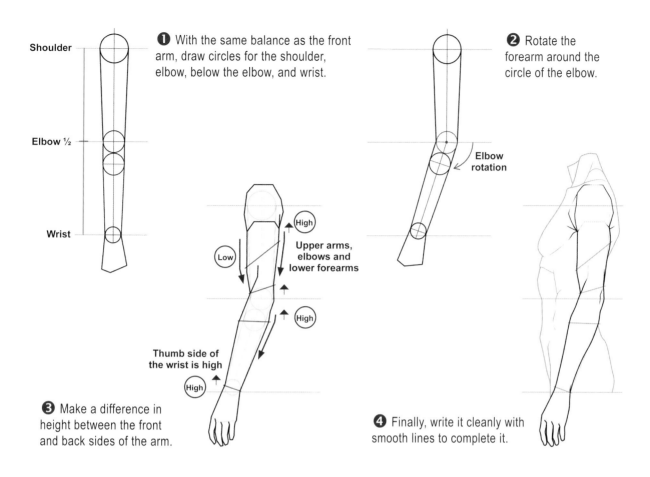

Shoulder

Elbow ½

Wrist

❶ With the same balance as the front arm, draw circles for the shoulder, elbow, below the elbow, and wrist.

❷ Rotate the forearm around the circle of the elbow.

Elbow rotation

High

Low

High

High

Upper arms, elbows and lower forearms

Thumb side of the wrist is high

❸ Make a difference in height between the front and back sides of the arm.

❹ Finally, write it cleanly with smooth lines to complete it.

Elbow Position

Approximately ½ of your arm should end at your elbow.

55%

45%

The Wrist Does Not Rotate

We say to rotate the wrist, but the wrist itself does not rotate. Try it yourself. Actually, it rotates by twisting the two bones in the forearm.

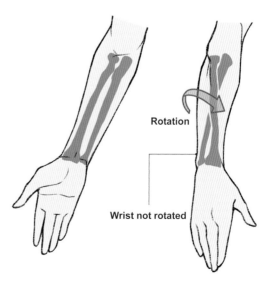

Rotation

Wrist not rotated

Be Aware of Thumb Position

It turns out that the bulge of the arm is different in height on the inside and outside. So which one will be higher when you turn your hand? First, take a look at the diagram below. It looks complicated at first glance, but I think it's easier to understand if you remember that the silhouette on the thumb side has more undulations.

Front

Sideways

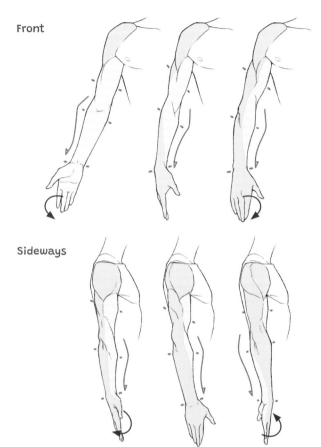

Key Point

When the arm falls naturally, the elbow is slightly bent. If you draw the upper arm and forearm straight, it will look like you put a lot of effort into it, so if you want to draw a natural arm, bend the elbow slightly.

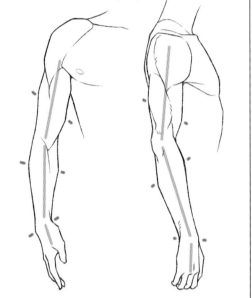

Slanted Arms

Just like your face, you should be conscious of the fact that when you look at your arms from an angle, you can see two sides: the front and the side. Robot arms are exactly the same, as seen below.

Front Side

Shoulder

Elbow ½

Limb

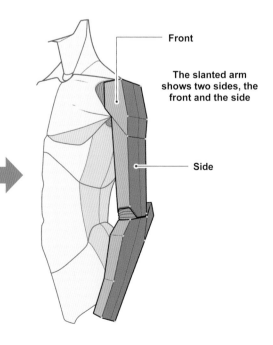

Front

The slanted arm shows two sides, the front and the side

Side

Arms Up

The chest muscle, the pectoralis major, is attached to the upper arm bone. So, when you raise your arms, your pectoral muscles will also stretch with your arms. In the case of women, the breasts are affected by the movement of the pectoralis major muscle, so they are pulled upward when the arm is raised.

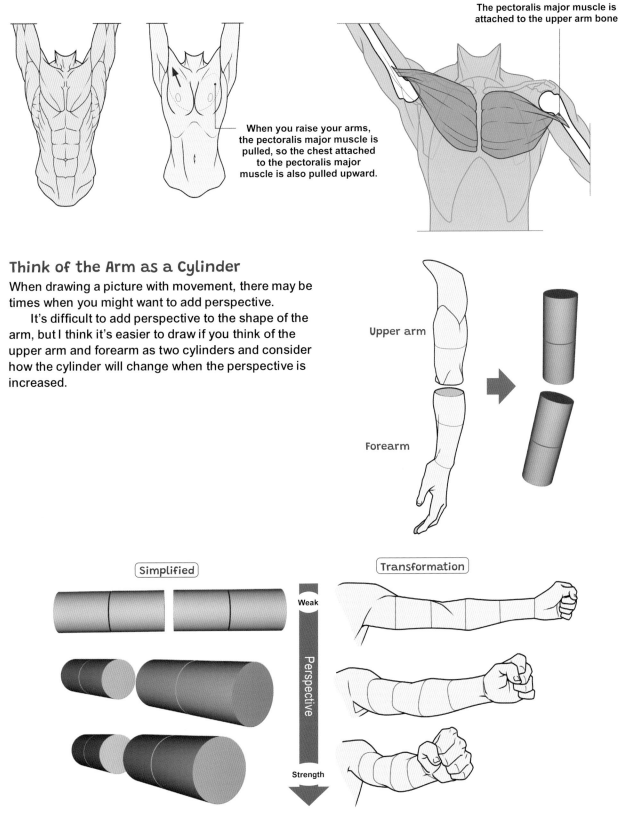

The pectoralis major muscle is attached to the upper arm bone

When you raise your arms, the pectoralis major muscle is pulled, so the chest attached to the pectoralis major muscle is also pulled upward.

Think of the Arm as a Cylinder

When drawing a picture with movement, there may be times when you might want to add perspective.

It's difficult to add perspective to the shape of the arm, but I think it's easier to draw if you think of the upper arm and forearm as two cylinders and consider how the cylinder will change when the perspective is increased.

Upper arm

Forearm

Simplified

Transformation

Weak

Perspective

Strength

How to Draw the Hands

Once you can draw the arm, next master drawing the hand. Hands are one of the most difficult parts of the body to draw. First, I will explain how to draw a hand by making a rough sketch with overlapping shapes. As you get used to drawing hands, you will be able to do this without making a simple rough sketch.

(LESSON 1) Draw the Palm Side

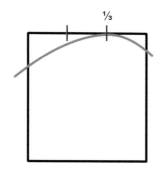

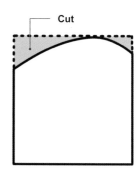

❶ Draw the right palm. First draw a square.

❷ Draw a curve with the ⅓ position of the horizontal side as the vertex.

❸ Cut above the curve drawn in ❷.

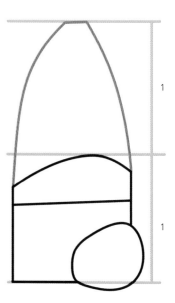

❹ The red line in the figure above is where the finger actually bends. Be careful when drawing bent hands.

❺ Draw the base of the thumb.

❻ Draw the silhouette of the fingers. With the tip of the middle finger as the apex, the base of the finger and the length of the palm are one to one.

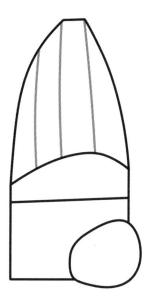

❼ Divide the fingers into 4 parts. The point is to draw the little finger a little thinner.

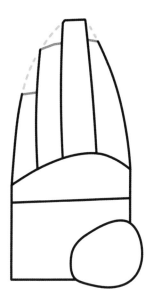

❽ Make fingertips. Although there are individual differences, the index finger and ring finger are almost the same height.

❾ Draw two circles on your thumb. The finger is divided into three parts, and the third part is in the palm (the circle drawn in **❻**).

❿ The draft of the hand is now complete.

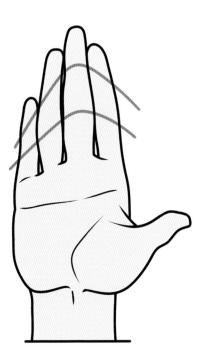

⓫ The red lines represent the joint positions of each finger. If you make the joints, it will look like it.

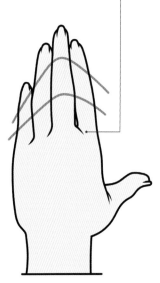

The crotch of the finger is longer on the instep side

The silhouette is the same as the palm side

LESSON 2 **Draw the Back Side of the Hand 1**

❶ Draw a trapezoid as shown above.

❷ Draw a triangle on the base of the trapezoid. This will be the ground surface of your finger.

❸ Draw a triangle at the base of the thumb.

❹ Draw the index finger. Draw the fingers so that each part becomes a trapezoid.
*See page 70 for finger shapes

❺ Draw the thumb. The point is that at this angle, the fingers are facing near the front.

❻ Draw the little finger from the middle finger. The point is to draw the index finger at a different angle.

❼ Draw the arm. Arms and insteps look natural if they are slightly curved rather than straight.

❽ Draw the details on the base of the overlap and it's complete.

Draw the Back Side of the Hand 2

❶ Draw a slightly distorted pentagon that will be the back of the hand.

❷ Draw a triangle at the base of the thumb.

Cut

❸ Draw a finger silhouette.

❹ Split the fingers. If you draw the index finger from the top of the pentagon, you can draw it in a well-balanced manner.

❺ Draw the thumb.

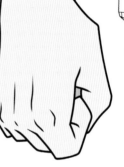

If you think about it in terms of surface, it will be like this

❻ Draw details on the base of the stroke to complete.

How to Attach the Hand

It is often thought that the hand connects to the wrist in a horizontal line, but in fact it is slightly angled toward the little finger. Make sure that the center of your wrist is the same as your middle finger.

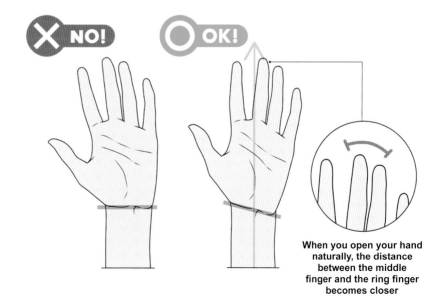

When you open your hand naturally, the distance between the middle finger and the ring finger becomes closer

Wrist Range of Motion

When the wrist is moved from side to side, the little finger side bends a lot, but the thumb side does not bend much.

How to Attach the Fingers

The length and shape of the index, middle and ring fingers are almost the same. The middle finger looks the longest but it isn't actually true.

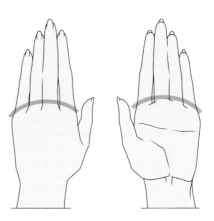

Finger Shape

Fingers taper towards the tip. The instep side is warped and the flat side is bulging. If you want to draw masculine fingers, create a flat surface on the tip and emphasize the joints.

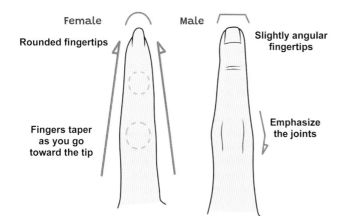

Female
Rounded fingertips

Male
Slightly angular fingertips

Fingers taper as you go toward the tip

Emphasize the joints

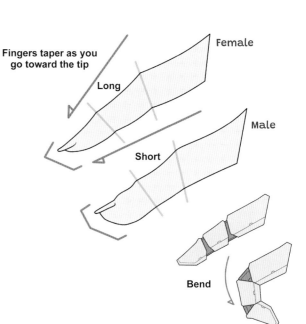

Fingers taper as you go toward the tip

Long

Female

Short

Male

Bend

Range of Motion of the Thumb

The thumb can be bent to the palm side by bending from the joint at the base of the thumb called the CM joint.

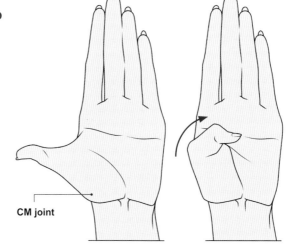

CM joint

Collection of Hand Poses

Here are some hand shapes that I often draw when drawing characters, so if you are in trouble, try to imitate them. I think it's also good to imitate the hand of your favorite artist, or take a picture of yourself and use it as a reference.

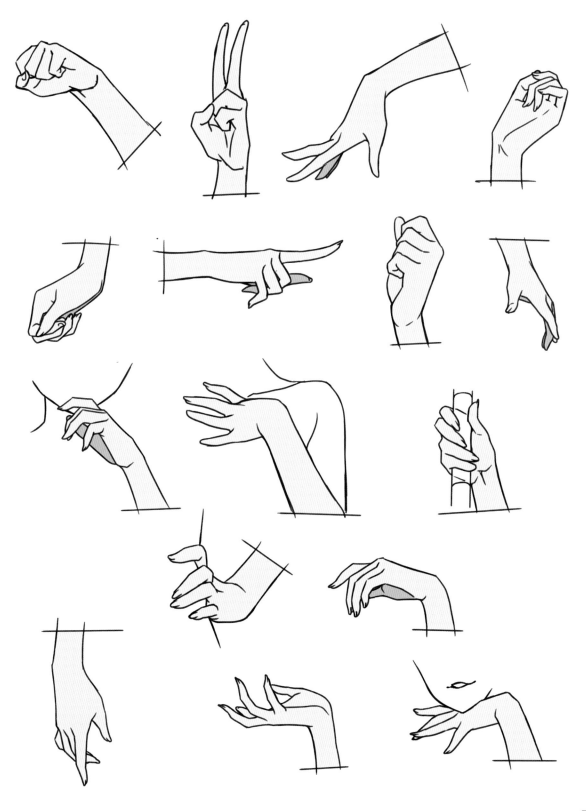

Basics | Human Body | Anatomy

How to Draw the Legs

Once you are comfortable drawing the arms, you can easily learn to draw the legs. The basics of the arms and legs are the same and the proportions are the same. The cause of confusion lies in the positional relationship between elbows and knees. The elbows are on the back side and the knees are on the front side, so I just think that they are separate parts.

(LESSON 1) Draw the Front of the Legs

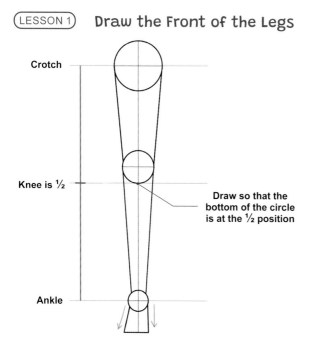

Crotch

Knee is ½

Draw so that the bottom of the circle is at the ½ position

Ankle

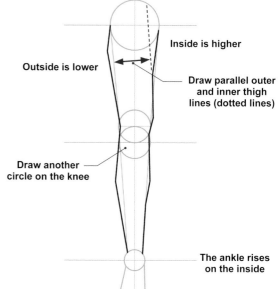

Inside is higher

Outside is lower

Draw parallel outer and inner thigh lines (dotted lines)

Draw another circle on the knee

The ankle rises on the inside

❶ Draw the front of the right leg. Draw smaller circles at the crotch, knees and ankles.

❷ Draw bulges on the inside and outside in the same way as when drawing the arm. Do not add curves to the lines at the stroke stage.

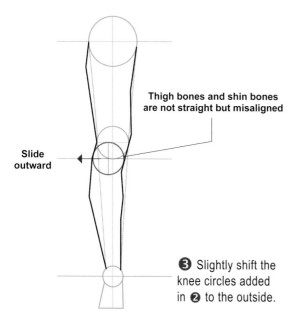

Thigh bones and shin bones are not straight but misaligned

Slide outward

❸ Slightly shift the knee circles added in ❷ to the outside.

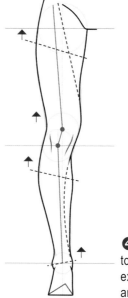

❹ Finally, draw clean lines to complete the legs. I will explain the legs below the ankles in "Day 18 (page 78)."

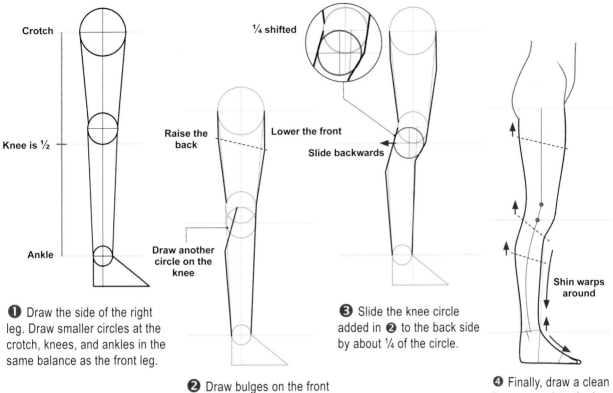

Crotch

Knee is ½

Ankle

¼ shifted

Raise the back

Lower the front

Slide backwards

Draw another circle on the knee

Shin warps around

1 Draw the side of the right leg. Draw smaller circles at the crotch, knees, and ankles in the same balance as the front leg.

2 Draw bulges on the front and back sides. Thighs and calves are higher in the back.

3 Slide the knee circle added in **2** to the back side by about ¼ of the circle.

4 Finally, draw a clean line to complete the legs.

Knee Position

The knee should be placed at about ½ of the length of the leg.

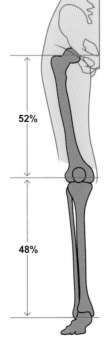

52%

48%

Arms and Legs are the Same Shape

Arms and legs are made of almost the same shapes. In other words, if you can draw arms, you can also draw legs.

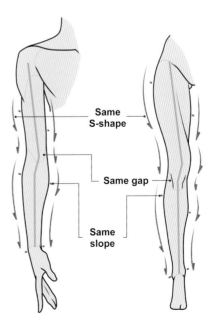

Same S-shape

Same gap

Same slope

73

Elbows and Knees Function the Same

When you bend your arm or leg, the bent side bulges and the other side stretches, so the bulge becomes smaller.

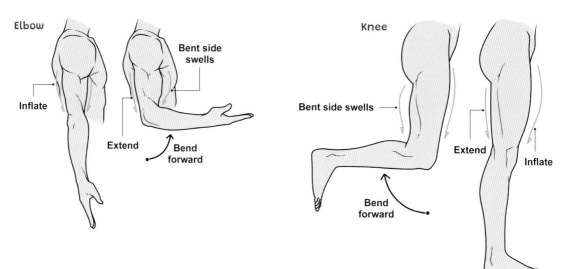

Elbow and Knee Shape

The elbow is part of the forearm (ulna). When you bend it, it follows your forearm, which changes the position of your elbow. When you bend your knees there is a similar effect. Here, the patella (knee cap) and the shin bone are connected by a ligament, so when the knee is bent, it is pulled toward the shin and the position of the knee changes.

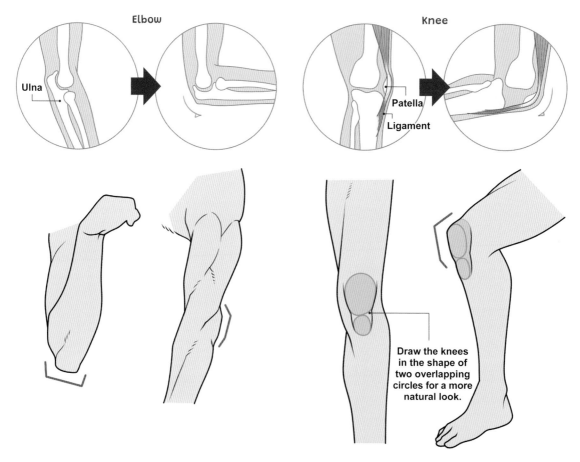

Draw the knees in the shape of two overlapping circles for a more natural look.

Sartorius and Adductor Muscles

In Lesson 1 ❷ (page 72) you drew the outer line and the dotted line parallel to each other, and this dotted line represents the Sartorius muscle. There is a muscle called the adductor muscle group on the inside, and there is a step on the border of this Sartorius muscle. In the case of realistic drawings, lines and shadows are added here.

Cross section

Adductor muscle group

Outside

Sartorius

Front

Inside

Diagonal

Draw the Sartorius muscle and the silhouette of the outer thigh parallel to each other for a good balance.

Center of Leg

When you look at the leg from the front, the highest point is where the bone is. The shin bones are exaggerated a little, but it will be easier to draw if you remember that the calf muscles are inside the bones.

Front and Back of Shin

The shin line is V-shaped on the front and V-shaped on the back, and the back is slightly higher.

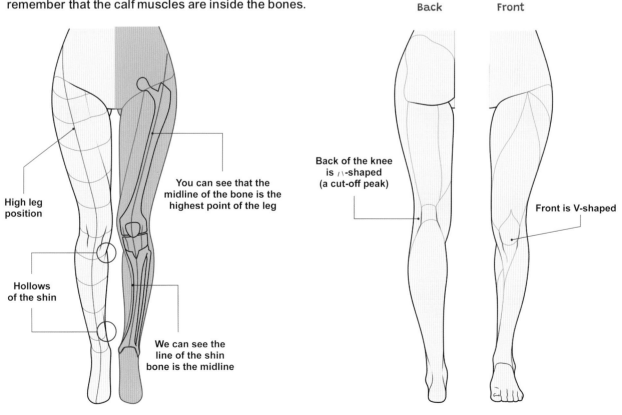

High leg position

Hollows of the shin

You can see that the midline of the bone is the highest point of the leg

We can see the line of the shin bone is the midline

Back

Front

Back of the knee is /\-shaped (a cut-off peak)

Front is V-shaped

Places Where Fat is Likely to Accumulate

For women, fat tends to accumulate from the waist to the outside of the thighs. Fat also accumulates around joints such as knees and ankles.

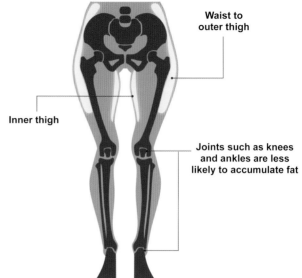

Waist to outer thigh

Inner thigh

Joints such as knees and ankles are less likely to accumulate fat

Bent Leg Shape

Notice the anteroposterior relationship between the thigh and calf when the leg is bent and viewed from the side. The thigh lines up on the inside, and the shin lines up on the outside. Please note that there is a difference in depiction between the inside and outside like this.

Inside

Outside

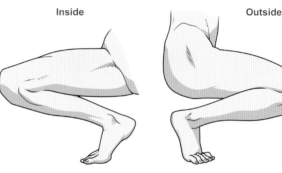

Leg Bones

If you draw the leg bones on a human figure as a series of circles and lines, it will look like this.

Once the leg bones are done, let's look at the bones of the entire body again. Don't make it complicated, first be conscious of being able to draw with simple symbols, and gradually flesh out from there.

Bones of the entire body

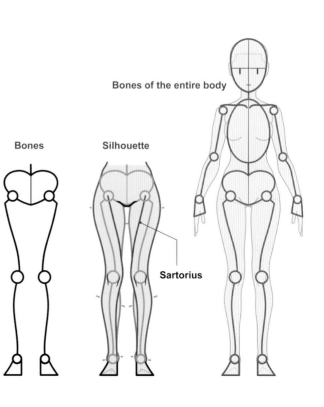

Bones

Silhouette

Sartorius

FEATURE Difference Between Real Life and 2D

There is almost no difference between real and 2D legs. In real life, half of the leg from crotch to ankle ends at the knee, but in 2D the shins are a little longer, so if you draw half of the leg from crotch to the ankle, the balance will be better.

Key Point

2D has a short torso, so the position of the crotch is a bit higher. If the knee position is the same in the drawing as it is in the real one, the thighs will be longer and the legs will look short. Therefore, the balance is achieved by raising the knee position and lengthening the shins.

Real

Two dimensions

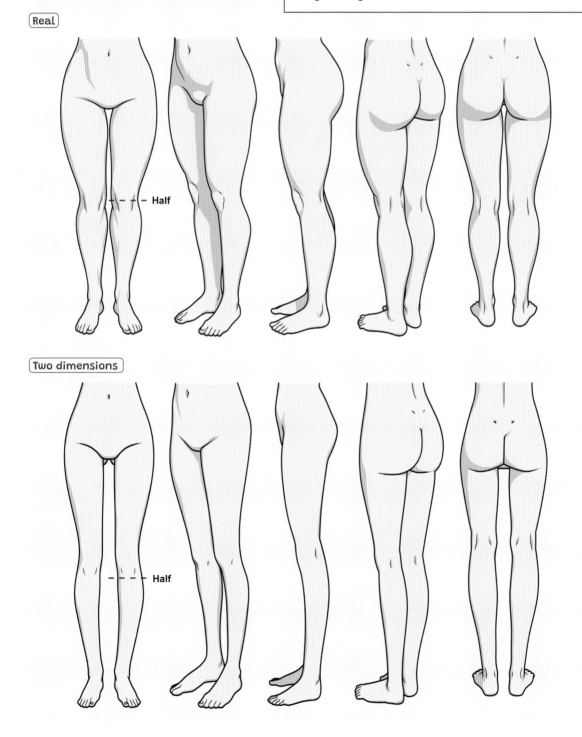

How to Draw the Feet

Once you can draw the legs, you should move on to the feet. If you can draw a silhouette of bare feet, you will be able to easily draw shoes. First, I will explain how to draw using overlapping shapes in a rough sketch.

(LESSON 1) **Draw the Front of the Legs**

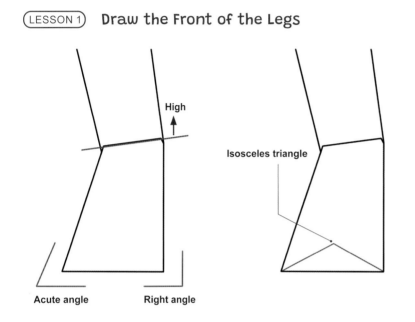

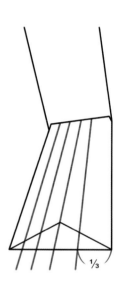

❶ Draw a silhouette as shown above.

❷ Draw rough sketch with an isosceles triangle.

❸ Place your thumb on ⅓. The point between the index finger and the middle finger is the position of the apex of the isosceles triangle drawn in ❷.

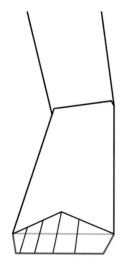

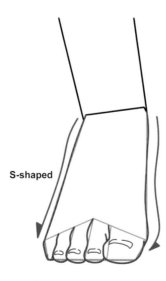

❹ Draw and add the trapezoid.

❺ Adjust the shape according to the overlap.

❻ Make a clean reproduction and you are done.

Draw the Angled Foot (inside)

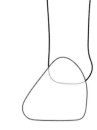

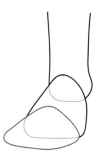

❶ Draw the ankle as shown in the picture above.

❷ Draw the top of the foot with the image of drawing a rounded triangle.

❸ Draw the toes.

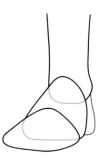

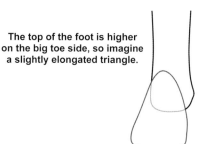

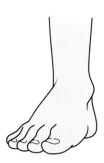

❹ Draw and add the heel.

❺ Draw the toes based on the mark drawn in **❸**.

❻ Make a clean reproduction and you are done.

LESSON 3 **Draw the Angled Foot (outside)**

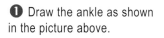

The top of the foot is higher on the big toe side, so imagine a slightly elongated triangle.

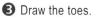

❶ Draw the ankle as shown in the picture above.

❷ Draw the top of the foot with the image of drawing a rounded triangle.

❸ Draw the toes.

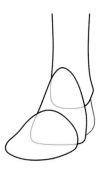

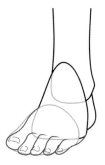

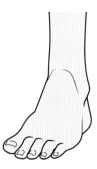

❹ Draw and add the heel.

❺ Draw toes based on the mark drawn in **❸**.

❻ Make a clean reproduction and you are done.

Foot Direction

The direction of the foot can be drawn differently by changing the lines of the trapezoid.

Outward-facing feet

For the outward-facing foot, the inner line is drawn vertically down, and the outer line is stretched outward to draw the stroke. The stroke of the toes can be drawn in a well-balanced manner by drawing the apex of the triangle so that it is on the outside.

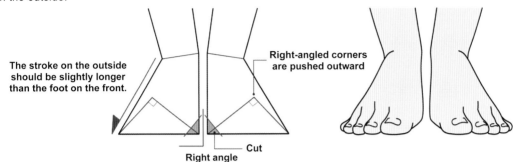

The stroke on the outside should be slightly longer than the foot on the front.

Right-angled corners are pushed outward

Cut

Right angle

Inward feet

For the inward foot, the outer line is drawn vertically down and the inner line is extended outward to draw the stroke. The stroke of the toes can be drawn in a well-balanced manner by drawing the apex of the triangle so that it is inside.

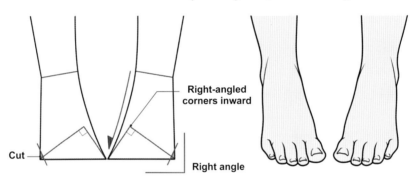

Right-angled corners inward

Cut

Right angle

Range of Motion of the Foot

The foot is made up of four main parts: toes, instep, heel, and ankle. It's easier to understand if you think of it as having a range of motion in between, where the parts stick together and separate.

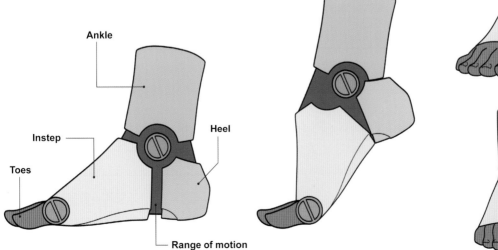

Ankle

Instep

Toes

Heel

Range of motion

80

Collection of Foot Poses

When expressing femininity, you can also show the
personality of the character by the angling the legs inward.
Here is an example of some poses. Please try to imitate
and draw them as well as you drew the poses of the hand.

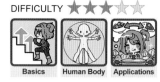

Basics | Human Body | Applications

How to Fix Arm Mistakes

Today, let's take a look at some common arm mistakes. Now that you have learned to draw limbs, you will have noticed some inconsistencies. Arms and legs have the same structure, so if you notice differences in the arms, you should also notice the same differences in the legs.

Common Mistakes

A common mistake that beginners often make is having an ungainly puffy arm, as shown in the picture on the right.

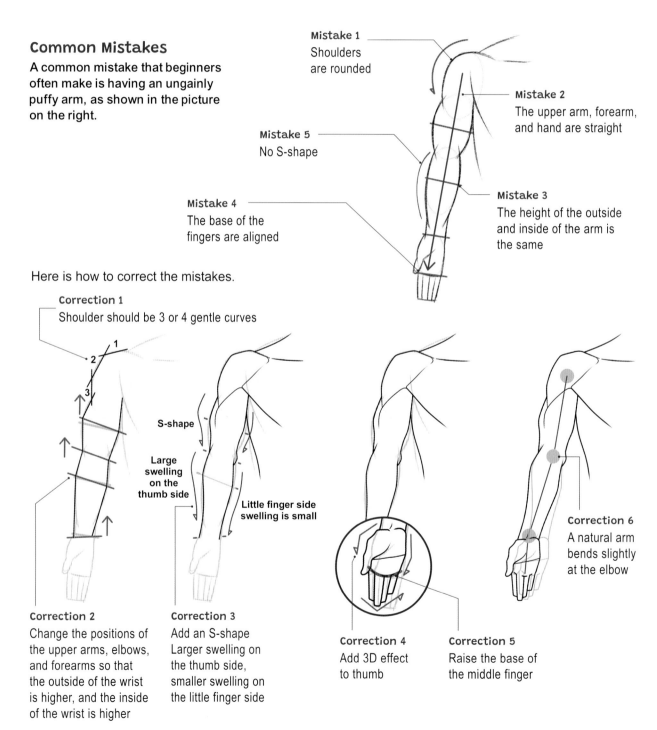

Mistake 1
Shoulders are rounded

Mistake 2
The upper arm, forearm, and hand are straight

Mistake 5
No S-shape

Mistake 3
The height of the outside and inside of the arm is the same

Mistake 4
The base of the fingers are aligned

Here is how to correct the mistakes.

Correction 1
Shoulder should be 3 or 4 gentle curves

S-shape

Large swelling on the thumb side

Little finger side swelling is small

Correction 6
A natural arm bends slightly at the elbow

Correction 2
Change the positions of the upper arms, elbows, and forearms so that the outside of the wrist is higher, and the inside of the wrist is higher

Correction 3
Add an S-shape Larger swelling on the thumb side, smaller swelling on the little finger side

Correction 4
Add 3D effect to thumb

Correction 5
Raise the base of the middle finger

Next, we will list some common mistakes and how to correct them. Refer to the facing page for the methods.

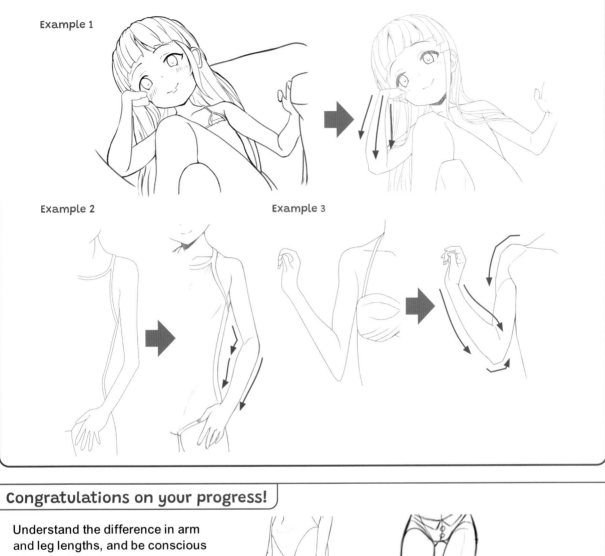

Example 1

Example 2

Example 3

Congratulations on your progress!

Understand the difference in arm and leg lengths, and be conscious of the S-shape.

That's it for this week. Take a break for 2 days!

DIFFICULTY ★★☆☆☆

Basics　Human Body　Permanence

The Front Balance of the Whole Body Drawing

By the third week, I explained how to draw the head, body, and limbs. In the fourth week, I will explain how to draw a standing picture that combines each of these elements. First, let's use the "Balancing Guide for the Human Body" to observe the balance of the front view standing figure.

Balance Between 6 and 6.5 Heads

In this book, we mainly explain proportions using 6.5 heads as a guide, but the balance will be the same even with 6 heads. First of all, compare the two drawings below.

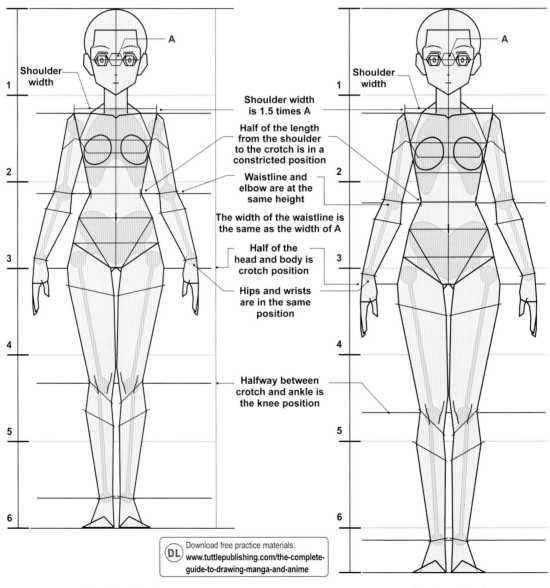

Shoulder width

Shoulder width is 1.5 times A

Half of the length from the shoulder to the crotch is in a constricted position

Waistline and elbow are at the same height

The width of the waistline is the same as the width of A

Half of the head and body is crotch position

Hips and wrists are in the same position

Halfway between crotch and ankle is the knee position

Download free practice materials:
www.tuttlepublishing.com/the-complete-guide-to-drawing-manga-and-anime

6 head and body

6.5 head and body

6.5 Head-To-Body Character

Based on the balance on the left page, the drawing below shows male and female characters. There are some differences in width, but the vertical balance is the same. The differences between men and women are explained in the Day 11 lesson (page 54).

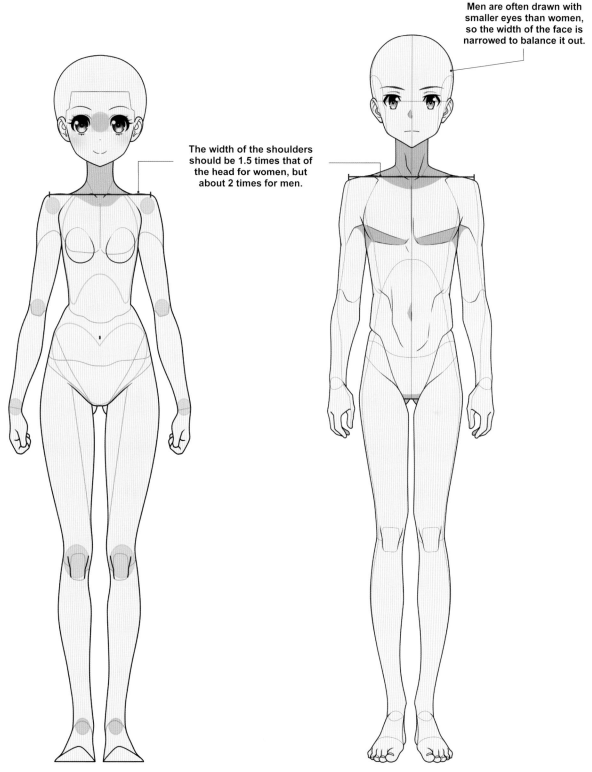

Men are often drawn with smaller eyes than women, so the width of the face is narrowed to balance it out.

The width of the shoulders should be 1.5 times that of the head for women, but about 2 times for men.

Female

Male

Understanding the Front Balance

Now that we have covered the balance of the head and body, let's draw a rough sketch. These are the basics you should be able to master so you can better understand this balance.

LESSON Draw a Rough Sketch of the Front Standing Figure

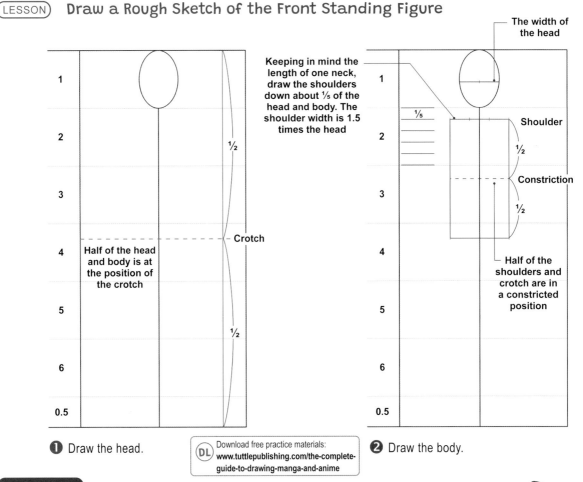

Keeping in mind the length of one neck, draw the shoulders down about ⅕ of the head and body. The shoulder width is 1.5 times the head

The width of the head

Shoulder

Constriction

Half of the head and body is at the position of the crotch

Crotch

Half of the shoulders and crotch are in a constricted position

❶ Draw the head.

DL Download free practice materials: www.tuttlepublishing.com/the-complete-guide-to-drawing-manga-and-anime

❷ Draw the body.

Key Point

A measurement of 5.5 to 8 heads is often used when drawing people who have the same balance. Please note that these basics do not apply to other fantastical characters that have 2 heads or 3 heads and so on.

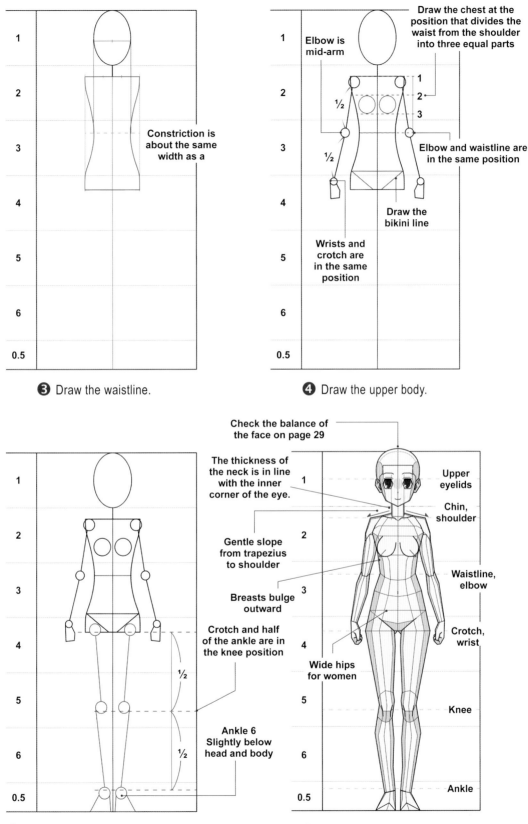




1, 2, 3, 4, 5, 6, 0.5

Constriction is about the same width as a

❸ Draw the waistline.


Numbers on left axis: 1, 2, 3, 4, 5, 6, 0.5

Draw the chest at the position that divides the waist from the shoulder into three equal parts

Elbow is mid-arm

½

1
2
3

Elbow and waistline are in the same position

½

Draw the bikini line

Wrists and crotch are in the same position

❹ Draw the upper body.


1, 2, 3, 4, 5, 6, 0.5

½

½

Crotch and half of the ankle are in the knee position

Ankle 6
Slightly below head and body

❺ Draw the legs to complete the sketch

Panel ❻ (bottom right):
Numbers: 1, 2, 3, 4, 5, 6, 0.5

Check the balance of the face on page 29

The thickness of the neck is in line with the inner corner of the eye.

Gentle slope from trapezius to shoulder

Breasts bulge outward

Wide hips for women

Upper eyelids

Chin, shoulder

Waistline, elbow

Crotch, wrist

Knee

Ankle

❻ It will look like this when fleshed out based on the overlap. Memorize the position of the parts.

Standing Front Drawing Review

You can now draw the balance of the 6.5 head and body. Now, let's review the standing picture that you actually drew. I'm sure you'll find something that's distorted or out of balance. These three days will be a review period. Repeat drawing and reviewing to remember the balance.

Use Our Guide to Fix It

Look at the standing picture of a novice drawer. This portrait is full of common mistakes. First, let's find out what's wrong.

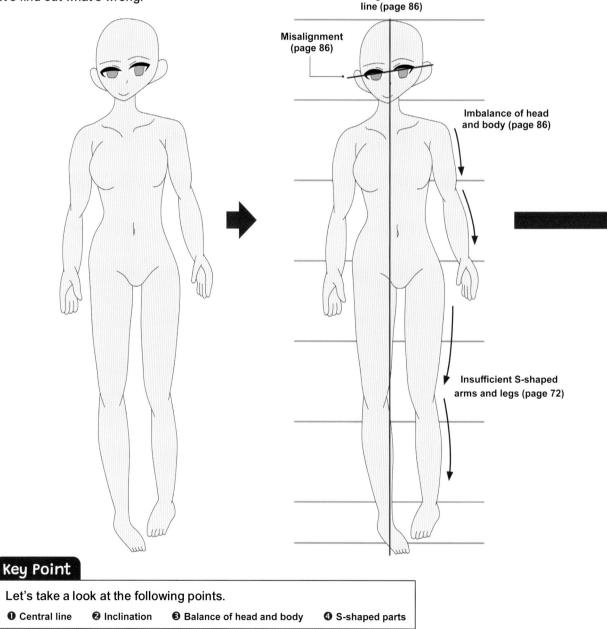

Misaligned median line (page 86)

Misalignment (page 86)

Imbalance of head and body (page 86)

Insufficient S-shaped arms and legs (page 72)

Key Point

Let's take a look at the following points.

❶ Central line　　❷ Inclination　　❸ Balance of head and body　　❹ S-shaped parts

The picture on the left page has been revised to the figure below. If you find something strange, go back to the previous commentary pages and try again.

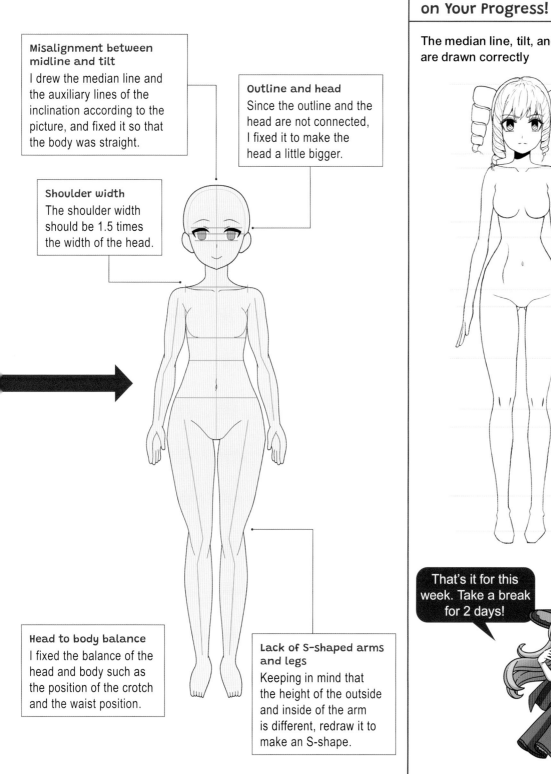

Misalignment between midline and tilt
I drew the median line and the auxiliary lines of the inclination according to the picture, and fixed it so that the body was straight.

Outline and head
Since the outline and the head are not connected, I fixed it to make the head a little bigger.

Shoulder width
The shoulder width should be 1.5 times the width of the head.

Head to body balance
I fixed the balance of the head and body such as the position of the crotch and the waist position.

Lack of S-shaped arms and legs
Keeping in mind that the height of the outside and inside of the arm is different, redraw it to make an S-shape.

Congratulations on Your Progress!

The median line, tilt, and balance are drawn correctly

That's it for this week. Take a break for 2 days!

The Side View Balance of the Whole Body Drawing

In the 5th week, I will explain the sideways standing picture. The vertical balance is the same as the front, but the thickness of the body becomes important in the horizontal direction. In addition to the thickness, let's look at the S-shaped balance from the back to the waist and buttocks.

Comparing Front and Side

First, compare the front and side view balance. The vertical balance is the same, so be careful not to shift while looking at the guide below.

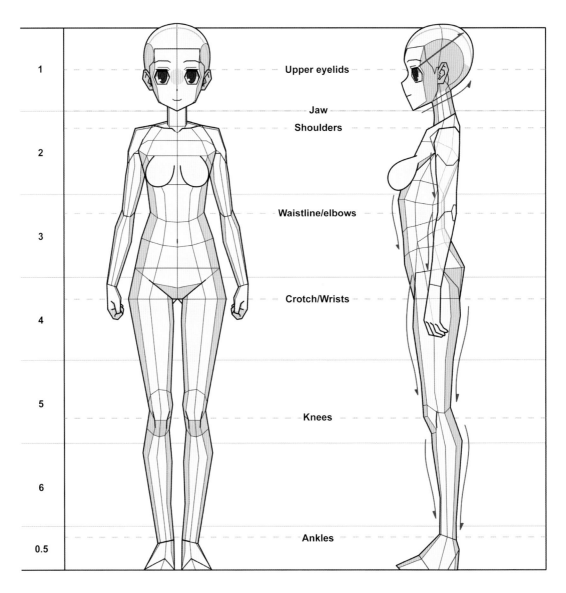

1	Upper eyelids
	Jaw
	Shoulders
2	
	Waistline/elbows
3	
	Crotch/Wrists
4	
5	Knees
6	
0.5	Ankles

Front view · Side view

6.5 Head-to-Body Character

Based on the balance on the left page, the following figures show male and female characters.

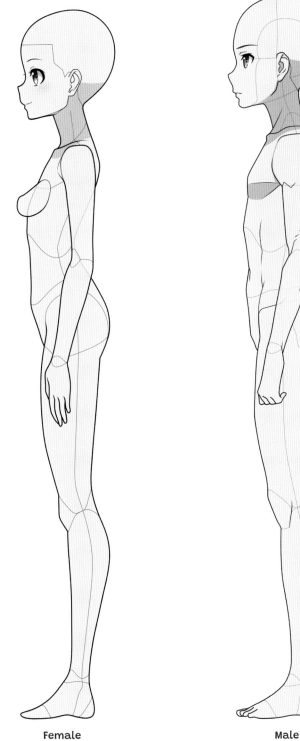

Female Male

DIFFICULTY ★★★★☆

Basics | Human Body | Drawing Techniques

Understanding the Side View Balance

Drawing the side balance will be a little more complicated than the front, but if you follow the steps, you will definitely be able to master it. These are basics, so repeat and remember this balance.

DL Download free practice materials: www.tuttlepublishing.com/the-complete-guide-to-drawing-manga-and-anime

(LESSON) **Draw a Side View Standing Figure**

❶ Draw a circle for the head and a rectangle (pink) for the body. Draw the head slightly smaller than the body.

❷ Draw the details of the torso. Draw the body inside the square shape drawn in ❶. Draw a straight line here.

Key Point

Simple way of thinking about torso sketches

If ❷ is difficult, think of the chest and waist in a simple shape like a square.

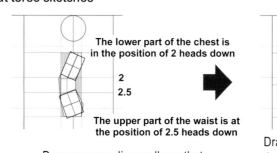

The lower part of the chest is in the position of 2 heads down

2
2.5

The upper part of the waist is at the position of 2.5 heads down

Draw squares diagonally so that the chest is tilted backward and lower back is tilted forward.

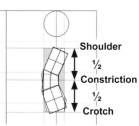

Shoulder
½
Constriction
½
Crotch

Draw the abdomen to connect the chest and waist. It's a good idea to stick out the buttocks and sternum from the pink torso.

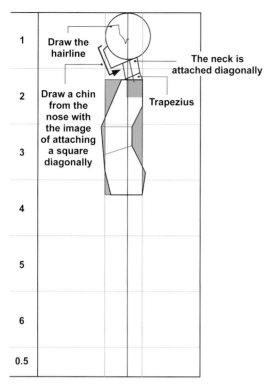

Draw the hairline

The neck is attached diagonally

Trapezius

Draw a chin from the nose with the image of attaching a square diagonally

❸ Draw the shape of the head according to the instructions above.

Draw an auxiliary line from the center line of the body to the center line of the head

Draw an auxiliary line according to the body stroke drawn in **❶**. This will be the heel position

Draw the fingertips so that they protrude slightly from the light blue auxiliary lines

Where the center line of the circle on the head meets the ankle

❹ Draw the legs.

Straight from elbow to shoulder

Draw the breasts where waist-to-shoulders is equally divided into 3

Elbow is midway between shoulder and crotch

Since the wrist is at the center line of the head, the wrist is diagonal from the elbow

❺ Draw the arm.

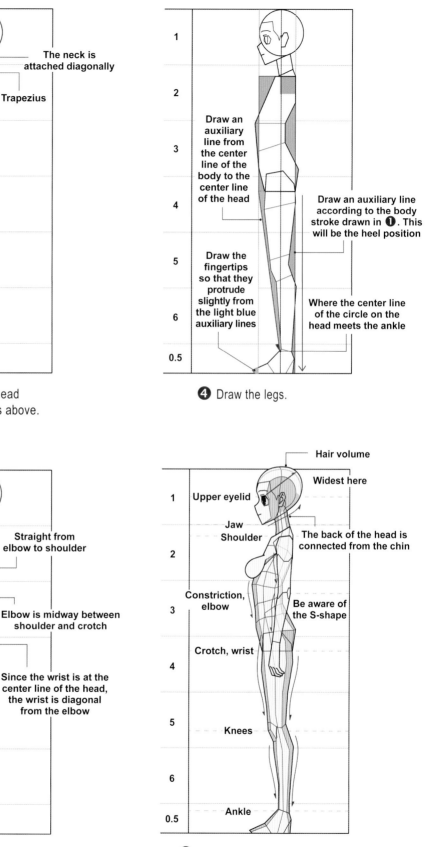

Hair volume

Widest here

Upper eyelid

Jaw

Shoulder

The back of the head is connected from the chin

Constriction, elbow

Be aware of the S-shape

Crotch, wrist

Knees

Ankle

❻ The figure will look like this when fleshed out. Be aware of the S-shape of the back, arms, and legs.

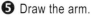

Side View Drawing Review

Just like last week, please review the side portrait you actually drew. I'm sure you'll find something that's distorted or out of balance. These three days are a review period. Repeat drawing and reviewing to learn the balance.

Use Our Guide to Fix It

Take a look at the side portrait drawn by a drawing novice. This portrait is full of common mistakes. First, find out what's wrong.

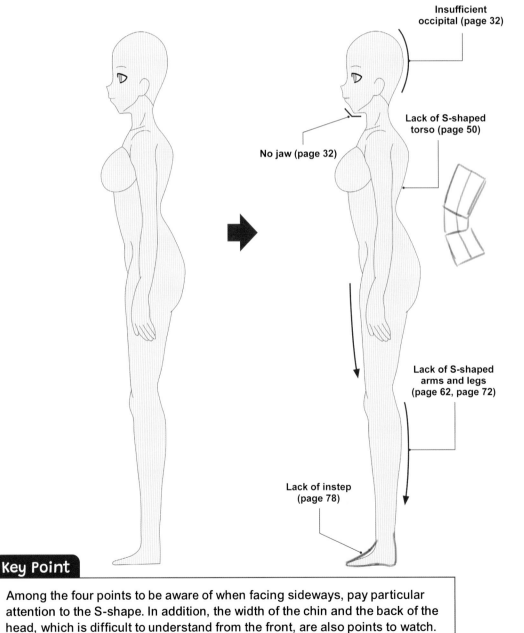

Insufficient occipital (page 32)

Lack of S-shaped torso (page 50)

No jaw (page 32)

Lack of S-shaped arms and legs (page 62, page 72)

Lack of instep (page 78)

Key Point

Among the four points to be aware of when facing sideways, pay particular attention to the S-shape. In addition, the width of the chin and the back of the head, which is difficult to understand from the front, are also points to watch.

The picture on the left page has been revised to the figure below. If you find something incongruous, go back to the previous commentary page and try again.

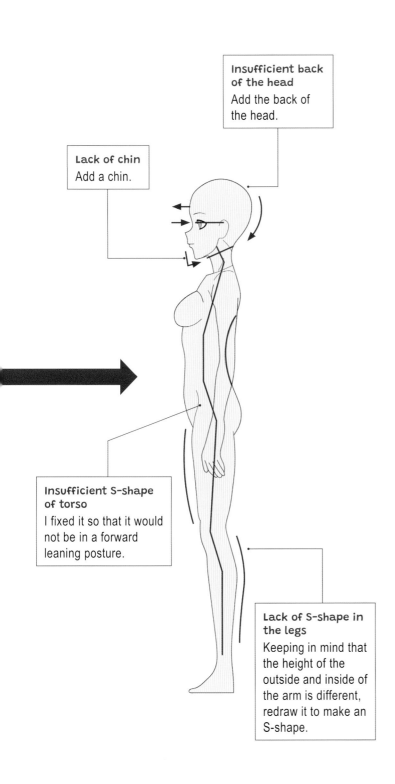

Insufficient back of the head
Add the back of the head.

Lack of chin
Add a chin.

Insufficient S-shape of torso
I fixed it so that it would not be in a forward leaning posture.

Lack of S-shape in the legs
Keeping in mind that the height of the outside and inside of the arm is different, redraw it to make an S-shape.

Congratulations on your progress!

In addition to being able to draw the balance correctly, the S-shape is fully incorporated.

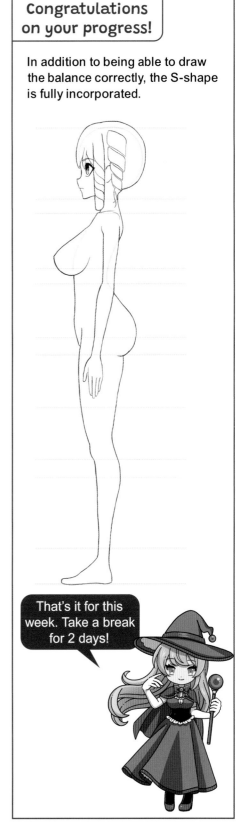

That's it for this week. Take a break for 2 days!

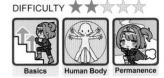

Basics | Human Body | Permanence

The Angled Balance of the Whole Body Drawing

In the 6th week, I will explain the angled standing picture. As with the horizontal orientation, the vertical balance is the same as the front, but by angling it, you can see both the front and the side. It's going to be more complicated because it's going to have depth, but let's learn while checking each one.

Compare Front and Angled

First, compare the frontal balance and angled balance. The vertical balance is the same, but there are subtle errors due to the angle. Let's check it while looking at the guide carefully.

Upper eyelid

Chin
Shoulder

Waistline/elbow

Crotch/wrist

Knees

Because of the angle, the feet will protrude slightly from the guide.

Ankle

Front

Angled

6.5 Head-to-Body Character

Based on the balance on the left page, the following figures shows male and female characters.

Female

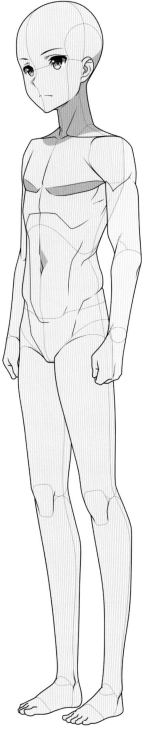

Male

DIFFICULTY ★★★★☆

Basics | Human Body | Drawing Techniques

Understanding the Angled Balance

Let's draw the diagonal balance based on the front balance. It's more complicated because you can only see the front and side so check each step carefully.

(LESSON) **Draw a Diagonal Pose**

Balance of face parts

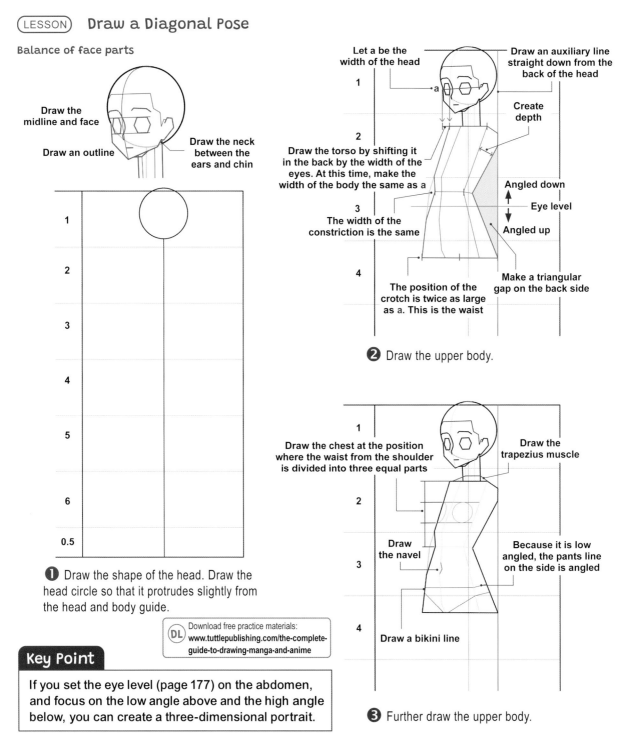

Draw the midline and face

Draw an outline

Draw the neck between the ears and chin

1 Draw the shape of the head. Draw the head circle so that it protrudes slightly from the head and body guide.

DL Download free practice materials:
www.tuttlepublishing.com/the-complete-guide-to-drawing-manga-and-anime

Let a be the width of the head

1

Draw an auxiliary line straight down from the back of the head

Create depth

2

Draw the torso by shifting it in the back by the width of the eyes. At this time, make the width of the body the same as a

Angled down
Eye level
Angled up

3

The width of the constriction is the same

Make a triangular gap on the back side

4

The position of the crotch is twice as large as a. This is the waist

2 Draw the upper body.

1

Draw the chest at the position where the waist from the shoulder is divided into three equal parts

Draw the trapezius muscle

2

Draw the navel

Because it is low angled, the pants line on the side is angled

3

4

Draw a bikini line

3 Further draw the upper body.

Key Point

If you set the eye level (page 177) on the abdomen, and focus on the low angle above and the high angle below, you can create a three-dimensional portrait.

Connect the lines from the waist to the knees and draw the thighs

Since it is angled, shift the height of both knees

❹ Draw the thighs.

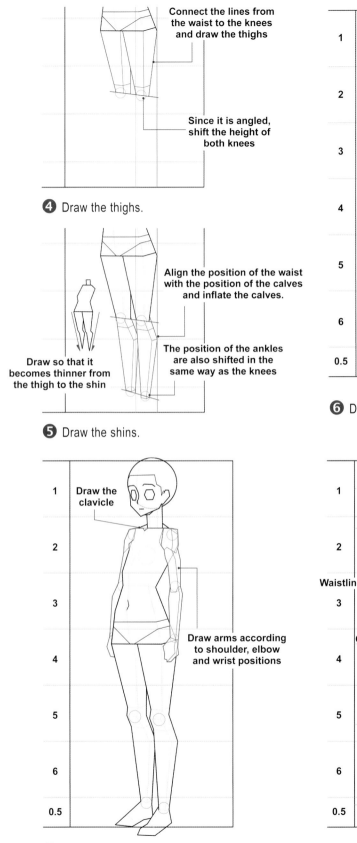

Align the position of the waist with the position of the calves and inflate the calves.

Draw so that it becomes thinner from the thigh to the shin

The position of the ankles are also shifted in the same way as the knees

❺ Draw the shins.

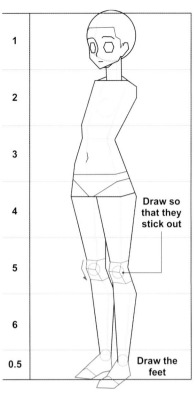

1	
2	
3	
4	**Draw so that they stick out**
5	
6	
0.5	**Draw the feet**

❻ Draw the knees and feet.

1	**Draw the clavicle**
2	
3	
4	**Draw arms according to shoulder, elbow and wrist positions**
5	
6	
0.5	

❼ Draw the arm.

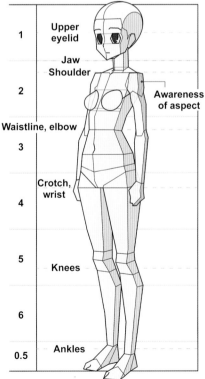

1	**Upper eyelid**
	Jaw / **Shoulder**
2	**Awareness of aspect**
Waistline, elbow 3	
4	**Crotch, wrist**
5	**Knees**
6	
0.5	**Ankles**

❽ It will look like this if you add meat based on the overlap. Be aware that you can see two sides, the front and the side.

DIFFICULTY ★★★★☆

Basics Human Body Applications

Week 6 | Days 38–40

Angled Drawing Review

Just like last week, please review the angled drawing you actually drew. I'm sure you'll find something that's distorted or out of balance. These three days are a review period. Repeat drawing and reviewing to remember the balance.

Use Our Guide to Fix It

Take a look at the angled portrait drawn by a drawing novice. This portrait is full of common mistakes. First, let's find out what's wrong.

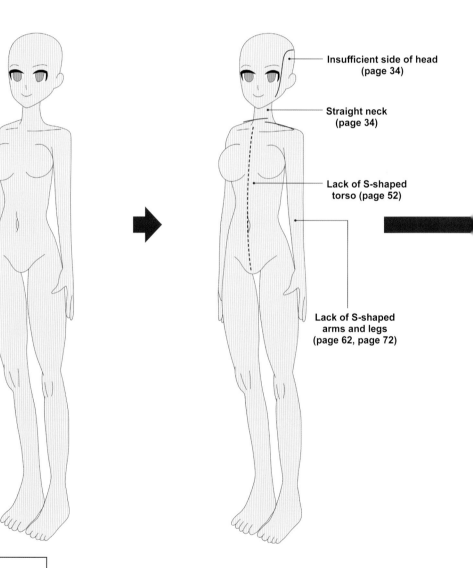

Insufficient side of head
(page 34)

Straight neck
(page 34)

Lack of S-shaped
torso (page 52)

Lack of S-shaped
arms and legs
(page 62, page 72)

Key Point

For angled drawings, be aware that in addition to the front, you can see the front and the sides.

The picture on the left page has been revised to the figure below. If you find something incongruous, go back to the previous commentary page and try again.

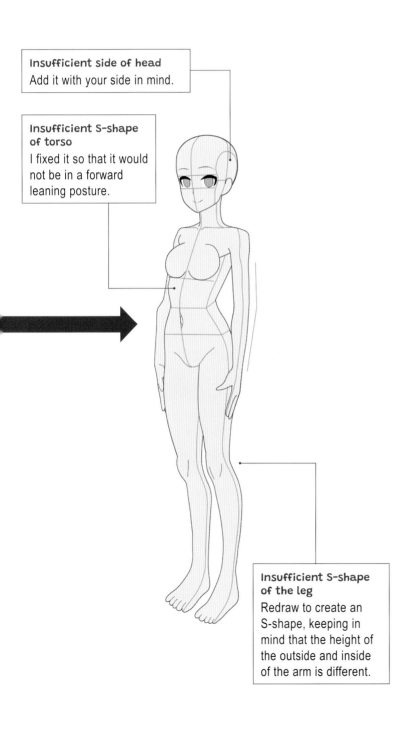

Insufficient side of head
Add it with your side in mind.

Insufficient S-shape of torso
I fixed it so that it would not be in a forward leaning posture.

Insufficient S-shape of the leg
Redraw to create an S-shape, keeping in mind that the height of the outside and inside of the arm is different.

Congratulations on your progress!

In addition to drawing the balance and S-shape well, I am conscious that I can see two sides, the front and the side.

That's it for this week. Take a break for 2 days!

DIFFICULTY ★★★★☆

Basics | Human Body | 3D

How to Draw Hair

Once you can draw the character's whole body, let's draw the hair next. Hair plays a major role in expressing the character's personality.

(LESSON) **Draw Hair**

DL Download free practice materials:
www.tuttlepublishing.com/the-complete-guide-to-drawing-manga-and-anime

❶ Divide your hair into bangs, the middle hair, and the back hair.

If you do not understand the bundle of hair, it is OK to draw after doing ❸ first

❷ Draw a separate bundle for each part of the hair.

If you draw with fine locks of hair from the beginning, it will be easy to lose the balance, so draw in a rough shape first.

❸ Draw block-like rough shapes according to the flow of hair.

It will be natural if you draw while adjusting the size so that the locks of hair do not have the same area

❹ Use the blocks as a sketch and draw the hair strands in detail.

Finished Example

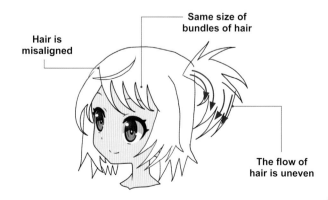

If you draw a character based on the completed guide, it will look like this.

Common Mistakes

Below are common mistakes. Compare them with the example on the left to see how to draw hair properly.

Hair is misaligned

Same size of bundles of hair

The flow of hair is uneven

Be Aware of Blocks of Hair

Hair can be roughly divided into three blocks: **bangs**, **the middle hair**, and the **back hair**. Observe and memorize the position of the blocks.

Bangs

Middle hair

Back hair

Curls

Medium hairw

Back hair

Bangs

Tied-back hair

Combine them all!

How to Draw Locks of Hair

If you can't draw hair well, let's review the bundles of hair. Are you drawing in the same shape or do you have a consistent flow of hair? Today, I will explain the points of how to draw locks of hair.

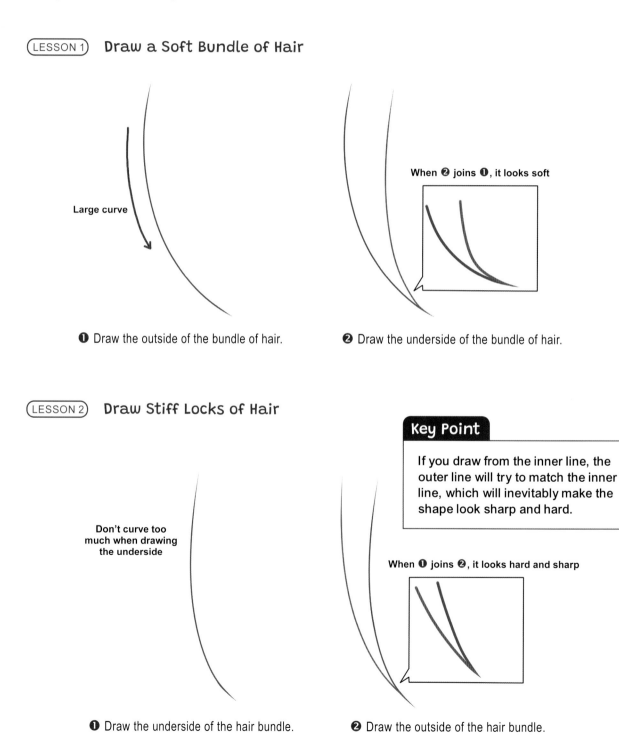

(LESSON 1) **Draw a Soft Bundle of Hair**

Large curve

When ❷ joins ❶, it looks soft

❶ Draw the outside of the bundle of hair.

❷ Draw the underside of the bundle of hair.

(LESSON 2) **Draw Stiff Locks of Hair**

Don't curve too much when drawing the underside

Key Point

If you draw from the inner line, the outer line will try to match the inner line, which will inevitably make the shape look sharp and hard.

When ❶ joins ❷, it looks hard and sharp

❶ Draw the underside of the hair bundle.

❷ Draw the outside of the hair bundle.

Express the Softness of the Hair With the Center of Gravity

Hair also has weight. If you place the center of gravity at the tip of the hair, it will look soft, and if you place it in the center, it will look hard and sharp.

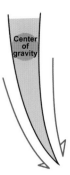

If you place the center of gravity in the middle of the bundle of hair, the tip straightens and it looks hard and sharp.

If you create the center of gravity on the tip side of the bundle of hair, it will look soft and rounded.

Patterns of Hair

Roughly speaking, the locks of hair can be made to look more three-dimensional by using "thick and thin," "front and back," "loose," "over and under," and "overlapping."

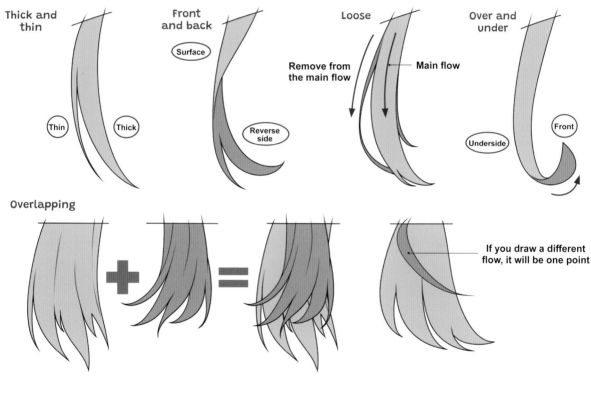

Thick and thin

Thin · Thick

Front and back

Surface · Reverse side

Loose

Remove from the main flow · Main flow

Over and under

Underside · Front

Overlapping

If you draw a different flow, it will be one point

How to Draw Natural Hair Ends

When drawing strands of hair in succession, instead of repeating the same shape, change the height and thickness as randomly as possible to create a natural look.

OK!

The heights of the gaps and the thickness of the locks of hair are random

NO!

The heights of the gaps and the thickness of the locks of hair are the same, and it looks like a copy. The same shape is repeated, so it feels monotonous and strange

Understanding the Shape of the Head

The head is actually a sphere, as you can see. By being conscious of the sphere, it becomes easier to imagine the depth of the head and the three-dimensional effect of the hair. Today I will explain the shape of the head and the depth of hair.

(LESSON) **Think About Hair as Ribbons**

Imagine a birdcage-like object with ribbons attached to a head. If you cut out the face, you can draw beautiful bobbed hair.

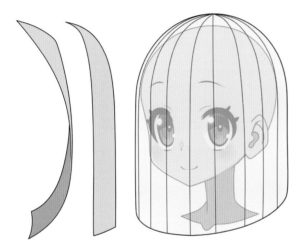

❶ Here we see ribbons hanging in a veil shape.

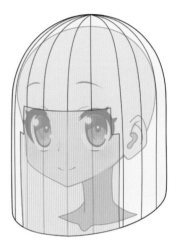

❷ Cut out the face area.

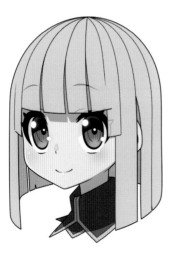

❸ Draw the back side.

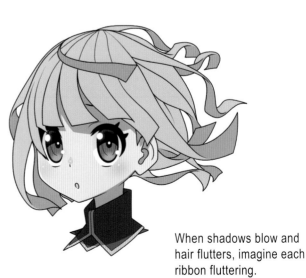

When shadows blow and hair flutters, imagine each ribbon fluttering.

Three-Dimensional Effects of Head and Hair

If we think about the head as a **sphere**, it will be easier to imagine the flow and depth of hair.

Depth
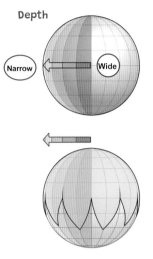

Hair flow

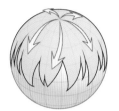

Highlighting

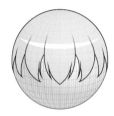

When you draw a guide on the sphere, the distance between the lines seems to narrow as you go deeper. In the same way when drawing locks of hair, you can express depth by narrowing the locks of hair as you go deeper.

Draw the hair flow according to this guide to create a natural impression.

Aligning the horizontal lines will create natural highlights.

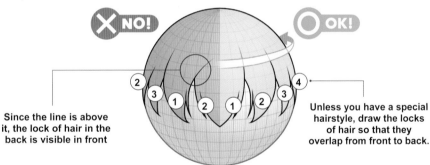

NO!

Since the line is above it, the lock of hair in the back is visible in front

OK!

Unless you have a special hairstyle, draw the locks of hair so that they overlap from front to back.

Three-Dimensional Effects of Locks of Hair

In simple terms, a lock of hair has a triangular cross-section, similar to the shape of a banana. By layering this, you can draw hair three-dimensionally. If you look at the hair of the figure, you can see that it has a similar shape.

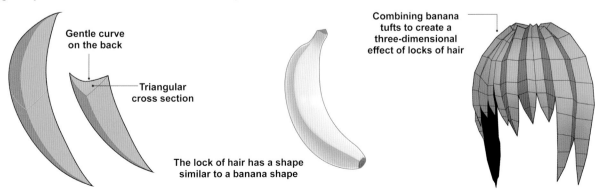

Gentle curve on the back

Triangular cross section

The lock of hair has a shape similar to a banana shape

Combining banana tufts to create a three-dimensional effect of locks of hair

DIFFICULTY ★★☆☆☆

Basics | Human Body | 3D

Deciding on a Hairstyle

Even with the same length of hairstyle, the look changes greatly depending on where the volume is. Let's use a silhouette to get closer to the image you want to draw.

Thinking About Hair

Hair flows down the head from the part. Thinking about where the part of the hairstyle you want to draw is, and drawing all the locks of hair from the part will allow you to draw natural hair.

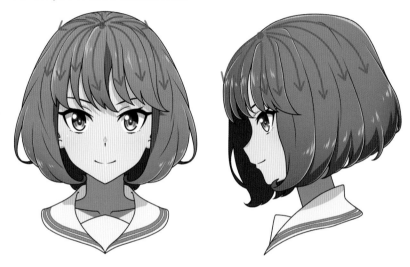

Change the Look with the Weight of the Hair

Every hairstyle has weight. The weight is the position where the volume is greatest, and changing the position of the weight can greatly change the look of the hair. A low weight gives a calm look, and a high weight gives a lively look.

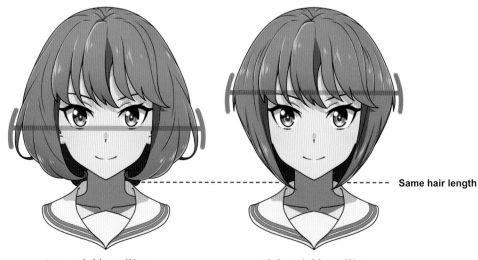

Same hair length

Low weight position　　　　High weight position

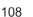

Out-Silhouette and In-Silhouette

The out-silhouette refers to the image of the hairstyle itself, and the in-silhouette refers to the way the face looks with that hairstyle.

Out-silhouette

In-silhouette

Draw the Back Hair with a Towel

It will be easier to understand the flow of the back hair if you imagine it with a towel on your head.

Conforms to the body

Place a towel on the head

Replace with hair

Bring the back hair forward for a natural impression

FEATURE Time-saving Silhouette Method

Use a thick, broad-tipped pen to draw choppy locks of hair to determine the silhouette. By drawing the lines of the flow of the hair there, I draw the shape of the hair. If you roughly decide the overall silhouette, you can quickly redraw it even if the image is different, which saves time. Once you understand the bangs, middle hair, back hair, the shape of the hair bundle, the weight, the flow of the hair, etc., you will be able to draw from a rough stroke like this.

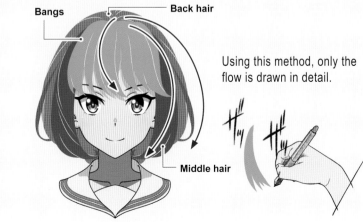

Bangs

Back hair

Middle hair

Using this method, only the flow is drawn in detail.

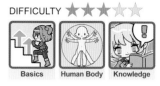

Basics | Human Body | Knowledge

Hairstyles Types

The hairstyle determines the style of the character. Even with the same length, the style changes greatly depending on volume and bangs. Also, there are hairstyles that are difficult to achieve in real life, but in drawing you can try any style you like. So try various hairstyles and see how they affect character design.

Changing Style with Hair Length

I tried different hairstyles on the same face. You can see that changing the length and volume of the hair gives a completely different look.

DL Download free practice materials:
www.tuttlepublishing.com/the-complete-guide-to-drawing-manga-and-anime

Body

Asymmetric | Short | Bob

Middle straight | Middle | Middle wave

Long straight | Curly hair | Long wave

Inner roll | Outer splash

Changing Style with Bangs

Even with the same hairstyle, if the bangs are different, the style will be quite different. When thinking about hairstyles, changing the combination of bangs, middle hair, and back hair will greatly alter the look of the character. Mix and match to create your own style.

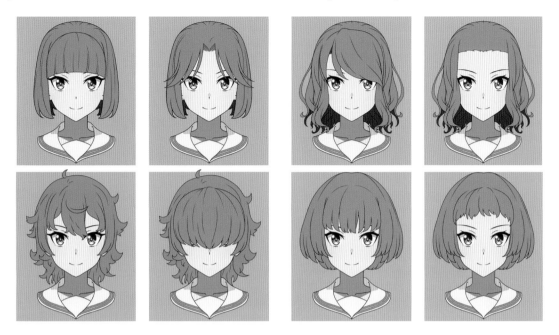

Different Knots

Even with the same knot, the impression will change depending on the position and height of the knot, so try adding variations.

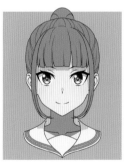 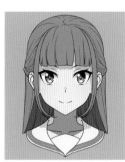 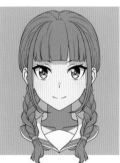 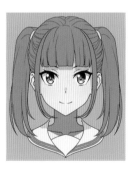

| Ponytail | Half up | Braided | Pigtails |

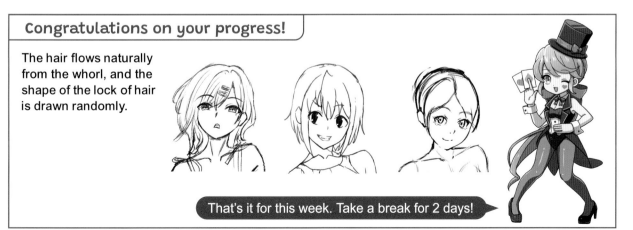

Congratulations on your progress!

The hair flows naturally from the whorl, and the shape of the lock of hair is drawn randomly.

That's it for this week. Take a break for 2 days!

Basics | Permanence | Knowledge

Wrinkle Types

Now that you can draw characters, I will explain how to draw clothes in Week 8. Wrinkles have patterns so they are easily understood.

Start with Traveler's Clothes

You definitely will want to draw gorgeous and cool (or cute) clothes! Start with simple, unadorned clothes. If I were to use an RPG as an analogy, it would be the first outfit the traveler can obtain. This traveler's outfit is full of wrinkle basics. Let's look at them one by one.

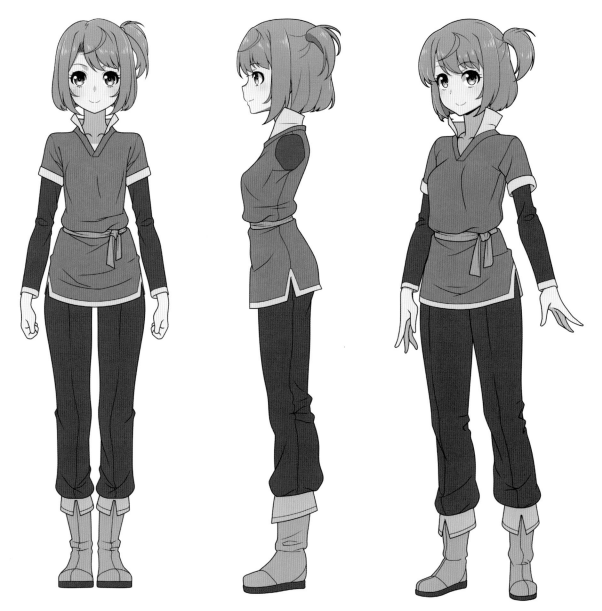

Front Side Angled

Wrinkle Basics

Wrinkles can be roughly divided into three types. If you look at the traveler's clothes from earlier, you can find these three wrinkles.

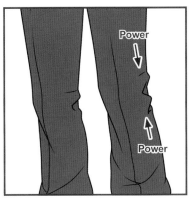

Skinny wrinkles

Wrinkles that appear around joints and are caused by applying force from multiple directions

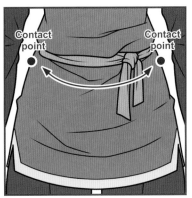

Tensile wrinkles

Wrinkles caused by pulling contact points together

In addition to the standard wrinkles, there are also those wrinkles that can occur when fallen wrinkles accumulate on the cuffs and hem, as well as those wrinkles that become fixtures where force gets applied time and again.

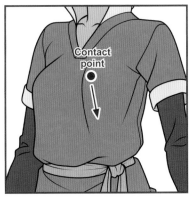

Falling wrinkles

Wrinkles that flow downward due to gravity from a contact point

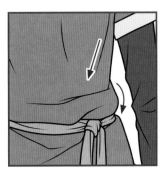

Accumulated wrinkles

Wrinkles in areas where the fabric is tightened, such as the cuffs and hem

Start with simple clothes, gradually increase the number of things you can draw, and gradually make them more luxurious.

At first, if you gradually increase the number of things you can draw, even if it's traveler's clothes...

You will be able to draw complex costumes (and equipment)

Wrinkle Shapes

Wrinkles transform into various S-shapes with the addition of gravity and force to the basic patterns. It is important to be fully conscious of the points of contact where clothes touch the body, the force of gravity, and the flow of cloth.

Positions Prone to Wrinkles

Joints are always prone to wrinkles. When you bend your arms or legs, the cloth on the bent side will get wrinkled. On the other hand, the cloth is pulled taut on the other side, so the wrinkles are stretched.

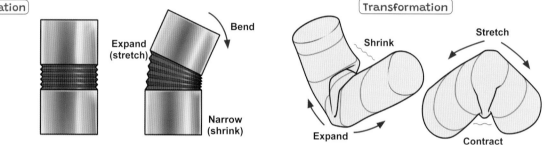

Simplification

Expand (stretch)

Bend

Narrow (shrink)

Transformation

Shrink

Stretch

Expand

Contract

Cloth Gravity

When an object is covered with cloth, the upper surface follows the shape of the object while the lower surface does not conform to the shape, and the cloth hangs down.

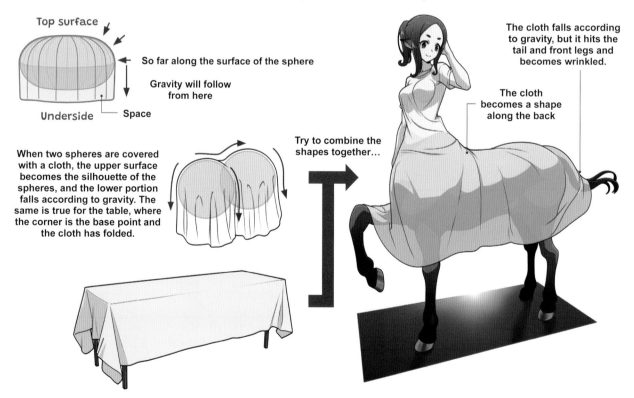

Top surface

So far along the surface of the sphere

Gravity will follow from here

Underside — Space

When two spheres are covered with a cloth, the upper surface becomes the silhouette of the spheres, and the lower portion falls according to gravity. The same is true for the table, where the corner is the base point and the cloth has folded.

Try to combine the shapes together…

The cloth falls according to gravity, but it hits the tail and front legs and becomes wrinkled.

The cloth becomes a shape along the back

Differences in Wrinkles Between Men and Women

A major difference between men and women is wrinkles in the lower back. In men, the pelvis is vertical, so wrinkles can be radial. Women's pelvis is tilted, so wrinkles can be V-shaped.

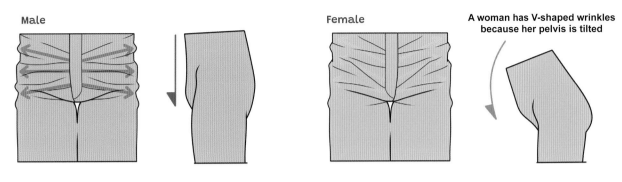

Male

Female

A woman has V-shaped wrinkles because her pelvis is tilted

Different Wrinkle Shapes

Wrinkles in clothes are caused by the pull of the contact points of the body and the fall of the fabric due to gravity. Various patterns are introduced here.

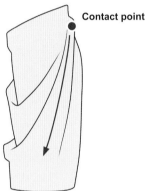

Contact point

Pulled
Wrinkles from contact points caused by pulling

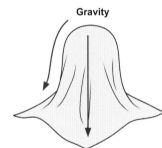

Gravity

Drop down
Wrinkles that fall downward due to gravity. The softness of the cloth can also be expressed by the degree of adhesion to the object

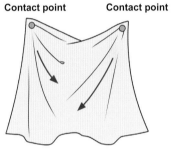

Contact point Contact point

Slack
Gravity is applied to the wrinkles that are created when contact points are pulled together, and the wrinkles are created by sagging downward

Pulled from each other
Wrinkles caused by being pulled more strongly than pulled wrinkles

Overlapped
Cloths are gathered and overlap to create this kind of wrinkle

Bent
Wrinkles that form toward the starting point of bending

Starting point

How Wrinkles Move

Wrinkles change shape depending on the movement of the body and the direction of the wind. First, let's draw the movement of the skirt fluttering in the wind. In addition, I will explain how wrinkles change when the body moves.

(LESSON) ## Drawing the Fluttering of a Skirt

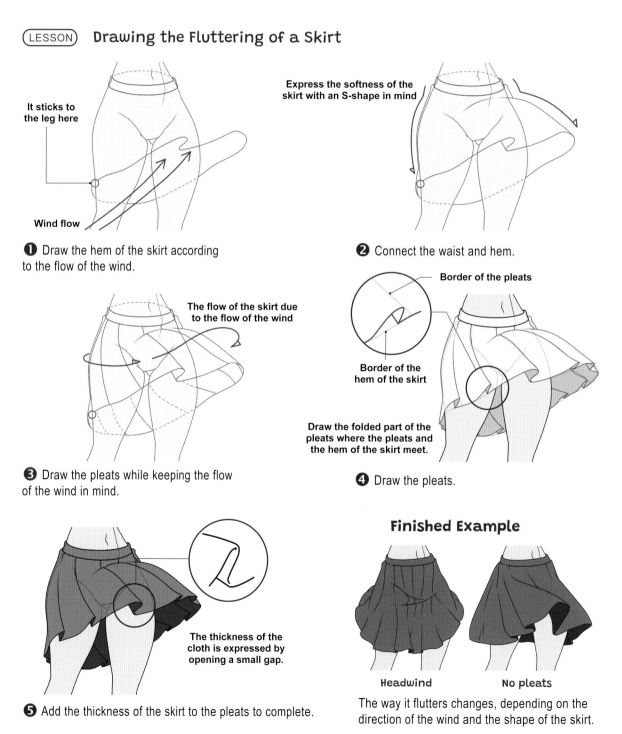

It sticks to the leg here

Wind flow

❶ Draw the hem of the skirt according to the flow of the wind.

Express the softness of the skirt with an S-shape in mind

❷ Connect the waist and hem.

The flow of the skirt due to the flow of the wind

❸ Draw the pleats while keeping the flow of the wind in mind.

Border of the pleats

Border of the hem of the skirt

Draw the folded part of the pleats where the pleats and the hem of the skirt meet.

❹ Draw the pleats.

The thickness of the cloth is expressed by opening a small gap.

❺ Add the thickness of the skirt to the pleats to complete.

Finished Example

Headwind No pleats

The way it flutters changes, depending on the direction of the wind and the shape of the skirt.

Relationship Between Contact Points and Gravity

Wrinkles change shape depending on the movements of the body and clothes. The key point is the points of contact between clothes and the body. Please pay attention to which contact points are stretched wrinkles, where fallen wrinkles are formed, and also the slackness of the wrinkles created by the gravitational force on stretched wrinkles.

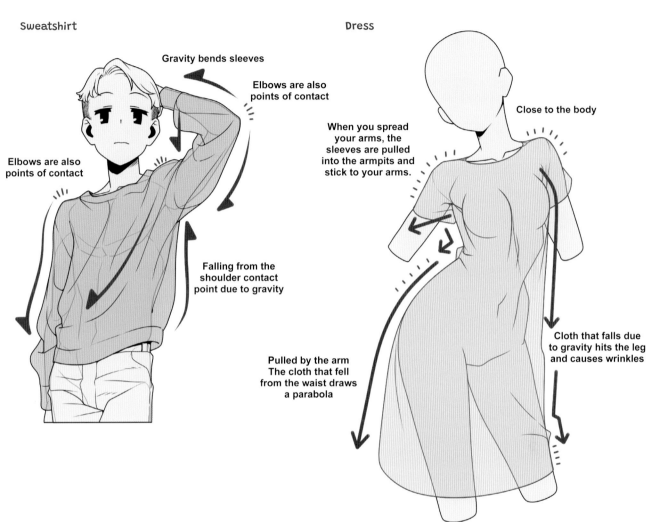

Sweatshirt

Gravity bends sleeves

Elbows are also points of contact

Elbows are also points of contact

Falling from the shoulder contact point due to gravity

Dress

Close to the body

When you spread your arms, the sleeves are pulled into the armpits and stick to your arms.

Pulled by the arm
The cloth that fell from the waist draws a parabola

Cloth that falls due to gravity hits the leg and causes wrinkles

Changes in Wrinkles

Once you know where wrinkles are likely to occur and the types of wrinkles, you will be able to understand how to draw wrinkles when the person wearing the clothes moves.

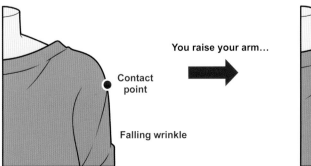

Contact point

Falling wrinkle

You raise your arm…

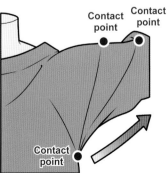

The point of contact between the clothes and the body changes, causing wrinkles

Contact point

Contact point

Contact point

Depicting Material Texture

There are various materials for clothes such as soft/hard, thin/thick, light/heavy. Wrinkles can be drawn to emphasize the texture of the material.

Flow and Tension

The texture of the cloth is determined by how much flow and tension (= angle) are included. If there is a lot of tension, it will appear hard, and if there is more flow, it will look soft.

Flow = flowing

Tension = flowing

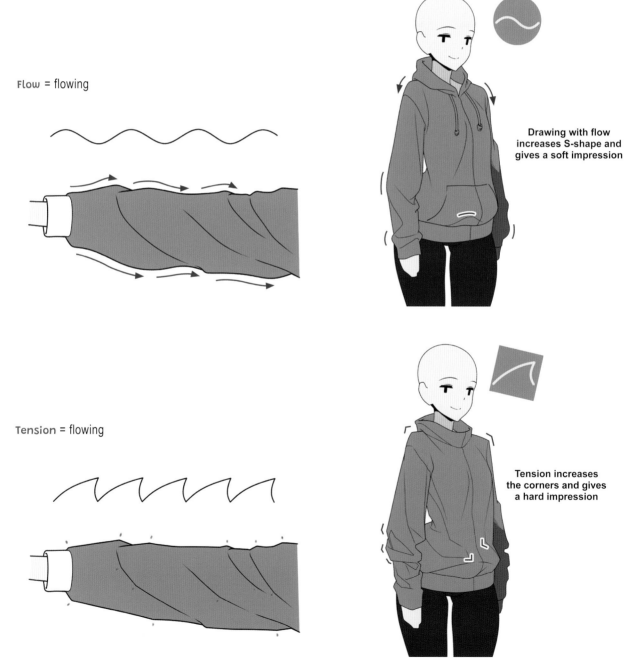

Drawing with flow increases S-shape and gives a soft impression

Tension increases the corners and gives a hard impression

Hardness and Weight

Depending on the material, clothes can show hardness and weight. Let's compare them.

Thick
Expressing the thickness of the cloth by creating a gap

Thin
Expressing thinness by reducing the gap

Soft (flowing, curvilinear)
Overall strong wrinkles of flow

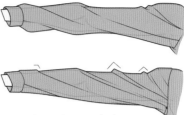

Hard (tension, linear)
There are corners and wrinkles with strong linear tension as a whole

Stiff cloth doesn't stretch, so the armpits have a lot of space to make it easier for the arms to move.

Heavy (flow, slack)
The weight of the cloth causes the cloth to sag downward. Since the fabric is often thick, it is easy to create a space on the upper part of the arm.

Light (flowing, close to the body)
Since it follows the body line, it is difficult to create clear wrinkles.

FEATURE Clothing Seams

Various techniques are used in clothes to match the lines of the body. By drawing these seams when drawing the costume, you can add information about the costume and make the picture look more plausible.

Darts are made by cutting cloth into diamond or triangle shapes and stitching them together to create waistlines and fit the body line.

Put a cut in the cloth and sew it back together......

Can be constricted

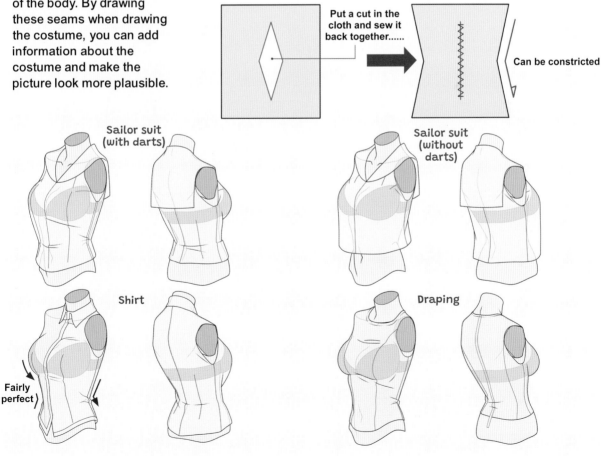

Sailor suit (with darts)

Sailor suit (without darts)

Shirt

Draping

Fairly perfect

119

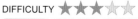

DIFFICULTY ★★★☆☆

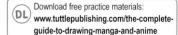

Basics Permanence Applications

How to Draw Basic Wrinkles

Draw basic wrinkles on a plain sweatshirt.
First, draw wrinkles as you like without referring to anything, and then compare them with the samples to learn where and what kind of wrinkles will appear.

(LESSON) **Draw Basic Wrinkles**

DL Download free practice materials:
www.tuttlepublishing.com/the-complete-guide-to-drawing-manga-and-anime

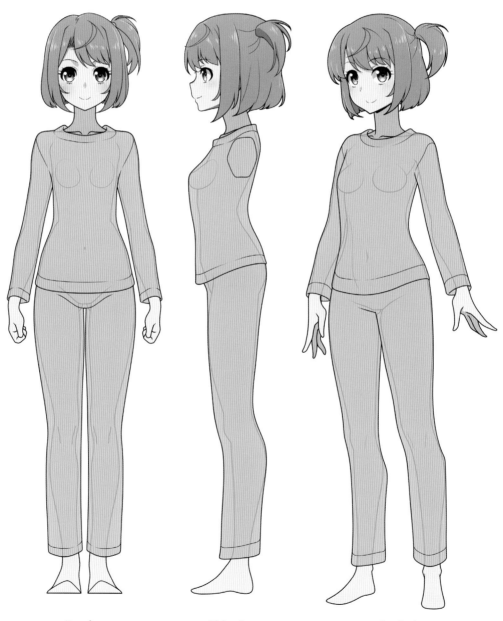

Front Side view Angled

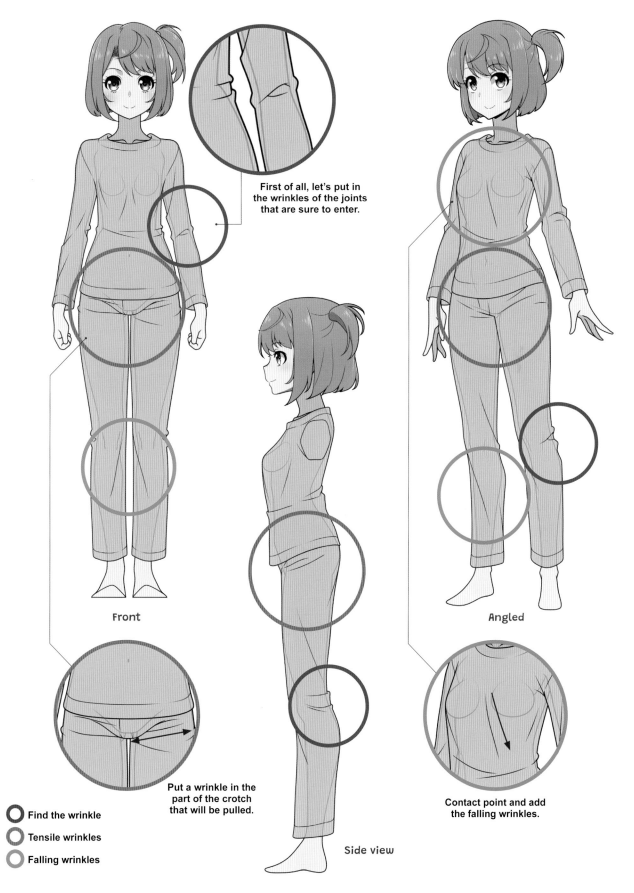

First of all, let's put in the wrinkles of the joints that are sure to enter.

Front

Put a wrinkle in the part of the crotch that will be pulled.

Side view

Angled

Contact point and add the falling wrinkles.

Find the wrinkle

Tensile wrinkles

Falling wrinkles

121

Wrinkle Patterns

Check the shape and pattern of wrinkles by referring to the following illustration. It will be easier to understand if you look at the starting point of the armpit, the points of contact of the shoulders and arms, gravity, etc.

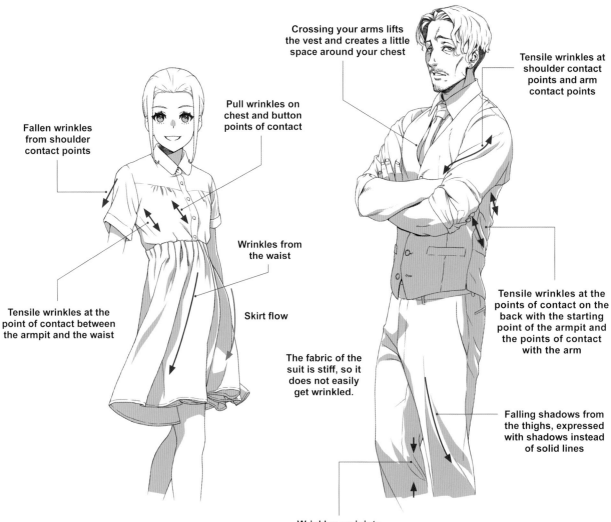

Crossing your arms lifts the vest and creates a little space around your chest

Tensile wrinkles at shoulder contact points and arm contact points

Pull wrinkles on chest and button points of contact

Fallen wrinkles from shoulder contact points

Tensile wrinkles at the point of contact between the armpit and the waist

Wrinkles from the waist

Skirt flow

The fabric of the suit is stiff, so it does not easily get wrinkled.

Tensile wrinkles at the points of contact on the back with the starting point of the armpit and the points of contact with the arm

Falling shadows from the thighs, expressed with shadows instead of solid lines

Wrinkles on joints

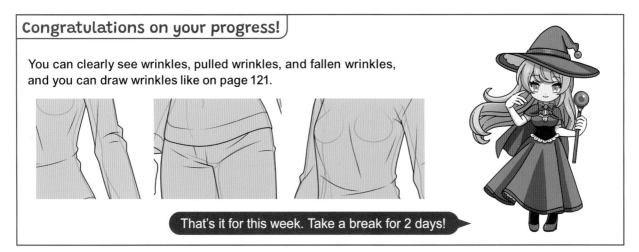

Congratulations on your progress!

You can clearly see wrinkles, pulled wrinkles, and fallen wrinkles, and you can draw wrinkles like on page 121.

That's it for this week. Take a break for 2 days!

Intermediate Level

Level Up Your Drawing

A 90-Day Course to Improve Your Drawing Skills

It's been about two months since you started the course and it's time to move to the Intermediate level. The Intermediate level will focus on more advanced lessons that allow you to draw more attractive characters. There will be no more lesson sections. From this point on, you will be taught a series of skills that you can practice by by following the instructions carefully.

Drawing the Human Body in Three Dimensions

Now that you have learned to draw a person, this week I will explain techniques for creating a three-dimensional drawing of a human body. It is important to know how to represent the human figure on a plane when drawing a three-dimensional figure.

The Three-Dimensional Effect

By being conscious of a plane when drawing a character, your understanding of the three-dimensional effect will be greatly improved. This can be a complicated thing so let's learn the technique step-by-step.

Canvas

Face not visible from the front

Space that cannot be seen from the front

Beginners should first be able to draw the human body on a plane.

As you progress, you will be able to better draw three-dimensional objects that can be seen from the front.

Advanced users can understand the space and the back side that cannot be seen from the front.

Front, Side and Back

When you look at a person from the front, you can see not only the front but also the sides. If you think of a person on a plane, it looks like the figure on the right. The dark colored parts are the side portions. By keeping in mind that the sides can be seen even when viewed from the front like this, it becomes easier to understand the three-dimensional effect when adding wrinkles and shadows on the clothes.

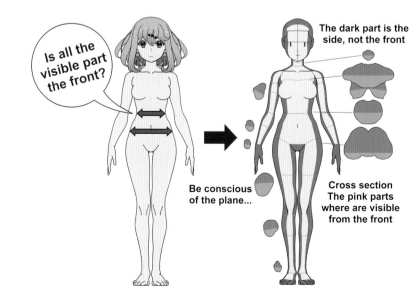

Is all the visible part the front?

Be conscious of the plane...

The dark part is the side, not the front

Cross section The pink parts where are visible from the front

By Being Aware of the Surface, the Three-Dimensional Effects Change

Keep in mind that if you look at it from an angle, you can see the sides of a body. The places where the surface changes become the borders of shadow or highlights. When observing a photograph or the real thing, pay attention to where the surface changes.

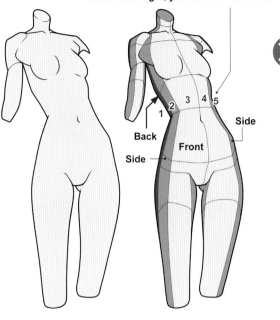

If you divide the back, side and front into left and right, you can see five sides

Back
Side
Front
Side
1 2 3 4 5

By being aware of the surface when drawing the lines of the clothes, you can make the body look slimmer and three-dimensional even with the same body.

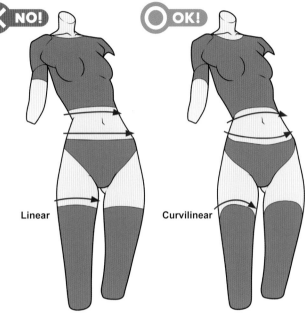

Linear

Curvilinear

Since we are not conscious of the surface, there is little three-dimensional effect. It looks thick and flat

It looks three-dimensional because it follows the surface. The body looks thinner than the "NO!" example

FEATURE Why Does the Face Look so Big?

If you are not careful, you will make the head look too big by forgetting how to represent the sides of the face in relation to the eyes. If the eyes are drawn too far to the side, the face looks bigger than it should.

As you can see in the common mistakes on page 33, you can draw a well-balanced head just by paying attention to two common problems, the lack of the back of the head and the problem of not being conscious of the sides.

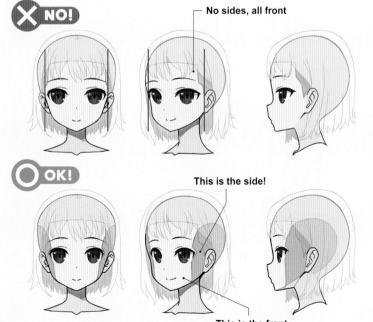

No sides, all front

This is the side!

This is the front

Adding Shadows

Now that you have learned to draw a person to some extent, I will explain techniques for creating a more three-dimensional effect this week. First, I will explain how to express a three-dimensional effect with shadows.

Shadow Types

As for shadows, there are form shadows and there are cast shadows, and each is used differently in drawing.

Form Shadows

A form shadow is the dark area that appears on a hidden surface when light hits an object. It refers to the shadow that falls on the opposite side of the light source to create a three-dimensional effect. A form shadow can also be called a "3D shadow."

Cast Shadows

A cast shadow is the shadow cast by light on an object. Be sure to add shadows on the ground and under the neck when a person stands.

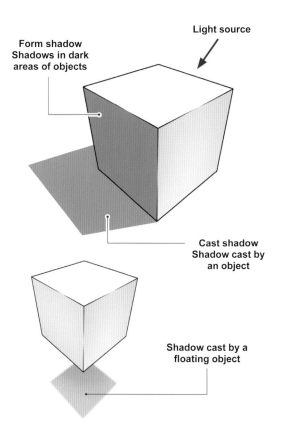

Light source

Form shadow
Shadows in dark areas of objects

Cast shadow
Shadow cast by an object

Shadow cast by a floating object

Reflected Light

In addition to highlights that brighten when light hits them directly, there are reflected lights that brighten when they are reflected off of objects. Looking at the image on the right, there are areas in the shadow that look a little brighter. This is a phenomenon that occurs when light reflects off surrounding objects such as the floor.

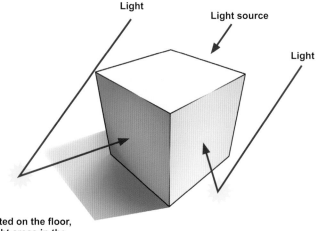

Light

Light source

Light

Light is reflected on the floor, creating bright areas in the form shadow

How Shadows are Made

Let's see how shadows can be cast against the light source.

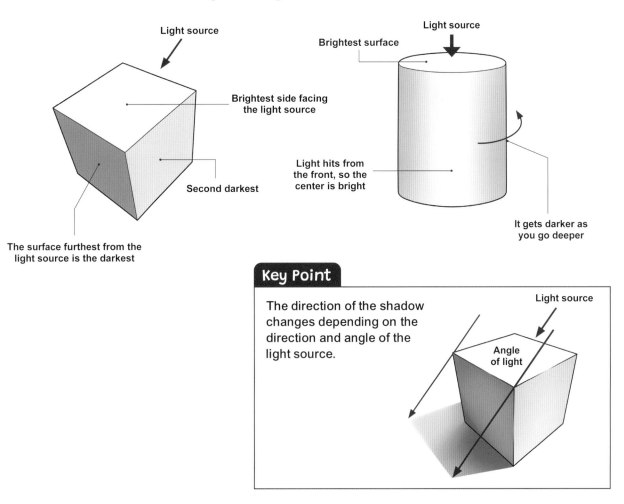

Light source

Brightest side facing
the light source

Second darkest

The surface furthest from the
light source is the darkest

Light source

Brightest surface

Light hits from
the front, so the
center is bright

It gets darker as
you go deeper

Key Point

The direction of the shadow
changes depending on the
direction and angle of the
light source.

Light source

Angle
of light

Solids and Highlights

Observe the position of the highlight carefully. You can see that each highlight is connected on a line. The highlight can be placed at the most front facing position with respect to the light source. We tend to think that 3D objects are shadows, but highlights are also an important factor in 3D objects. You can draw a more three-dimensional picture by carefully considering the position of the light source and the surface and arranging the highlights.

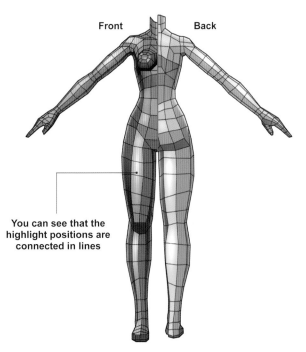

Front Back

You can see that the
highlight positions are
connected in lines

127

Shadow Position

Study the illustrations below to see how cast shadows and form shadows appear on the human figure. When drawing, the order of priority is: Cast shadow → Form shadow.

= form shadow

= cast shadow

Light source

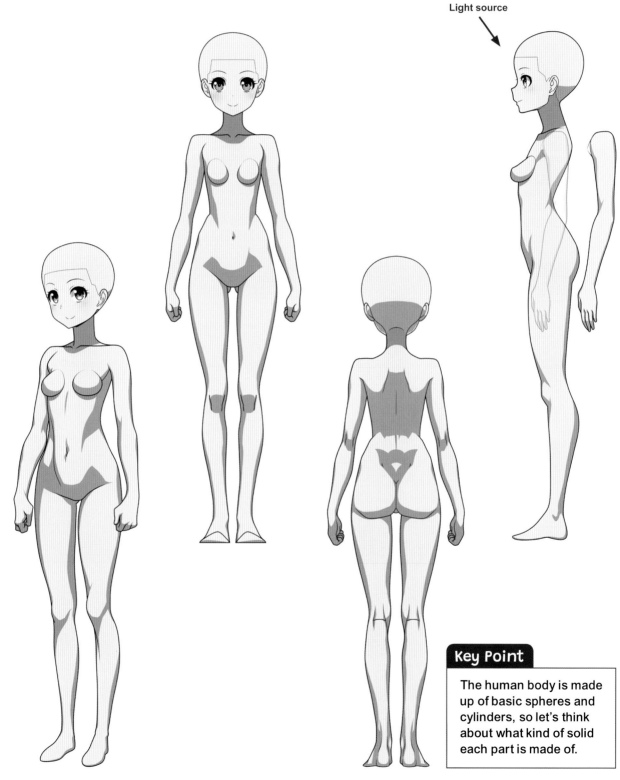

Key Point

The human body is made up of basic spheres and cylinders, so let's think about what kind of solid each part is made of.

Clothes Shadow

Compare this with the shadow on the body on the left page. You can see that the shadow is basically in the same position. If you are conscious of the position of the shadow of the base body and the three-dimensional shape of the clothes, you can draw the shadows of the clothes.

Light source

Light

Dark

The highlight is a bright color close to the base color, not a pure white

Common Mistakes

The following figure shows shadow drawing that is common among beginners.

The shadows and highlights are painted with a brush using a strong blur, so it has a vague impression without sharpness. Also, I tried to express the flow of wrinkles too much with shadows, and the shadows ignored the three-dimensional effect.

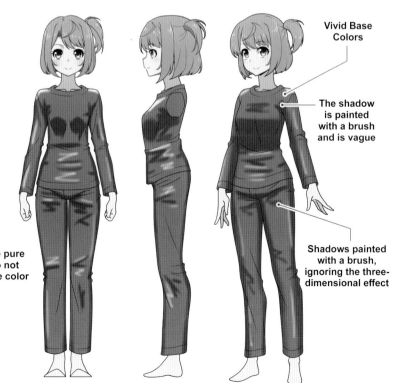

Vivid Base Colors

The shadow is painted with a brush and is vague

Highlights are pure white and do not match the base color

Shadows painted with a brush, ignoring the three-dimensional effect

Understanding Muscles

So far, we have talked about where the body swells and where unevenness is created when drawing a person's body, but it can be said that most of this is the three-dimensional effect of muscles. Today I will go into detail about the human musculature system.

Names of the Main Muscles

By knowing the locations of the various muscles, you can give the three-dimensional effect of the body a sense of reality. Only the names of the main muscles are shown here.

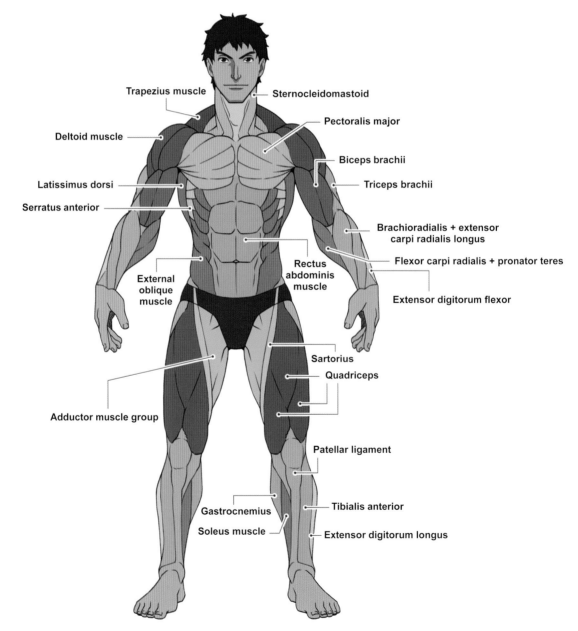

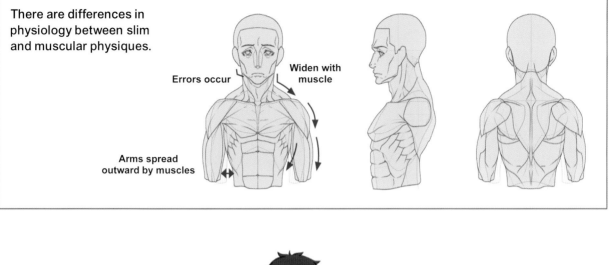

There are differences in physiology between slim and muscular physiques.

Errors occur

Widen with muscle

Arms spread outward by muscles

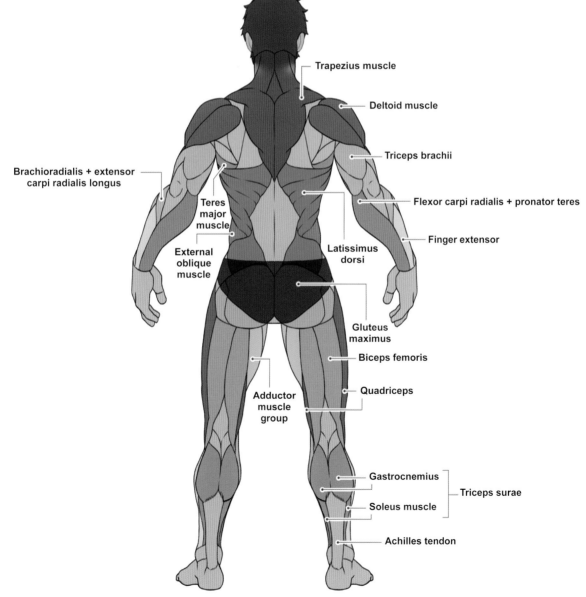

Trapezius muscle

Deltoid muscle

Triceps brachii

Brachioradialis + extensor carpi radialis longus

Flexor carpi radialis + pronator teres

Teres major muscle

Finger extensor

External oblique muscle

Latissimus dorsi

Gluteus maximus

Biceps femoris

Quadriceps

Adductor muscle group

Gastrocnemius

Triceps surae

Soleus muscle

Achilles tendon

Thin Muscular and Thick Muscular

The body shape changes depending on the amount of muscle and how it is attached. Let's compare thin muscular and thick muscular.

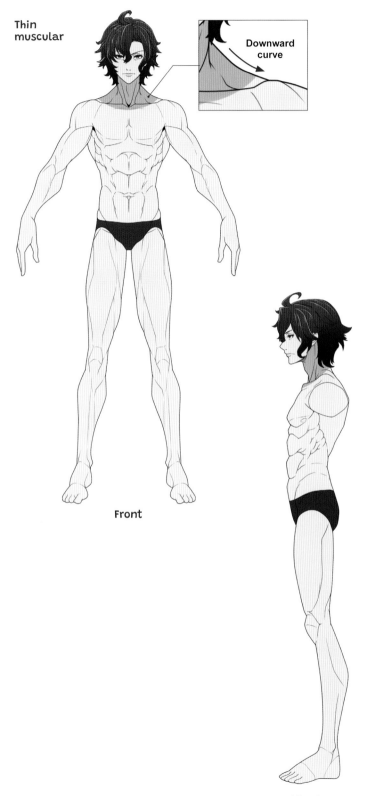

Thin muscular

Downward curve

Front

Side view

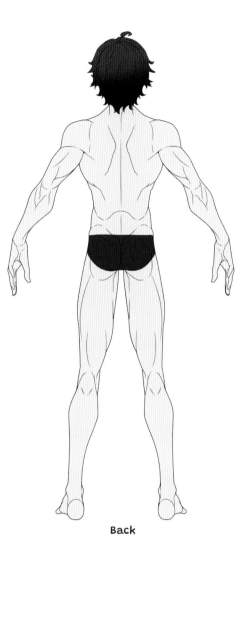

Back

Thick muscular

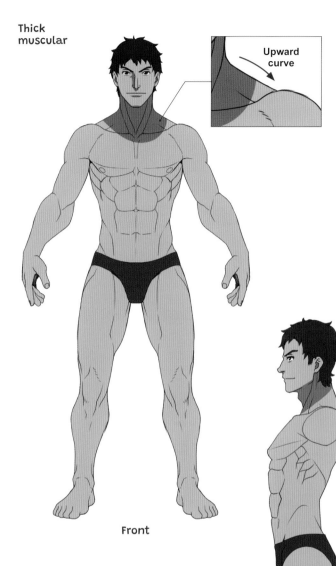

Upward curve

Front

Side view

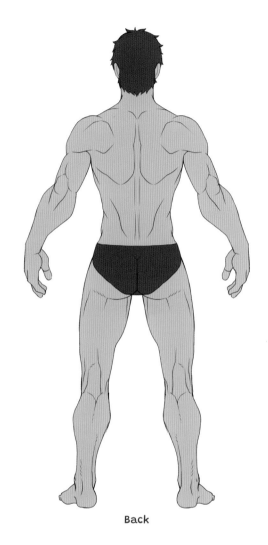

Back

How to Draw Using Various Rough Sketch Styles

If you can understand the three-dimensional effect of faces and shadows, you can draw while being conscious of the three-dimensional effect when drawing rough sketches. Earlier I explained how to draw basic brush strokes in the Beginner level, but here I will introduce various methods used to draw brush strokes.

Various Sketches

I draw the brush strokes when I pose the figure, but there is no one correct way to draw them. I will introduce an example, so please try to find a way to draw a brush stroke that suits you. You can also draw using a combination of these.

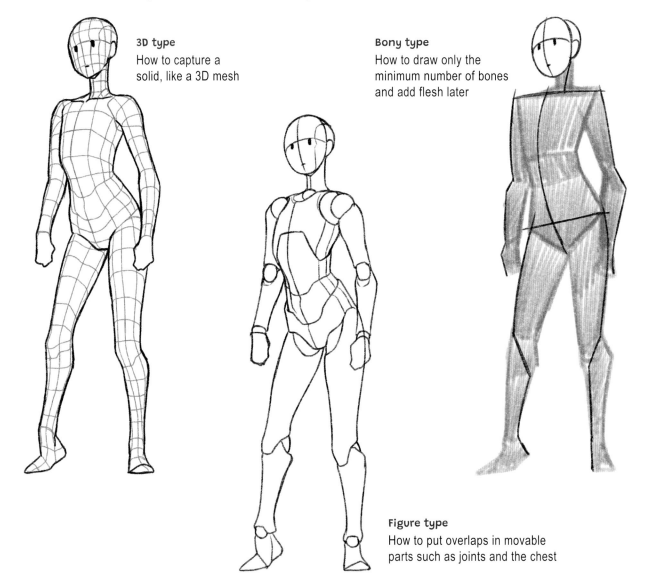

3D type
How to capture a solid, like a 3D mesh

Bony type
How to draw only the minimum number of bones and add flesh later

Figure type
How to put overlaps in movable parts such as joints and the chest

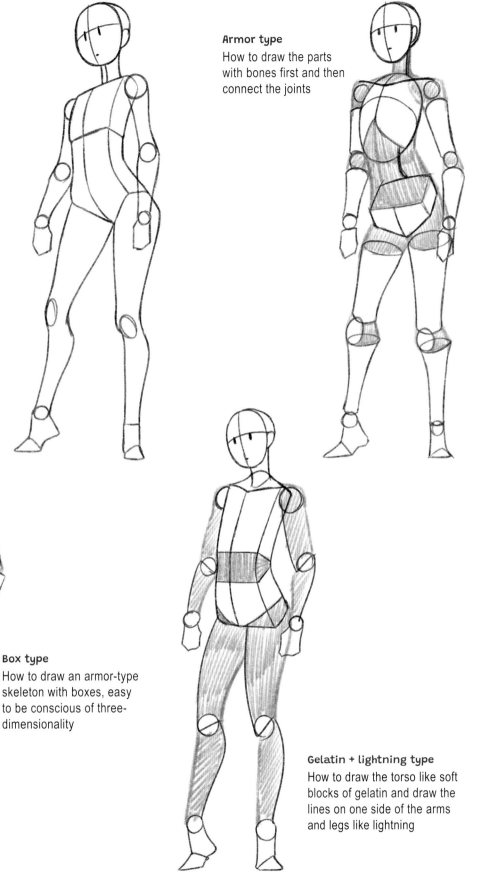

Armor type
How to draw the parts
with bones first and then
connect the joints

Box type
How to draw an armor-type
skeleton with boxes, easy
to be conscious of three-
dimensionality

Gelatin + lightning type
How to draw the torso like soft
blocks of gelatin and draw the
lines on one side of the arms
and legs like lightning

135

Tips for Drawing the Head

I've talked about the head several times before, but in the Intermediate level, I'll talk about the head including poses. I think that the shape of the head becomes difficult to draw at an angle, depending on the pose and composition, so let's explain the tips for the head again here.

The Head is P-Shaped

The head resembles the shape of the letter "P".

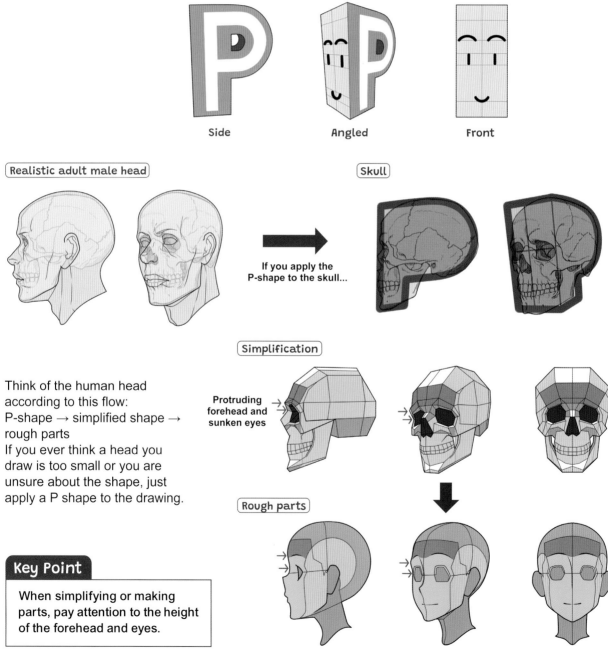

Side Angled Front

Realistic adult male head

Skull

If you apply the P-shape to the skull...

Simplification

Think of the human head according to this flow:
P-shape → simplified shape → rough parts
If you ever think a head you draw is too small or you are unsure about the shape, just apply a P shape to the drawing.

Protruding forehead and sunken eyes

Rough parts

Key Point

When simplifying or making parts, pay attention to the height of the forehead and eyes.

Relationship Between the Position of Facial Parts and Age

Look at the following illustration. The hairstyle and shoulder width are the same, and the age is drawn by the difference in the position of the eyes, mouth, chin, and collarbone. In this way, the age can be drawn according to the position of the parts.

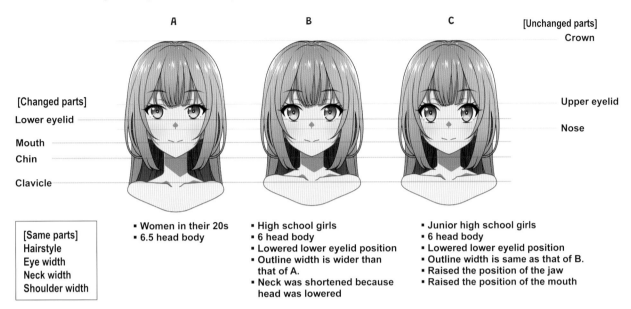

A B C

[Unchanged parts]
Crown

[Changed parts]
Lower eyelid
Mouth
Chin
Clavicle

Upper eyelid
Nose

[Same parts]
Hairstyle
Eye width
Neck width
Shoulder width

- Women in their 20s
- 6.5 head body

- High school girls
- 6 head body
- Lowered lower eyelid position
- Outline width is wider than that of A.
- Neck was shortened because head was lowered

- Junior high school girls
- 6 head body
- Lowered lower eyelid position
- Outline width is same as that of B.
- Raised the position of the jaw
- Raised the position of the mouth

FEATURE Head Balance by Age

There is a difference in the balance of the head depending on age. Furthermore, when comparing the same age in real life and in 2D, the 2D character will look younger.

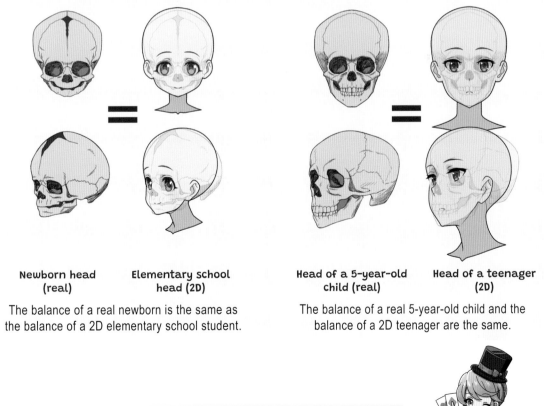

Newborn head (real) **Elementary school head (2D)**

The balance of a real newborn is the same as the balance of a 2D elementary school student.

Head of a 5-year-old child (real) **Head of a teenager (2D)**

The balance of a real 5-year-old child and the balance of a 2D teenager are the same.

That's it for this week. Take a break for 2 days!

Differences Between Real Life and 2D

When I practice drawing, I sometimes draw from real objects and photographs, but if I apply a realistic balance to a two-dimensional illustration, won't it look bulky? This week, I will explain the difference between real and 2D and how to draw in 2D.

From Real to 2D

The model looks cute in the photo, but if you draw her as a 2D character, she will look too slender. I will explain why this is the case.

❶ Take a closer look
Observation is important when drawing in 2D.

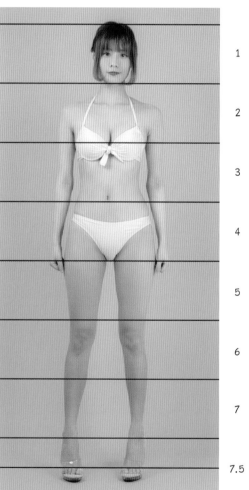

1
2
3
4
5
6
7
7.5

❷ Measure the head and body
If you measure the head and body, you can see that the body is 7.5 heads-high.

DL Download free practice materials:
www.tuttlepublishing.com/the-complete-guide-to-drawing-manga-and-anime

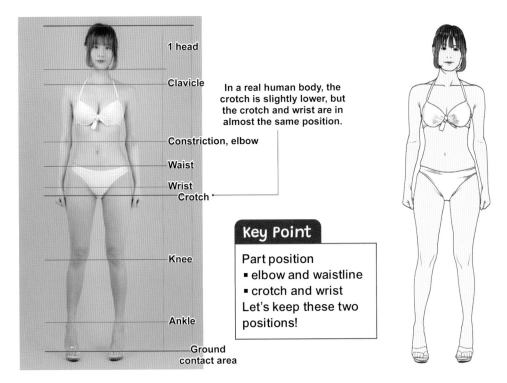

1 head

Clavicle

In a real human body, the crotch is slightly lower, but the crotch and wrist are in almost the same position.

Constriction, elbow

Waist

Wrist

Crotch

Key Point

Part position
- elbow and waistline
- crotch and wrist

Let's keep these two positions!

Knee

Ankle

Ground contact area

❸ Check the balance of the human body
Refer to the Balancing Guide for the Human Body that we learned in the 4th week (page 84). There may be some variations due to individual differences.

❹ Two-dimensionalization
Create a copy of the photo. This gives us a pretty rough impression. I'd like to make a two-dimensional picture. So what do we do?

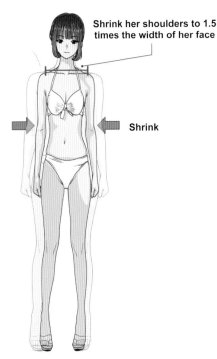

Shrink her shoulders to 1.5 times the width of her face

Shrink

❺ Take a 2D picture of the face
I made a two-dimensional picture of the face and added a shadow. However, this will make her neck and shoulders feel wider, and you see a lot of inconsistency.

❻ Make the width of the body thinner
Next, I shortened the width of the body to about 1.5 times the width of the face. It still feels a little strange, but it looks like it's getting closer to a two-dimensional picture.

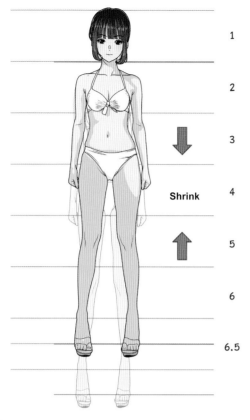

1

2

3

Shrink

4

5

6

6.5

❼ Make her 6.5 heads-high
7.5 head-high is too tall for a 2D picture, so I shortened it to 6.5 from the neck down. It's pretty close to a 2D drawing.

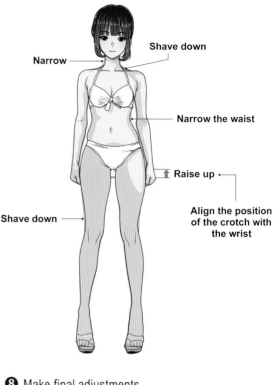

Narrow

Shave down

Narrow the waist

Raise up

Align the position of the crotch with the wrist

Shave down

❽ Make final adjustments
With reference to the Balancing Guide for the Human Body (page 84), I raised the crotch to the level of the wrist, narrowed the neck, and reduced the trapezius muscles. Furthermore, by shaving the joints and adding sharpness (to make it S-shaped), the two-dimensional drawing took shape.

Key Point

Finally, I adjusted the sharpness, S-shape, and thickness of the neck. Let's see what really changed.

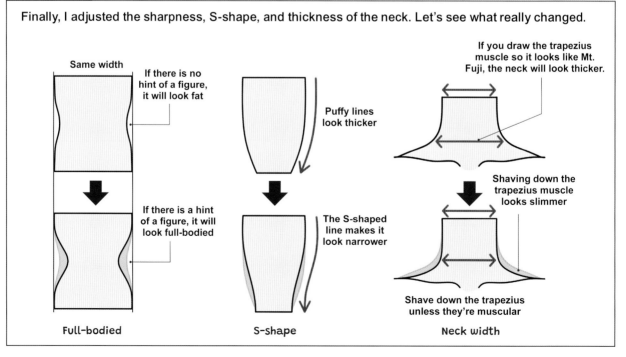

Same width

If there is no hint of a figure, it will look fat

If there is a hint of a figure, it will look full-bodied

Full-bodied

Puffy lines look thicker

The S-shaped line makes it look narrower

S-shape

If you draw the trapezius muscle so it looks like Mt. Fuji, the neck will look thicker.

Shaving down the trapezius muscle looks slimmer

Shave down the trapezius unless they're muscular

Neck width

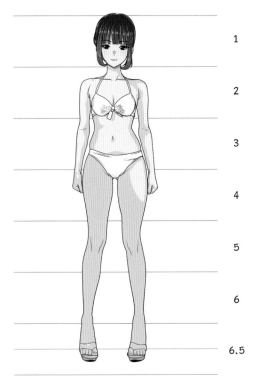

1
2
3
4
5
6
6.5

❾ Completion of a 6.5 heads-high body
Tall characters and realistic characters are completed with this.

The reason why the width of the upper body (chest) is shortened is because it looks relatively fat when the head and body are lowered. Balance it by narrowing the width.

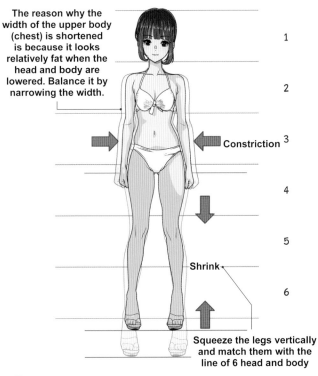

1
2
Constriction 3
4
5
6

Shrink

Squeeze the legs vertically and match them with the line of 6 head and body

❿ Convert to 6 heads-high
When making a six heads-high body, the upper body (chest) is shrunk horizontally and the lower body (legs) is shrunk vertically. In addition, the position of the lower eyelids is lowered to make the face look a little younger.

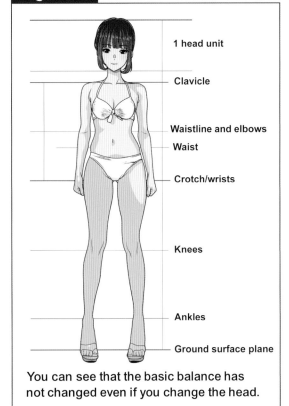

1 head unit

Clavicle

Waistline and elbows
Waist

Crotch/wrists

Knees

Ankles

Ground surface plane

You can see that the basic balance has not changed even if you change the head.

Key Point

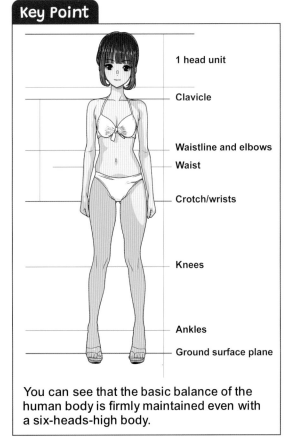

1 head unit

Clavicle

Waistline and elbows
Waist

Crotch/wrists

Knees

Ankles

Ground surface plane

You can see that the basic balance of the human body is firmly maintained even with a six-heads-high body.

DIFFICULTY ★★★☆☆

Human Body | Drawing Techniques | Applications

How to Draw Complex Poses

Now that you know how to draw from a photo and how to adjust the head and body, draw a slightly more complicated pose. Observation is the most important thing in drawing. Let's draw while observing carefully.

Drawing from a Photo

Until now, we have practiced drawing a standing figure without a pose, but let's try drawing with a pose here. I will practice using a "two-dimensional drawing" method.

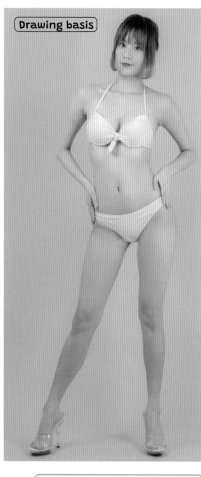

Drawing basis

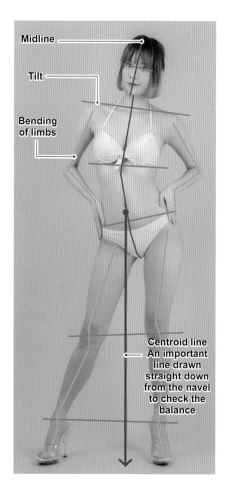

Midline

Tilt

Bending of limbs

Centroid line
An important line drawn straight down from the navel to check the balance

Download free practice materials:
www.tuttlepublishing.com/the-complete-guide-to-drawing-manga-and-anime

❶ Observe the original drawing

First, carefully observe the pose. Let's add the median line, tilt, how the arms and legs bend, and the center of gravity line on the original image.

Key Point

If you draw using a photo as reference, it's easier to create a more realistic drawing. In this book, we call this the "practice method of reproducing poses" and it used in a two-dimensional drawing.

1
2
3
4
5
6

❷ Prepare a head and body template

First, draw the auxiliary lines for the head and body you want to draw. It is convenient to create such data as a template in advance.

Key Point

Even if we draw the figure with the same balance as the photo, it doesn't look the same for some reason. Even if you trace the photo, there is no surface information, so the tilt feels weak and it does not look like the same three-dimensional object. Also, since there is no face information for the thickness of the body, it will look thick when traced. Therefore, exaggeration is necessary for two-dimensionalization. This is called a "two-dimensional lie."

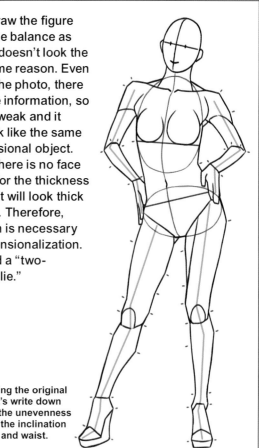

You can try tracing the original image first. Let's write down dots such as for the unevenness of the body and the inclination of the chest and waist.

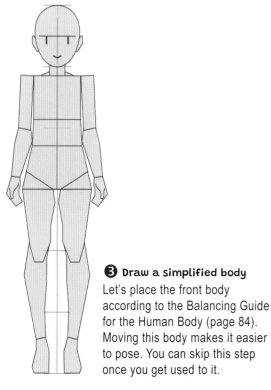

❸ Draw a simplified body

Let's place the front body according to the Balancing Guide for the Human Body (page 84). Moving this body makes it easier to pose. You can skip this step once you get used to it.

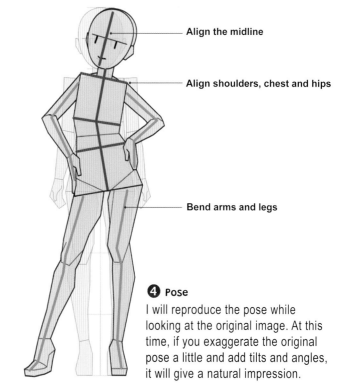

Align the midline

Align shoulders, chest and hips

Bend arms and legs

❹ Pose

I will reproduce the pose while looking at the original image. At this time, if you exaggerate the original pose a little and add tilts and angles, it will give a natural impression.

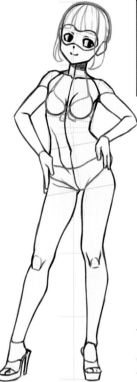

Key Point

What you have learned so far is important. If there is something you are unsure of, feel free to review the lesson.

❺ **Draw a draft based on the body in the pose of ❹**

Don't try to draw beautifully from the beginning, but first focus only on the rough shape and balance.

❻ **Make a fair reproduction**

Lower the opacity of the drafted layer and clean it up. At this time, let's draw while observing the original photo while paying close attention to the S-shape.

❼ **Observe shadows**

Observe the shadows in the original photo. At this time, if it is an image, if you convert it to monochrome and increase the contrast, the shadow will be clear and easy to observe.

❽ **Add shadows**

I will add the shadows. Don't Prioritize plausibility. If you don't understand, try using the shadows of your favorite picture as a reference.

One of the points that make the picture look beautiful is the beauty of the S-shape. However, it is very difficult to bring out the beauty of this shape, and it requires skill, so always be conscious of drawing the lines.

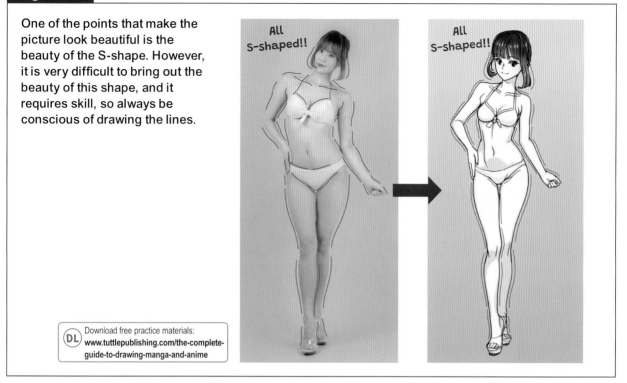

FEATURE Creating Balance When not Drawing the Whole Body

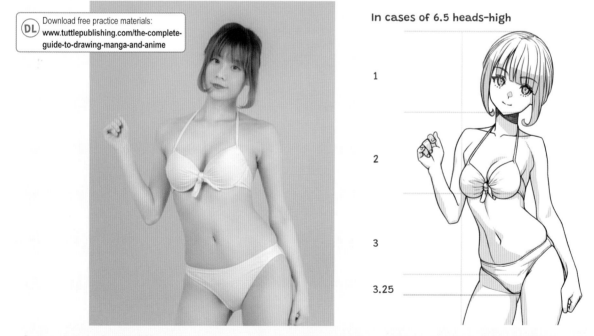

In cases of 6.5 heads-high

1

2

3

3.25

Some people find it difficult to draw a cropped body figure. If you refer to the Balancing Guide for the Human Body (page 84), half of the head and body is the position of the crotch, so if you have a 6 heads-high body, you can draw the crotch at the 3 heads-high body position, and if you have a 6.5 heads-high body, you can draw the crotch at the 3.25 heads-high body position. Similarly, the area between the shoulders and the crotch is constricted, so the basic balance is not lost, and if you know the key points, you can draw an accurate pose without drawing the whole body.

How to Draw Clothed Poses

Yesterday I drew a character using a photo of a woman in a swimsuit as reference, but today I will explain how to draw a figure fully clothed. It's important to draw while remaining conscious of the parts of the body that are hidden by clothes and cannot be seen.

Draw with Awareness of the Invisible Parts

When drawing poses with clothes on, it is important to be conscious of the parts of the body that are hidden and not visible. Be aware of the positions of key parts, such as the positions of knee and elbow joints and waistlines, and that the lines are connected even where they are hidden by clothes.

Drawing basis

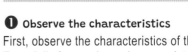

DL Download free practice materials:
www.tuttlepublishing.com/the-complete-guide-to-drawing-manga-and-anime

If she is standing on one leg, pay attention to her center of gravity.

Head tilt

Joint

Constriction

Hem that flows over the chest

Distance from centroid line

Thigh is angled

Right shin is slanted

Heel and toe lines are connected

Central axis

❶ Observe the characteristics

First, observe the characteristics of the pose. Especially for one-legged poses, determine the center of gravity precisely.

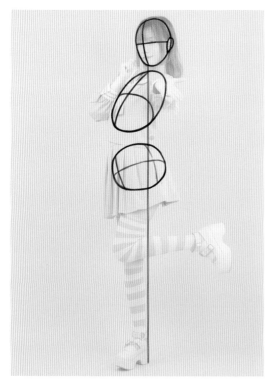

❷ Draw the head, chest, and waist

First, represent the position and inclination of the head, chest, and waist with simple circles.

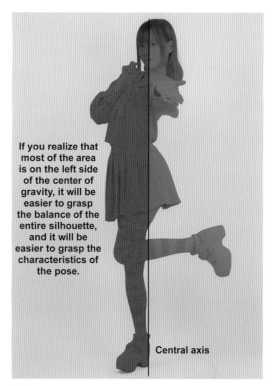

If you realize that most of the area is on the left side of the center of gravity, it will be easier to grasp the balance of the entire silhouette, and it will be easier to grasp the characteristics of the pose.

Central axis

❸ Confirm the area of the silhouette

The pose is easier to understand by observing how the areas of the human body are arranged on the left and right with respect to the central axis.

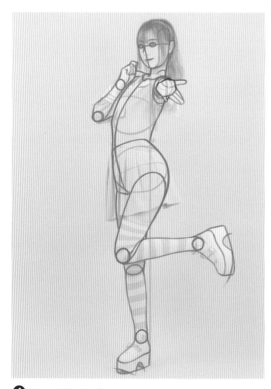

❹ Draw the body

Based on the three circles drawn in ❷, draw the features observed in ❶ to draw the body.

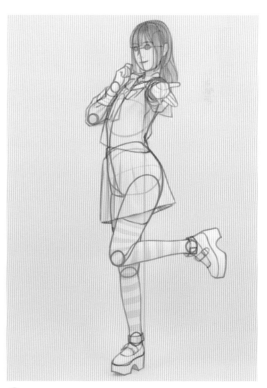

❺ Draw the costume

First, draw the costume in a simple form.

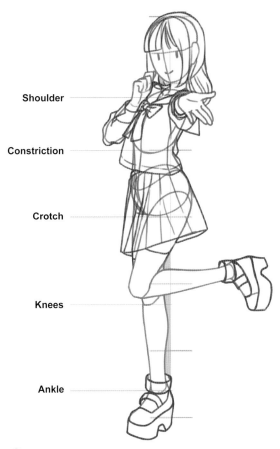

Shoulder

Constriction

Crotch

Knees

Ankle

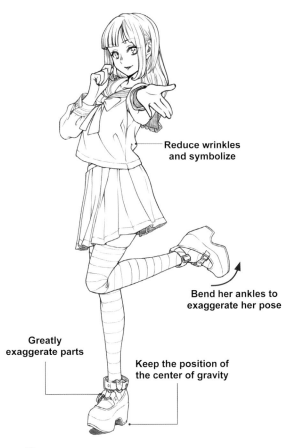

Reduce wrinkles
and symbolize

Bend her ankles to
exaggerate her pose

Greatly
exaggerate parts

Keep the position of
the center of gravity

⑥ Convert to 6 heads high

Imagining an idol pattern and converting it to 6 heads high. Refer to page 138 for the conversion method. At this time, be aware of the positions of the parts you observed in ❶.

⑦ Make a clean reproduction

While drawing the face and costumes, exaggerate the pose and make a fair reproduction.

FEATURE Center of Gravity

The center of gravity is important to make it look like the person is standing firmly on the ground. The center of gravity is roughly below the navel. When you are standing straight, the central axis and the center of gravity are in the same position, but when you stand on one leg or move, the central axis and the center of gravity shift.

Blue line: **Central axis of the body**
Red line: **Center of gravity**

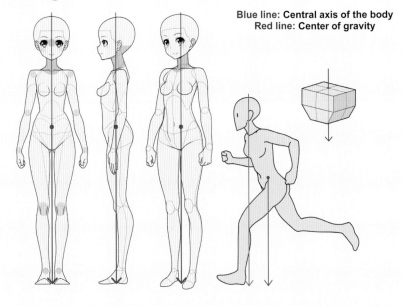

Exaggerating Small Objects

When drawing 2D pictures, if you draw ribbons or eyeglass accessories in real size, they may look small. This can be solved by exaggerating these small items.

Exaggerating Small Objects

When converting a photo to a 2D drawing, I reduce information such as shadows and wrinkles. Similarly, if you draw small items the same size as the real thing, the amount of information is reduced and they will look smaller. Rather than adding shadows and wrinkles, I can make up for the information that has been removed by exaggerating and drawing them slightly larger.

DL Download free practice materials:
www.tuttlepublishing.com/the-complete-guide-to-drawing-manga-and-anime

Hairpins, glasses, ribbons, and buttons are exaggerated and shown larger than their actual size. Small, detailed objects such as hairpins can be well balanced by exaggerating their appearance.

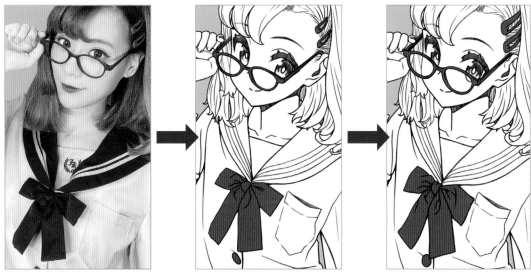

Photograph Drawn actual size Exaggerated

The Relationship Between the Front and Rear of the Body

When the body is leaning forward or the composition is angled up or angled down, the torso may become excessively long or short. This is also true when perspective is focused to the hands and feet and you do not pay attention to overlapping parts. Today I will explain the relationship between the front and back of the body.

The Relationship of Overlapping Parts

When drawing a picture that has a front-back relationship, such as a forward leaning posture, you can think of the head, chest, and waist as three circles. Be aware of the front-back relationship and how they overlap.

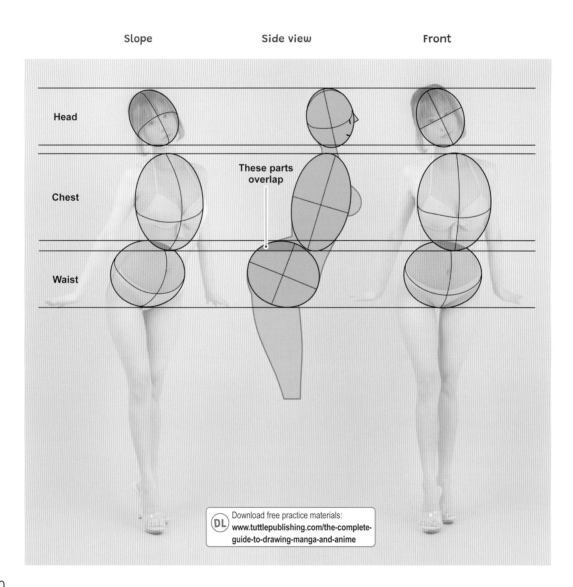

Slope Side view Front

Head

Chest

These parts
overlap

Waist

The Arm in Perspective

You can express perspective by layering parts in arms the same
way we did with the front and back of the body.

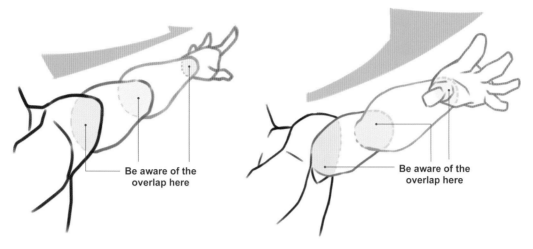

Be aware of the
overlap here

Be aware of the
overlap here

Expressing Context

Adding a line in the overlapping part makes the front and back relationship clear.

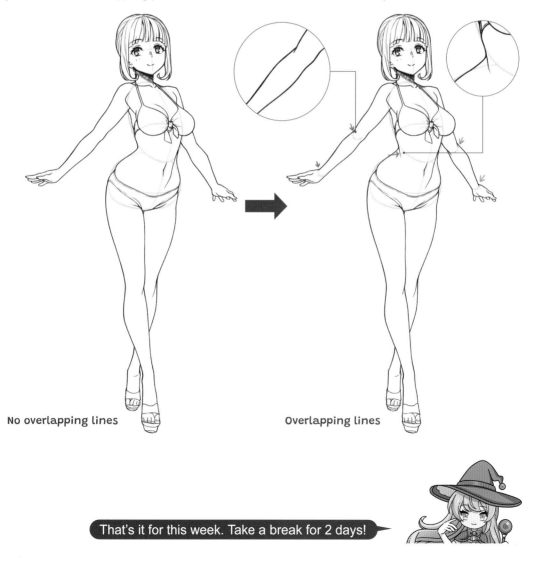

No overlapping lines

Overlapping lines

That's it for this week. Take a break for 2 days!

Character Pose Basics

When you're thinking about poses, do you find that the standing posture is unnatural or poses that don't suit your character? I will explain how to draw poses that match your personality and natural standing poses.

Open and Closed Poses

There are open poses and closed poses, and each gives a different impression. An open pose gives a lively impression, and a closed pose gives a gentle impression. Of course you can combine them. Think about poses that match your character's personality.

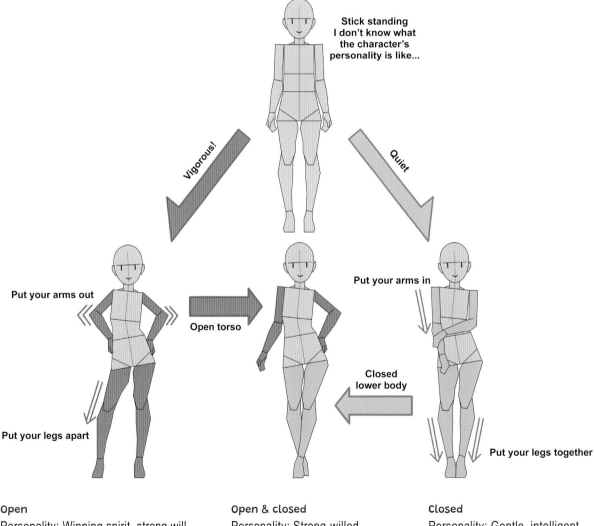

Open
Personality: Winning spirit, strong will
Type: Athlete, warrior
If you put your arms and legs outside your body, you will have a healthy image.

Open & closed
Personality: Strong-willed intelligence
Type: Student Council, Nobility
Combining open and closed will increase variations.

Closed
Personality: Gentle, intelligent
Type: Teacher, Healer
If you put your arms and legs inside your body, it will give you a gentle image.

Creating Natural Standing Poses with a *Contrapposto* Stance

A figure standing with weight on one leg is called a *contrapposto* stance. Since the weight is put on one leg in this stance, the inclination of the shoulders and hips are reversed, creating an S-shaped silhouette. By doing this, you can create a natural standing pose.

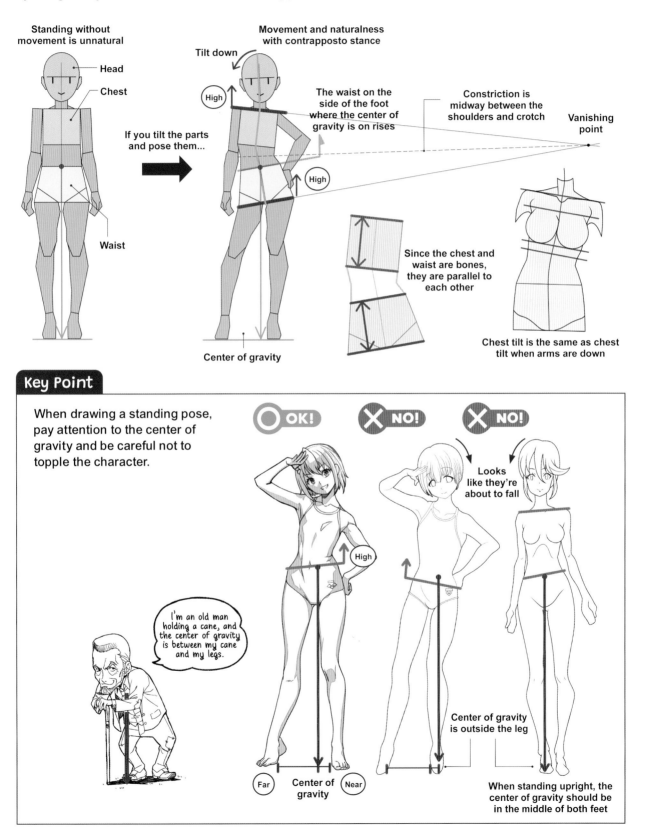

Standing without movement is unnatural

- Head
- Chest

If you tilt the parts and pose them...

Waist

Movement and naturalness with contrapposto stance

Tilt down

High

The waist on the side of the foot where the center of gravity is on rises

High

Constriction is midway between the shoulders and crotch

Vanishing point

Center of gravity

Since the chest and waist are bones, they are parallel to each other

Chest tilt is the same as chest tilt when arms are down

Key Point

When drawing a standing pose, pay attention to the center of gravity and be careful not to topple the character.

OK! NO! NO!

Looks like they're about to fall

I'm an old man holding a cane, and the center of gravity is between my cane and my legs.

High

Far Center of gravity Near

Center of gravity is outside the leg

When standing upright, the center of gravity should be in the middle of both feet

How to Draw Twisted Poses

In addition to tilting to the side, you can pose by twisting the body. A twist is also needed for retrospectives, feminine twists, and momentum poses. Today I'm going to explain how to draw twisted poses.

Twisted Poses

When you think of a pose that twists your body, you may think it's complicated, but I think it will be easier to understand if you apply the drawing method using circles explained in Day 8 (page 48). Draw the head, chest, and waist in the direction you want to twist, and then draw the limbs.

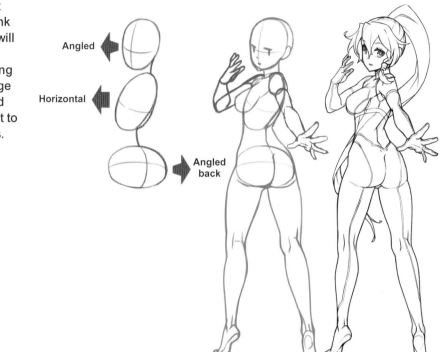

Angled

Horizontal

Angled back

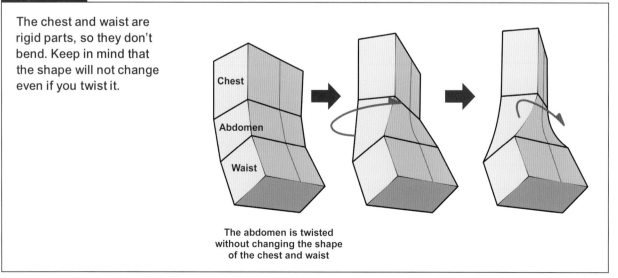

Key Point

The chest and waist are rigid parts, so they don't bend. Keep in mind that the shape will not change even if you twist it.

Chest

Abdomen

Waist

The abdomen is twisted without changing the shape of the chest and waist

Various poses can be drawn
by changing the orientation
of the head, chest, and waist.

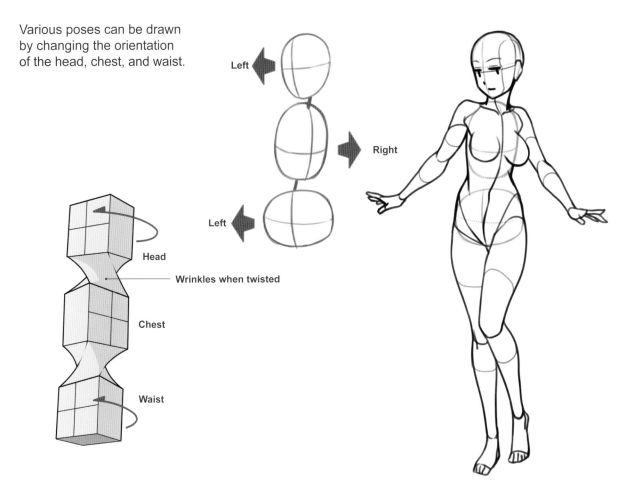

Left

Right

Left

Head

Wrinkles when twisted

Chest

Waist

FEATURE Cool Ways to Stand

No matter how good the
drawing is, if you show a
character just standing
upright in a straight line it
will look rather boring. By
adding an S-shape to the
pose the standing figure
will look more interesting.

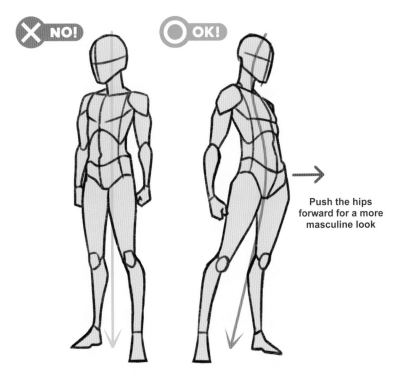

NO!

OK!

Push the hips
forward for a more
masculine look

Adding Arms and Legs to Poses

When you understand open and closed poses, you can see that the most important points are the arms and legs. Today we will practice posing with arms and legs.

Posing Points are the Arms and Legs

Take a look at the pictures below where the various poses are lined up. Actually, all the torsos in this figure are the same. I posed them by changing the direction of the head and the angle of the arms and legs.

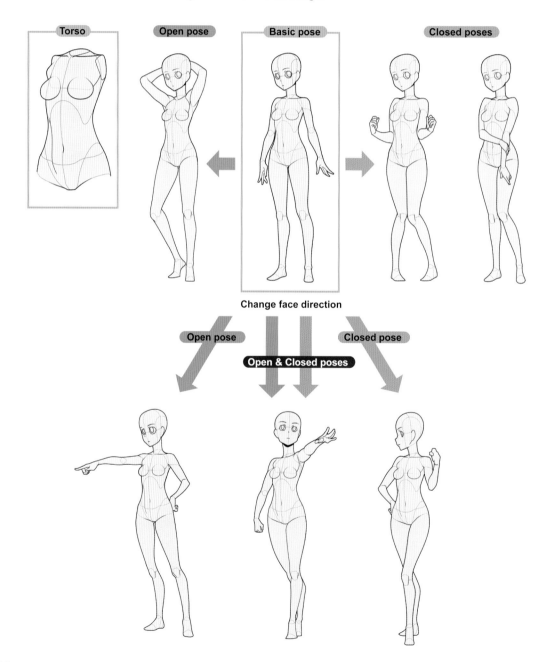

Examples of Poses

Here are several poses before arms and legs have been added.
How would they best be shown on these examples?

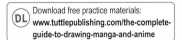
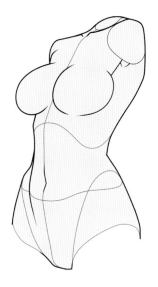
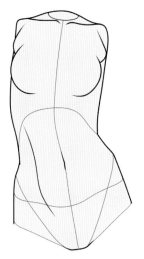
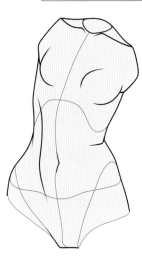

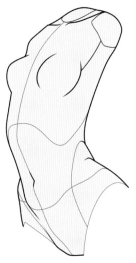
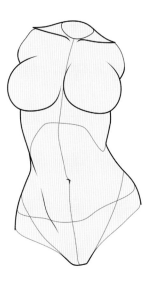
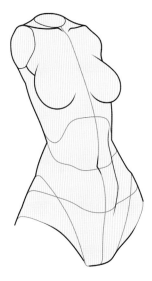

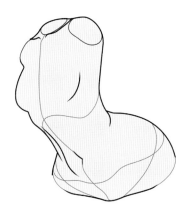
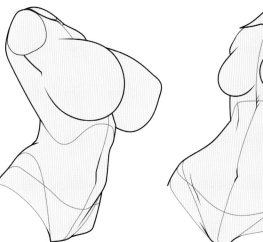
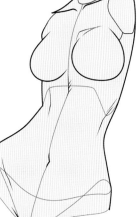

Range of Motion

The joints of the waist, arms and legs have a range of motion. If you draw without paying attention to the range of motion, you will end up with a what is called a "broken bone" image, where the joints are bent in the wrong direction. Let's look at the ranges of motion of the arms, legs, and neck.

Imagine a Figure with Joints

Adjustable toy figures are made of a hard material like plastic, but you can pose them. They use the same range of motion as a human being. It can be helpful when thinking about poses to use a one of these figures as an example of range of motion.

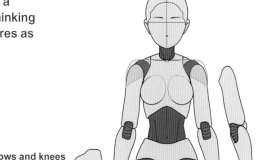

Arm

Elbows and knees cannot move except to bend

Leg

Muscles grow → ← Shrink

Waist ↓

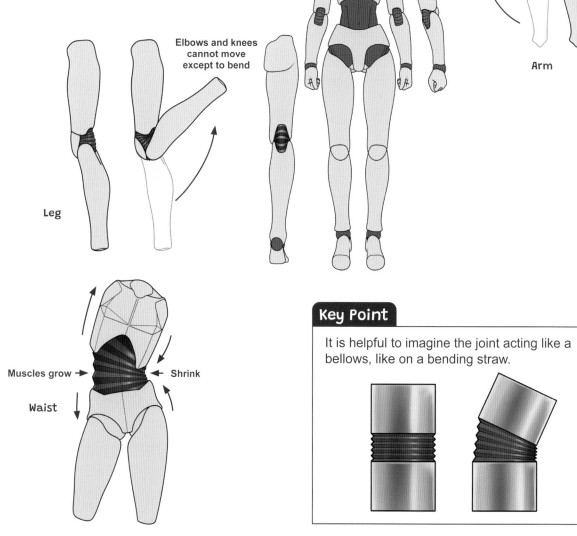

Key Point

It is helpful to imagine the joint acting like a bellows, like on a bending straw.

Arm and Leg Range of Motion

Study this illustration for the arm and leg
range of motion.

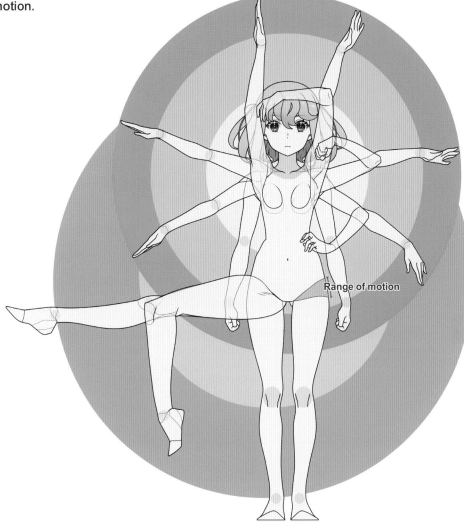

Range of motion

Range of Motion of the Neck

Consider the range of motion of the neck. When the neck moves,
the shoulders and chest move in conjunction.

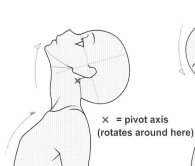

× = pivot axis
(rotates around here)

Tilt one's head sideways
The shoulder on the tilted
side rises slightly

**Turn one's head
sideways**
The shoulder on the
turned side rises slightly

Turned up
The chest feels tight
when looking up

Face down
The back side is tense
when looking down

Poses that Express Your Character's Personality

You have learned about open and closed poses, but poses are also important tools for making a character unique. Today, I will explain how to make poses that match a character's personality.

Clearly Express the Personality

Take a look at the following characters. Even though they are reading the same book, their personalities appear to be different due to the different poses. Let's draw with an open pose and a closed pose in mind.

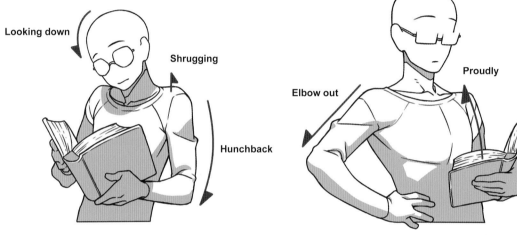

Looking down · Shrugging · Hunchback

Appears to have a timid personality

Proudly · Elbow out

Appears to have a firm personality

In the next figure, the body is the same, but the angle of the head is changed. The impression looks different depending on whether it is facing upward or downward.

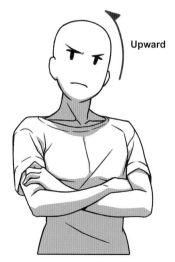

Upward

Emotions look outwardly facing

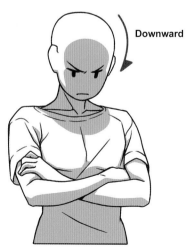

Downward

Feelings seem to be turned inward

Use Your Hands to Express Your Personality

Hand poses can also create character. First of all, let's have a character strike a pose. In this book, the method of expressing emotions with hand movements is called **hand acting**.

Giggles
Looks cute

Put a finger to the mouth and laughs

Looks demure

Points at someone and opens the mouth wide

Looks surprised

FEATURE Review Flow

This depicts the flow of movements when a person turns around. Please refer to the movement of the head and shoulders.

When you turn around a lot, you need to relax your shoulders; otherwise it will be difficult to rotate, so your shoulders will drop.

❶ Looking far away ❷ Casually turning around ❸ Recognition and raising the chin ❹ Relaxing the shoulders ❺ Turning around and facing the other person

Head rotation

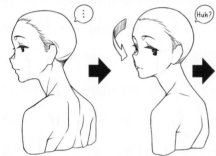

The jaw side rotates first

Rotate head side first

When the head is rotated in parallel, it can only be turned to the side

Attention should be paid to the facial aspect when expressing the movement of looking back.

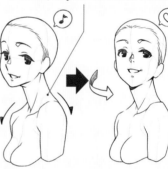

Forehead

Eye

Cheek

Red, blue and green lines are similar (page 38)

Keep in mind that the contours are the sides of each part.

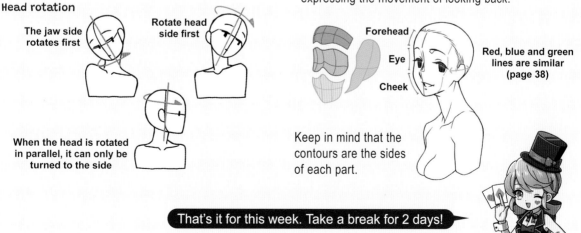

That's it for this week. Take a break for 2 days!

How to Draw Facial Expressions that Match the Character

What should you pay attention to when drawing facial expressions? Of course, the emotions of the character are important, but the personality and the level of emotion are also important factors. Today I will explain the points to put emotions on facial expressions.

What is Facial Expression

Even if the mouth and eyebrows have the same shape, you can change the expression just by changing the height. Be aware of the height of the eyebrows and mouth to control the person's emotions. In sales jobs and job hunting, people often advise you to wear a hairstyle that shows your forehead.

Serious expression

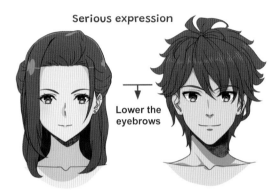

Lower the eyebrows

You can express fun and joy when your eyebrows and eyes are separated

Laughing expression

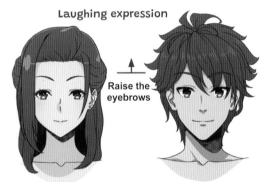

Raise the eyebrows

You can express seriousness and anger by bringing your eyebrows closer to your eyes.

Goofy expression

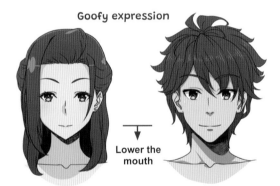

Lower the mouth

The height of the mouth can express the degree of relaxation

Key Point

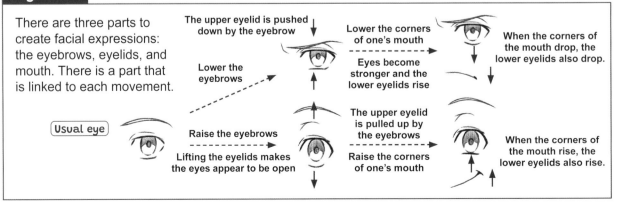

There are three parts to create facial expressions: the eyebrows, eyelids, and mouth. There is a part that is linked to each movement.

Usual eye

The upper eyelid is pushed down by the eyebrow

Lower the eyebrows

Lower the corners of one's mouth

Eyes become stronger and the lower eyelids rise

When the corners of the mouth drop, the lower eyelids also drop.

Raise the eyebrows

Lifting the eyelids makes the eyes appear to be open

The upper eyelid is pulled up by the eyebrows

Raise the corners of one's mouth

When the corners of the mouth rise, the lower eyelids also rise.

Draw Eyebrows with a Mask

The eyebrows are asymmetrical parts that can be moved. If you are unsure how to draw them, it will be easier to express yourself by imagining a mask worn by an typical comic-book hero.

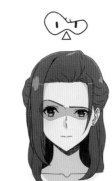

Make Facial Expressions with the Corners of Your Mouth

Take a look at the following illustrations. When you compare the two facial expressions, A looks displeased and B looks satisfied. This is due to the difference in the height of the corners of the mouth. In other words, you can create facial expressions even slightly by raising and lowering the corners of the mouth.

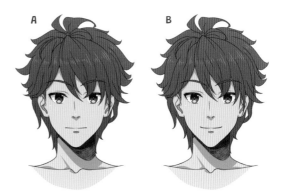

Common Mistakes

As I touched on briefly on Day 5, it is common for beginners not to draw the corners of the mouth. If you do not draw the corners of the mouth, it will be difficult to understand the expression, so be sure to draw them properly.

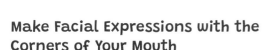

It is difficult to understand facial expressions without the corners of the mouth

You look dissatisfied when the corners of your mouth drop

If the corners of the mouth are straight, it looks expressionless

When the corners of the mouth are raised, they appear to smile.

Key Points in Character Design

What points should you pay attention to when creating an original character? Today, I will explain the points and ideas when designing characters.

Elements that Represent Characters

Characters are divided into elements that represent the characteristics of their appearance and elements that represent their personality. The point is to think carefully about what kind of character you want to create.

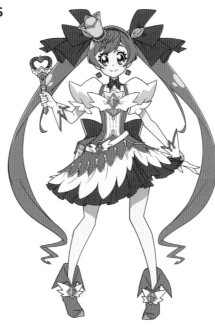

Reproducibility (features of appearance)

Hairstyle

Costume

Props (small items)

Color

Character (personality)

Expression

Silhouette

Pose

Body type

Imagine from the Silhouette

Even if you don't know the character, you can convey the image to another person by giving the silhouette a unique character.

Triangle

If the lower half of the body is voluminous, it gives the impression that the character is standing firmly on the ground, giving the character a sense of weight. Effective for powerful characters.

Rhombus

If there is volume in the center, it feels like a well-proportioned character. It is effective for balanced characters who can handle offense and defense.

Inverted triangle

If the upper body is voluminous, the character will feel unstable and light. Effective for quick characters.

Character and Pose

Again, poses are an important part of character design.
Let's create a character by solidifying the image you want
to make with open poses and closed poses.

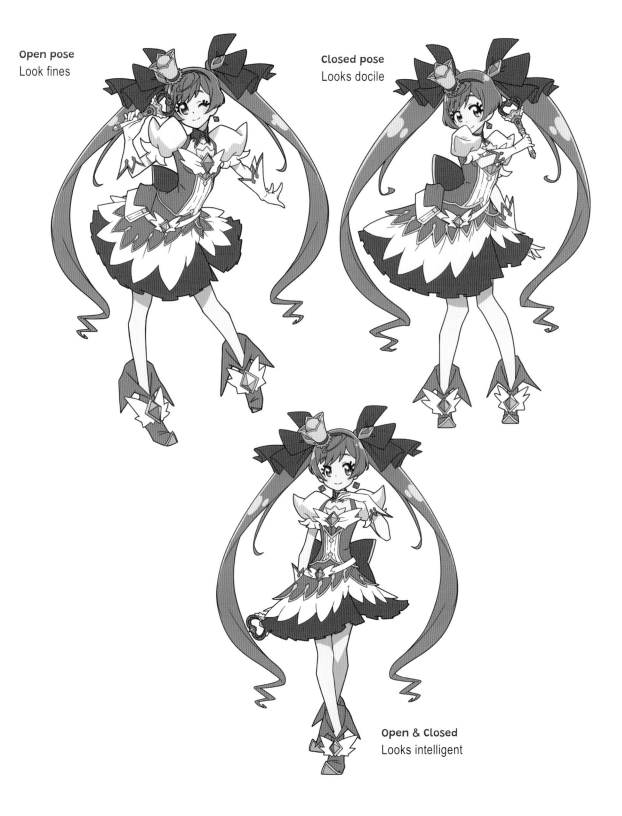

Open pose
Look fines

Closed pose
Looks docile

Open & Closed
Looks intelligent

Pattern and Body Width

You may wonder, "If the human body ratio is the same, how can you express individuality?" One of the answers lies **in the width** of the character. All the characters here have the same head and body proportions, but they don't seem to be in the same world. Basically, the body ratio cannot be changed, but the width of each part can be changed freely. Let's change the width of the parts to give the character individuality.

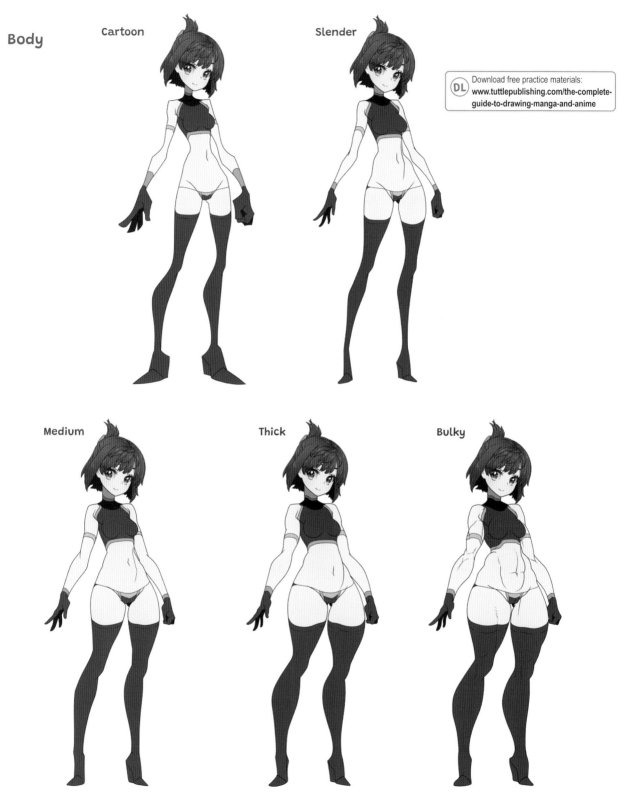

Body

Cartoon

Slender

Medium

Thick

Bulky

FEATURE How to Draw the Ground

Here is a simple method how to determine the position of the ground in relation to your character.

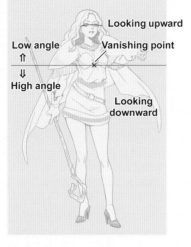

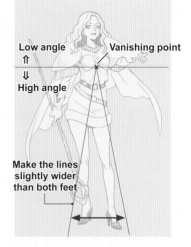

❶ The character has been drawn.

❷ Make an observation. If you observe what kind of perspective the character has, you can see the rough eye level and vanishing point.

❸ Draw an auxiliary line toward your feet. Let's draw two auxiliary lines from the vanishing point to the feet.

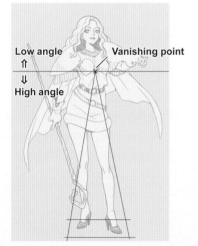

❹ Draw an auxiliary line at your feet. Draw two auxiliary lines on the front and back of the feet.

❺ Completion
Draw the ground from the auxiliary lines of ❸ and ❹. Now you can draw the ground.

Using Small Items

When designing a character, costumes and accessories are important points to strengthen the character, but by using those costumes and accessories, you can also strengthen the image you receive from the silhouette. Today I will explain how to use small items.

Enhance Your Silhouette with Accessories

I explained how to create an image from the silhouette in the point of character design (page 164), but you can freely change the image of the silhouette with clothes and accessories while keeping the basic character as-is.

Take a look at the following illustration. The base character is the same, but the character can look different with the addition of an element used in different ways. This is an effective technique in strengthening the silhouette using accessories.

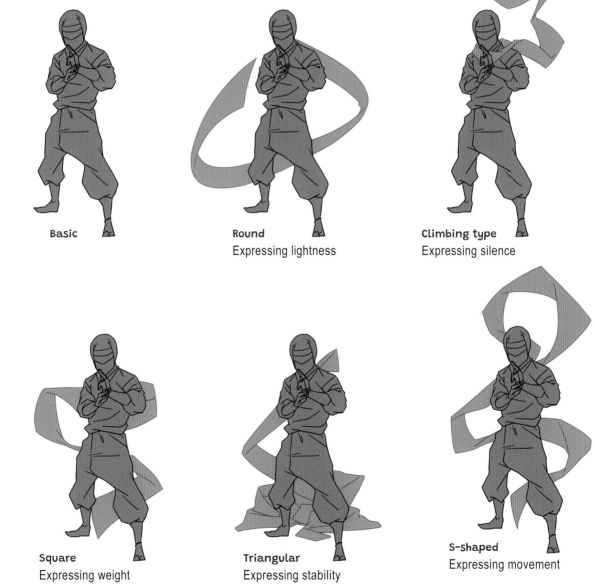

Basic

Round
Expressing lightness

Climbing type
Expressing silence

Square
Expressing weight

Triangular
Expressing stability

S-shaped
Expressing movement

Expressing Time with Small Items

It is effective matching the hair and clothes to the movement of the character. The drawing is still, but you can express how the character moves with the movement of the clothes, hair, and accessories. By thinking about the movement of the character and being conscious of where it is coming from and where it is heading, even a still picture will look like it is moving.

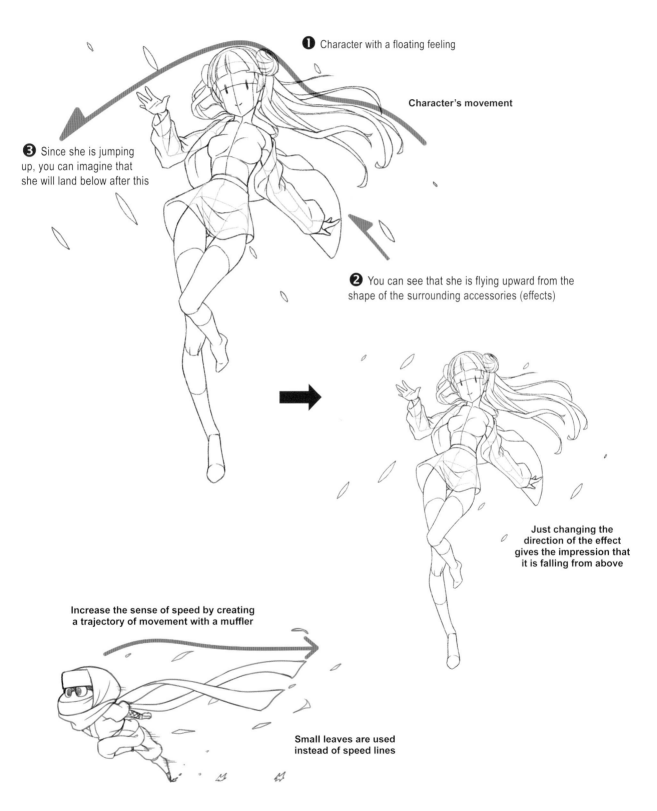

❶ Character with a floating feeling

Character's movement

❸ Since she is jumping up, you can imagine that she will land below after this

❷ You can see that she is flying upward from the shape of the surrounding accessories (effects)

Just changing the direction of the effect gives the impression that it is falling from above

Increase the sense of speed by creating a trajectory of movement with a muffler

Small leaves are used instead of speed lines

169

Adding Attractive Details

When designing a character, don't you worry about how many motifs and elements you should include? Today, I'm going to explain how to make characters attractive.

Do Not Pack the Elements

If you design a character, you want to pack a lot of things and motifs you like, right? However, if you pack it with too much, it will be difficult to convey what part you want to emphasize.

Compare the following two characters. Characteristics are easier to convey in A than in B, which is packed with lots of details. It is also important to carefully select the parts you want to be attractive by narrowing down the elements like this.

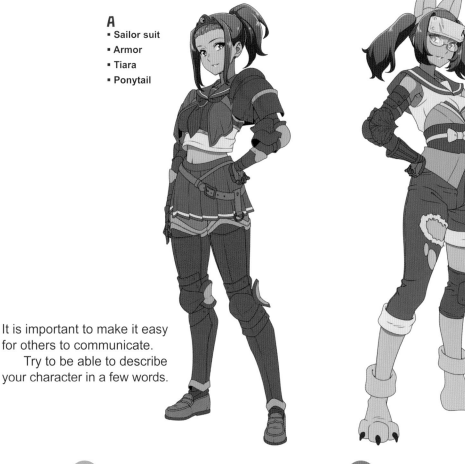

A
- Sailor suit
- Armor
- Tiara
- Ponytail

B
- Cat
- Ninja
- Twin ponytails
- Sailor suit
- Armor
- Jeans
- Kimono
- Gloves
- Supporters
- Glasses

 The design characteristics are all different, so it's hard to tell which one is the main one...

It is important to make it easy for others to communicate.

Try to be able to describe your character in a few words.

OK! A princess with a ponytail wearing a sailor suit and armor.

 NO! A woman with cat ears, twin ponytails, armor on her right arm, a glove on her left arm, a sailor suit, worn jeans, a kimono belt, cat feet shoes, a ninja forehead band, glasses, and an athletic supporter on her left knee.

Silhouette Exaggeration

If you want to express the character's characteristics or the part that you want to charm the most, there is a way to emphasize it by drawing the part you want to attract the most. In addition to this, if you use a complementary color for the part you want to emphasize, you can focus the eye on that part.

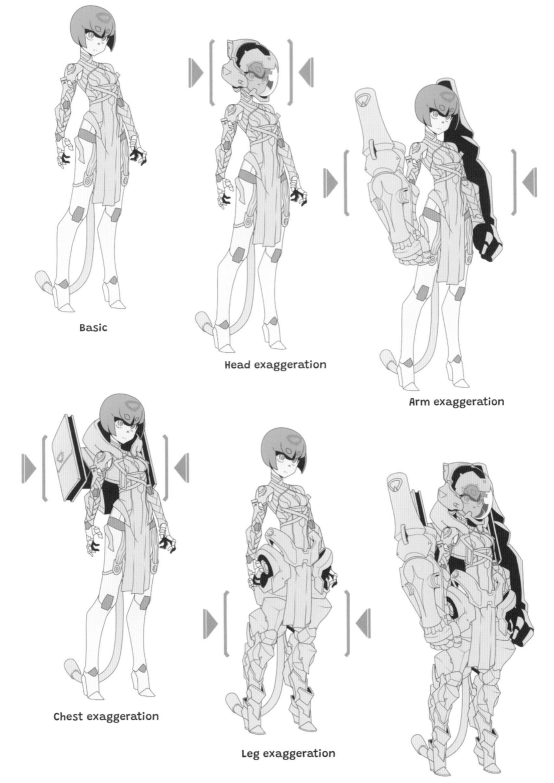

Basic

Head exaggeration

Arm exaggeration

Chest exaggeration

Leg exaggeration

Put it all together

The Concept of Character Design

Design Ability | Knowledge | Basics

Character creation begins when you decide on a theme. First, think carefully about what kind of role the subject has, what kind of features it has, and what kind of concept design to use.

Three Ideas for Design

If you think about the following three elements according to the theme you want to draw, it will be easier to organize.

Embody it with affection

If you clarify what kind of personality and impression the character has when others see it, attachment to the character will begin.

Give it a characteristic image

For example, in the case of Vocaloid Hatsune Miku, I think you can tell that it is Hatsune Miku even if you draw a simple image as shown to the right. Creating a symbol that serves as a point to represent the character is easy and nearly anyone can draw it.

Give it a role to serve

If you clarify the "reason of existence" for your character, such as what kind of role she will play in the finished artwork, the character will come to life.

Twin ponytails and a square barrette

Long sleeves

Three Colors for Your Design

Colors are arranged by considering the state of subtracting achromatic colors from the colors of the entire picture as 100%.

Main color: The color that accounts for 70 to 80% of the total
Secondary color: A color that accounts for 20 to 30% of the total
Point color: Colors that occupy 10–20% of the total

For Hatsune Miku

The motif is Yamaha's DX series, and the main color scheme is blue-green. The gray in the shirt contains blue, so it will be the main color along with the hair. The sub-color yellow is on the name tag, skirt, and arm console. The pink color used for the headphones and the number on the arm is the point color. Hatsune Miku has a lot of blue-green areas as the main color and less yellow as the secondary color. Also, the color scheme is triad (page 175).

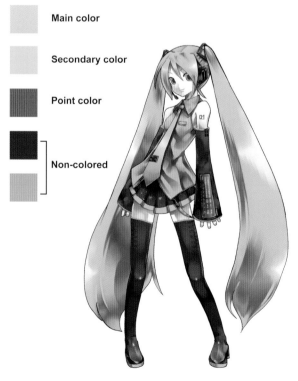

Main color

Secondary color

Point color

Non-colored

Three Preparations Required for Design

When you design a character, you may be at a loss as to how to start. Let's begin by thinking about what the main motif should be. From there, we will expand the character while doing brainstorming (an association game). Finally, we decide on a sub-motif.

Let's try a real example. First, decide on the design "main motif" that you want to convey the most. I made it an idol this time. Then brainstorm. Place the main motif of "idol" that you decided earlier in the center, and extend the branches from there. As you expand the elements like an association game, you can see the points that connect. That's the part that makes the character stand out.

Choose a sub-motif out of the ones that come up. At this time, you can choose the same design as the main one, or it might be interesting to choose a completely opposite design.

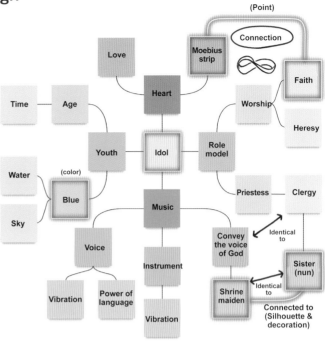

Key Point

Brainstorming Points
- Ignore common sense
- Produce a lot without worrying about quality
- Connect the ideas that result

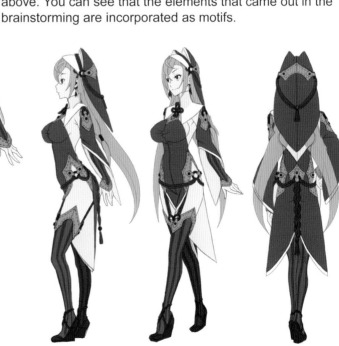

This is the character I made with reference to the brainstorming above. You can see that the elements that came out in the brainstorming are incorporated as motifs.

Colors

By understanding the three attributes of color, "hue," "saturation" and "brightness," you can use color effectively. Let's see what features each has.

Hue

Hue is the difference between colors such as red, blue, and green. A ring of hues arranged in a circle is called a hue wheel.

Black and white are represented by light and dark, not by hue.

Color wheel

Brightness

Brightness is the relative lightness or darkness of a color.

High Low

Saturation

Saturation is a measure of the vividness of a color.

High Low

About Color Relationships

When expressing the relationships between colors, there are complementary colors, opposite colors, and similar colors.

Complementary colors:

Green is the opposite color to red and is called a complementary color.

Opposite colors:

The complementary colors of red, green and the colors adjacent to green, are called opposite colors.

Similar colors:

Colors adjacent to red are called similar colors.

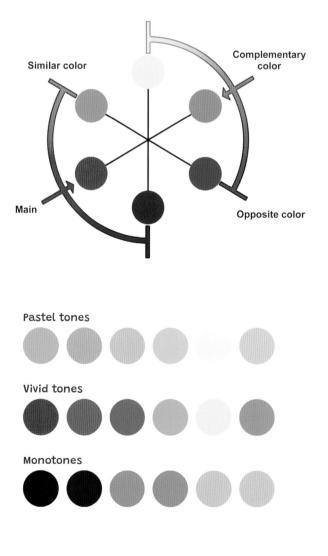

You may have heard the term "color tone." A tone is a group of colors that have the same atmosphere by combining the "saturation" and "brightness" of the color.

Pastel tones

Vivid tones

Monotones

Color Scheme

When deciding on a character's color, you should think about what colors to combine. Here, we introduce a color scheme using the color wheel.

Analogy

Combinations that are next to each other on the color wheel are called analogies (similar colors) and create a soft image.

Tetrad

Use the colors that are in the four equal parts of the color wheel to create a colorful finish.

Dyad

Opposite colors on the color wheel create a strong and balanced finish, but be careful as colors can easily fight.

Triad

Using the colors that are in the three equal parts of the color wheel, you can create a well-balanced and varied finish.

After choosing the color scheme of the color wheel, you can greatly change the image by adjusting the saturation, contrast, and brightness of each color.

 Strong differences in hue, brightness, and contrast

Similar Hue, Lightness, and Saturation with Weak Contrast

The hue is the same, but the brightness and saturation are different

Split complementary

This technique has a more balanced color scheme than the Dyad and is the most commonly used color scheme.

That's it for this week. Take a break for 2 days!

Design Ability Knowledge Basics

Plane Composition

Composition is an important point in drawing a picture to make it look attractive. I'm sure you've heard of triangular composition and *Hinomaru* composition (red sun centered in a white field, the Japanese flag), but it's important to be conscious of not only the composition based on the layout of the screen, but also the use of colors, the way to add light and shade, etc.

Make the Illustration Shine with a Flat Composition

When learning design, "plane composition" is important. You can create a picture that clearly shows where you want to direct line of sight by creating sparseness and fineness of a line drawing, color contrast, and contrast within the screen. I will explain what points I pay attention to when drawing the following sample characters.

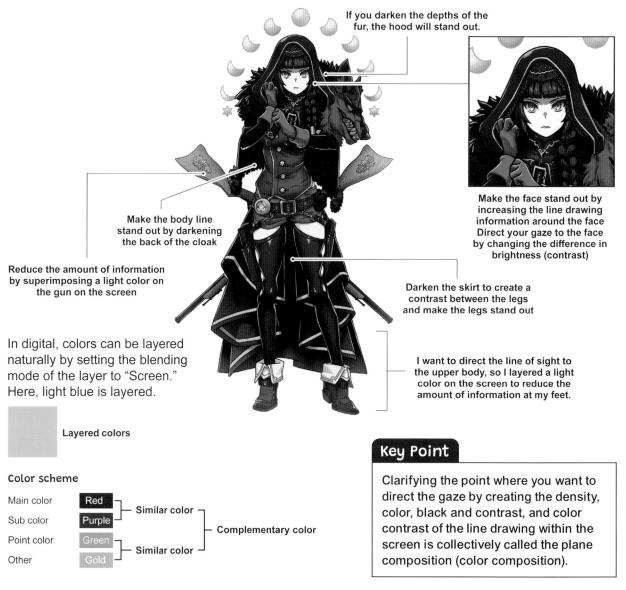

If you darken the depths of the fur, the hood will stand out.

Make the face stand out by increasing the line drawing information around the face Direct your gaze to the face by changing the difference in brightness (contrast)

Make the body line stand out by darkening the back of the cloak

Reduce the amount of information by superimposing a light color on the gun on the screen

Darken the skirt to create a contrast between the legs and make the legs stand out

In digital, colors can be layered naturally by setting the blending mode of the layer to "Screen." Here, light blue is layered.

Layered colors

I want to direct the line of sight to the upper body, so I layered a light color on the screen to reduce the amount of information at my feet.

Color scheme

Main color — Red — Similar color
Sub color — Purple
Point color — Green — Complementary color
Other — Gold — Similar color

Key Point

Clarifying the point where you want to direct the gaze by creating the density, color, black and contrast, and color contrast of the line drawing within the screen is collectively called the plane composition (color composition).

Aori and Fukan

You can express the emotions of the character by using *aori* and *fukan* methods. *Aori* (low angle or being angled up) expresses a person's strong emotions such as anger and sadness, while *fukan* (high angle or being angled down) expresses weak emotions such as loneliness and smallness. In addition, tilting is used to give an impression of an object's size and position.

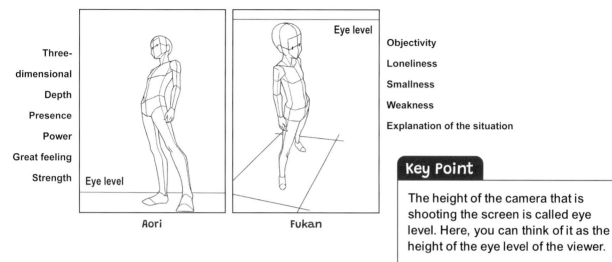

Three-
dimensional
Depth
Presence
Power
Great feeling
Strength

Eye level

Aori

Eye level

Fukan

Objectivity
Loneliness
Smallness
Weakness
Explanation of the situation

Key Point

The height of the camera that is shooting the screen is called eye level. Here, you can think of it as the height of the eye level of the viewer.

Person's Gaze

It depends on the production, but basically, if there is space ahead of the person's line of sight, the picture will be easier to view.

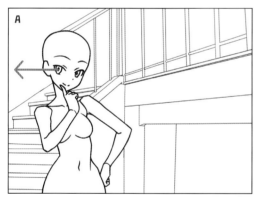

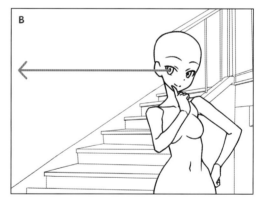

Sparse/Dense

The examples below have dots on white and black backgrounds. A has a rough white background and dense black spots. In B, the black background is rough and the white spots are dense. You can create coarseness and fineness by changing the color saturation and lightness, and the density of the line drawing information.

Comparison

When comparing A and B in the following figure, A is confused as to whether A should look at the black or white circle. By changing the size of the two circles like B, you can intentionally create the one you want the **eye to look at**.

Design Ability | Knowledge | Basics

Various Compositions

How should you arrange the characters and the background on the screen (the canvas)? There are various compositions, such as the triangle composition for creating a sense of stability, and the *Hinomaru* composition for making the person stand out. I will introduce what kind of compositions there are today.

Get to Know the Compositions

Composition is very important because it determines which parts of the screen should stand out and what kind of impression you will get when you take a quick look. There is no such thing as only one composition which can be used for one picture. Learn about the various compositions and try to combine them.

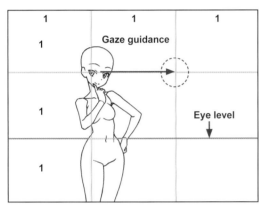

Third division

A trisection is a composition that draws the eye to the intersection of three equal parts of the canvas. By vacating at least one of the four points, you can create a "hole" that allows the line of sight to escape to the back. The composition will be stable if the eye level is aligned with the bottom of the horizontal thirds. However, it is not suitable for moving images.

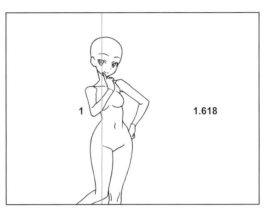

Golden ratio

The golden ratio is a ratio that has been considered beautiful in the West since ancient times. A ratio derived from the many beautiful things found in nature, the division of thirds is a simplified version of the golden ratio. The aspect ratios of A4 size paper and business cards are also made with the golden ratio.

Fibonacci sequence

The Fibonacci sequence is also one of the golden ratios. Arranging objects along the spiral line creates a well-balanced composition.

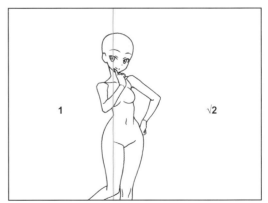

Silver ratio

In contrast to the Western golden ratio, the silver ratio is a ratio that has been used in Japan for a long time. B5 size paper is made with this silver ratio.

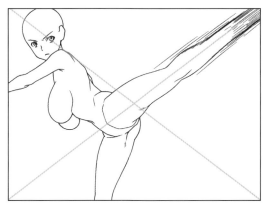

Diagonal

Compositions using diagonal lines are often used for pictures with movement such as action scenes. You can create a dynamic drawing by placing the parts you want to move diagonally.

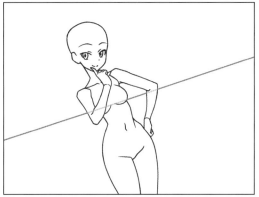

Rotated

A rotated composition is a composition that creates a sense of movement by rotating the picture itself left and right.

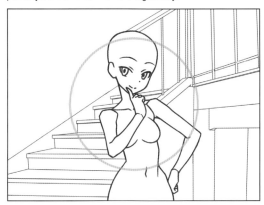

Hinomaru

The Hinomaru composition is the most popular composition in which the picture you want to look at is placed in the center of the canvas. However, since most of the line of sight does not go to anything other than the central picture, it is not suitable for pictures where you want to show the background as well.

Triangular

The triangle composition is a composition that is often used to create a sense of gravity. Arrange the limbs, accessories, and the background so that they form a triangle when connected. You can make multiple triangles.

FEATURE Composition and Silhouette

When people look at a picture, they first capture it as a silhouette. Effective use of silhouettes can convey the intended image.

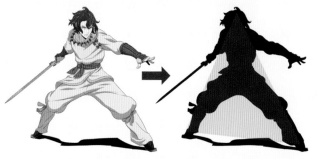

A triangular silhouette creates a sense of stability. The movement of small items creates a dynamic look.

By slightly tilting the triangular silhouette, it creates a sense of instability and makes it more dynamic.

FEATURE 2D Perspective

When you want to draw a cool picture with perspective, there is a unique technique for 2D drawing called 2D perspective. Originally, perspective is created with a wide angle, but a strong wide angle (fisheye) will distort the picture. Therefore, by using only the size of each part in the fisheye and drawing without the distortion caused by the fisheye, a perspective without distortion is realized.

Standard perspective
There is no power in this...

Fisheye
If you use a fisheye (wide-angle) lens, your fist will look more powerful, but the picture will be distorted...

2D perspective

If you remove the distortion while leaving the position and size of the fisheye parts, it will be a powerful picture.

Seen from the side...

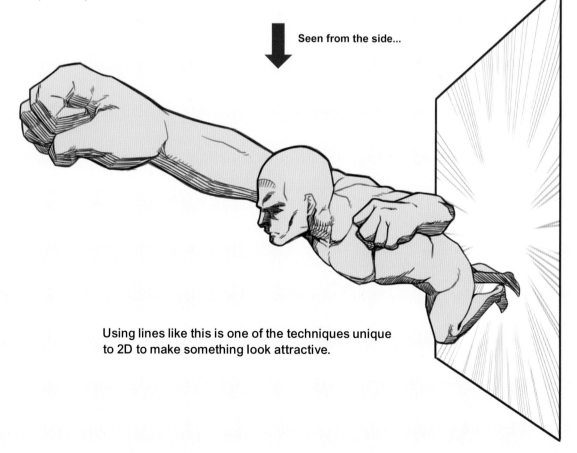

Using lines like this is one of the techniques unique to 2D to make something look attractive.

DIFFICULTY ★★★☆☆

Efficiency | Applications | Permanence

Idea Power-Up Game 1

I would like to introduce a game as a way to practice coming up with character design ideas. Today I would like to introduce a game that you and your friends can play like a quiz.

Message Game

"What do you want to convey to others?" and "How do you summarize the other person's proposal?" are very important for drawing pictures. They only grow with experience. The "telephone game" is a way to learn that experience as a game. Try it with your friends.

❶ You and your friend are either the questioner or the scribe. The questioner decides on a theme and conveys its characteristics to the scribe. At that time, convey the characteristics so that the scribe cannot see through the theme.

❷ The scribe draws a picture based on the characteristics conveyed.

❸ When you have finished drawing, check your answers. If the scribe draws a picture different from the theme, the questioner wins, and if the writer draws the same picture as the theme, the questioner wins.

Key Point

In this game, it doesn't matter if you win or lose. The purpose is to shape ideas in the game and find new discoveries. The questioner can learn to think about how to tell people. Scribes can shape new designs.

DIFFICULTY ★★★☆☆

Efficiency Applications Permanence

Idea Power-Up Game 2

Like yesterday's game, this is a practice method for coming up with character design ideas, but I will introduce a game that can be played by multiple people. As the number of people increases, the number of themes and motifs increases, so you will also acquire the ability to put together a design.

Random Design Game

The random design game is a game in which friends put together a theme and combine it to create a character. By creating a character from a theme, you can develop your imagination and creativity. You can also learn about other people's design patterns by showing them to your friends. From there, unexpected designs are born, and it is also an opportunity to learn about a new side to things.

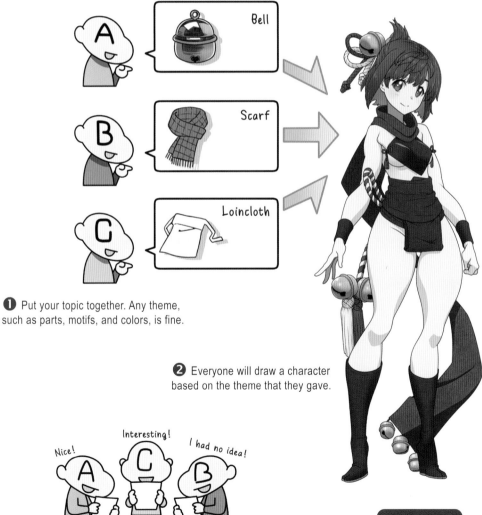

❶ Put your topic together. Any theme, such as parts, motifs, and colors, is fine.

❷ Everyone will draw a character based on the theme that they gave.

❸ Let's show each other when it's done. By doing this, you will be able to see ideas that are different from your own, such as the directions of other people.

Key Point

If you do it alone, it's fun to use a lottery (select themes at random)!

Improving Design Skill Game

Today is also a game that strengthens the idea of character design. It's perfect to play with others or by yourself. You can also use an original character or an existing character. it's your choice.

Character Morph Game

This is a game in which you draw three base characters and morph them to create a new character. Let's take Little Red Riding Hood as an example.

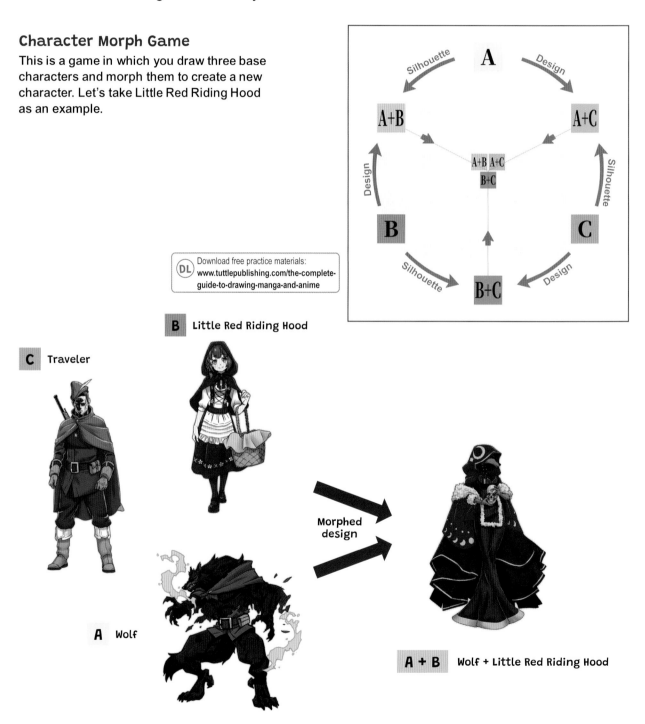

B Little Red Riding Hood

C Traveler

A Wolf

Morphed design

A + B Wolf + Little Red Riding Hood

❶ A B. Place the existing design in C.

❷ Morph the silhouette of A and the design of B.

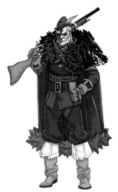
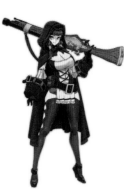

❸ Similarly, morph **A** and **C**, and **B** and **C**.

❹ Further morph the three designs.

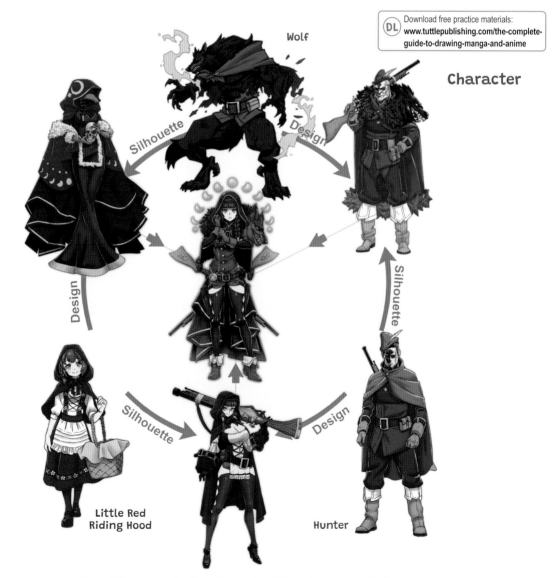

Character

Wolf

Silhouette

Design

Design

Silhouette

Little Red Riding Hood

Silhouette

Design

Hunter

We will incorporate the elements of the characters that are next to each other and morph them together.

Efficiency Applications Permanence

Professional Artist Simulation Game

It's finally the last day. Here, let's imagine what kind of instructions you will receive when you are asked to do a job, and simulate an actual request, such as how to manage the schedule.

Proposal Game

The proposal game is a game where you can experience a flow close to an actual procedure, assuming that the character design work will come. Write your own instructions and draw a picture. Writing instructions clarifies the purpose and allows aspiring professionals to familiarize themselves with the procedures before they actually do the work.

Game flow

① Determine the outline of the game, such as the title and story
② Write instructions
③ Determine the schedule and data format
④ Collect necessary materials
⑤ After drawing, write a delivery note and an invoice

confidential

Requester: _____
Request date: Year Month Day

Overview

Schedule

Process name	Start date	Delivery date
Rough	Y/M/D	Y/M/D
Draft	Y/M/D	Y/M/D
Line drawing	Y/M/D	Y/M/D
Finish	Y/M/D	Y/M/D

Data format

Size	B5 size /A4 size
Resolution	300–350dpi
Number of rough drafts	2–3 drafts
Number of retakes	2 retakes
Delivery format	PSD format / RGB

Directions

Name		race		age		main color		
Equipment		attributes		gender		notes		

Basic image		Items	
Systematic hairstyle		Background	
		Pose	
Facial expression			
Clothing		Remarks	

Document

▼ Character image ▼ Clothes image ▼ Pose/angle image ▼ Situation

※ Reference: facial expressions, hairstyles, costumes, weapons, items, etc.

It is a good idea to prepare a template for instructions.

Production Progress Chart

Knowing what process a professional uses to draw is an important clue to deciding upon a schedule. Also, depending on the content of the request, there are things that go up to the rough or even the color rough. Let's decide the contents of the request according to workable time.

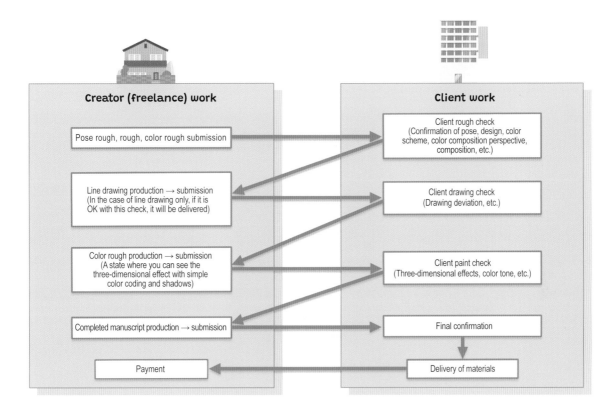

Work Schedule

Scheduling is very important in drawing. See the diagram below. The actual work takes 8 days, but if you include the client's holidays and waiting for checks, it will take 17 days to deliver. Also, if you include your own holidays, you will need more days. It may take several days to check with the client.

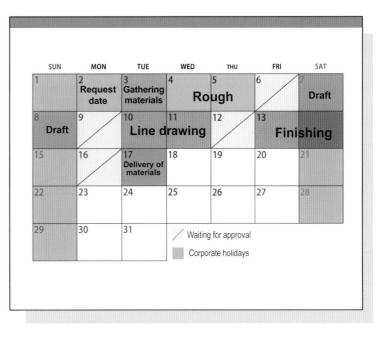

Delivery Slip and Invoice

Here is how to write a delivery slip when the drawing is completed. The delivery slip will be a list of when and what kind of drawing you drew. In addition, when the invoice is collected, it also helps confirm exactly what work I completed.

◆ Delivery slip

Invoice (copy)　December 25, 2021　No. 1
1-1-1 Isabelle, Asgard District, Midgard Glazheim 〒6
〇X Prefecture　City A-B-C
Naoto Date
TEL : 00-222-1111
Svajilfari Co., Ltd.
I have delivered as follows　Registration number _____

Product name	Quantity	Unit price	Amount (tax excluded/tax included)	Tax rate (%)	Remarks
1 Character design fee	4	¥80,000	¥320000	10	

Total (excluding tax/including tax)　Consumption tax, etc.　¥32,000　¥352,000

◆ Invoice

Invoice (copy)　December 25, 2021　No. 1
1-1-1 Isabelle, Asgard District, Midgard Glazheim 〒6
〇X Prefecture　City A-B-C
Naoto Date
TEL : 00-222-1111
Svajilfari Co., Ltd.
Payee: Japan Post Bank　〇Xpost office
Normal 1234567　Naoto Date
I would like to request the following

Date	Product Name	Quantity	Unit Price	Amount (tax excluded/tax included)	Remarks
	1 Character design fee	4	¥80,000	¥320000	

10 %　¥32,000　¥352,000

Manuscript Fee

Manuscript fees vary from company to company. Based on the author's experience, when I was a newcomer, a single character, no background, no differences, full color, cost about 6,000 to 8,000 yen per design. Also, there are cases where there is an additional charge for returning and correcting the rough draft, and there are cases where it is already included in the manuscript fee.

Payment Timing

You will surely be interested in when the payment will be transferred. Most companies tend to pay around the 25th of the month following the delivery month. In the case of freelancers, the amount after deducting the withholding tax from the manuscript fee will be deposited. Also, be sure to check the timing of the payment when making a request.

Proposal Game Example

The outline of the project is "character design for an app game". This delivery is up to the color rough.

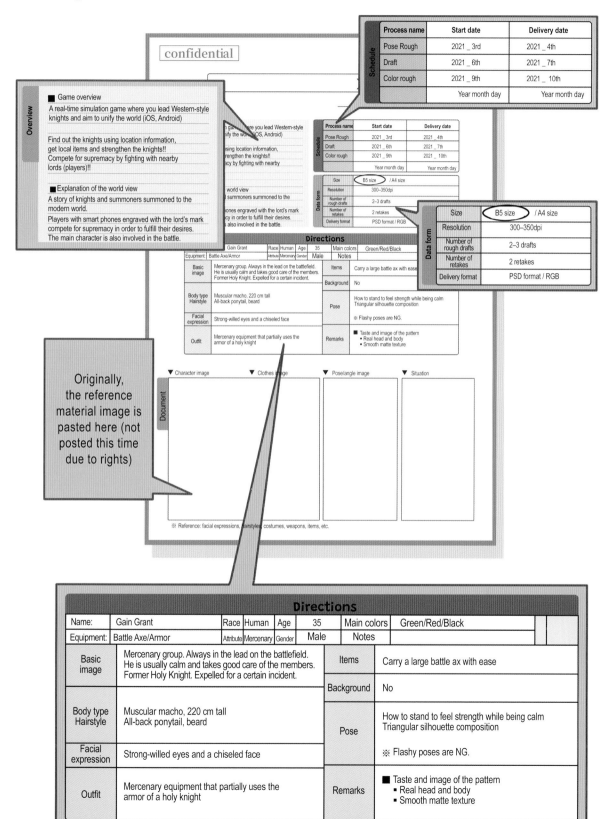

confidential

Overview

■ Game overview
A real-time simulation game where you lead Western-style knights and aim to unify the world (iOS, Android)

Find out the knights using location information, get local items and strengthen the knights!!
Compete for supremacy by fighting with nearby lords (players)!!

■ Explanation of the world view
A story of knights and summoners summoned to the modern world.
Players with smart phones engraved with the lord's mark compete for supremacy in order to fulfill their desires.
The main character is also involved in the battle.

Schedule	Process name	Start date	Delivery date
	Pose Rough	2021 _ 3rd	2021 _ 4th
	Draft	2021 _ 6th	2021 _ 7th
	Color rough	2021 _ 9th	2021 _ 10th
		Year month day	Year month day

Data form		
Size	B5 size / A4 size	
Resolution	300–350dpi	
Number of rough drafts	2–3 drafts	
Number of retakes	2 retakes	
Delivery format	PSD format / RGB	

Originally, the reference material image is pasted here (not posted this time due to rights)

▼ Character image ▼ Clothes image ▼ Pose/angle image ▼ Situation

※ Reference: facial expressions, hairstyles, costumes, weapons, items, etc.

Directions

Name:	Gain Grant	Race	Human	Age	35	Main colors	Green/Red/Black	
Equipment:	Battle Axe/Armor	Attribute	Mercenary	Gender	Male	Notes		

Basic image	Mercenary group. Always in the lead on the battlefield. He is usually calm and takes good care of the members. Former Holy Knight. Expelled for a certain incident.	Items	Carry a large battle ax with ease
		Background	No
Body type Hairstyle	Muscular macho, 220 cm tall All-back ponytail, beard	Pose	How to stand to feel strength while being calm Triangular silhouette composition
Facial expression	Strong-willed eyes and a chiseled face		※ Flashy poses are NG.
Outfit	Mercenary equipment that partially uses the armor of a holy knight	Remarks	■ Taste and image of the pattern • Real head and body • Smooth matte texture

Pose Rough Draft

I drew 3 rough poses according to the instructions. If I offer only 2 versions, the range of choices will be narrow, so it's better to go with 3 versions.

Gain pose rough draft

Draft

After careful consideration, I chose version A.

Gain draft

Holy knight armor

Line Drawing/Color Rough

Complete the line drawing and create a color rough. A simple color sketch is OK. Let's take care of the overall balance. It's also a good idea to put the colors you used side by side.

Gain color rough

Advantages of arranging used colors
- It is easier to work if the color used when correcting is clear
- Makes sure the color balance is correct
- Informs the person in charge

Efficient Way to Become a Professional—
Game Illustrator Version

When I get a job request, I try to be fully prepared by planning ahead. By understanding what it takes to be a professional artist, you should be able to complete work that is far more accomplished than that of novices.

◆ Efficient way to become a professional ~ Game illustrator version

① What is "Pro"?

Do the same thing as a professional job.

in-house (company)
Freelance (individual)
② Money

Even if it says a professional illustrator and it's small, it varies. Decide what kind of job you want to do first!

Concept designer
Background designer
Accessory designer
Character designer

The question is whether a picture is enough

Is it okay to make a frame because I'm a student or an amateur?

Some students create songs and learn to draw while developing app games.

There are also creators who skillfully use 3D to raise the degree of perfection.

3D technology will be needed in the future!

• The art of negotiating with clients is essential for illustrators, whether freelance or in-house.

• How do you get a job to become a professional?

How can an amateur become a pro?

③ Present

? Should students and amateurs only practice basics?

Basic practice ≠ professional work

• In the first place, I don't know where the basics end and where the practice starts.

• The basics that can be used change depending on the work content and design.

• If you only do the basics, you will lose track of your current level and end up continuing the basics.

• Basics → anatomy and drawing → "type" A pattern is born by breaking this mold.

If you try to make a pattern without doing the so-called "unconventional" foundation, it will be "no model".

A large number of technical manuals
• A.Loomis
• Hampton
• Bridgeman etc.

※ Of course the basics are important!

⑤ Efficient practice
① proposal
② Purchase order
③ schedule
④ Material creation
⑤ character creation
⑥ Background creation
⑦ Logo creation

Completion
repeat

Make a portfolio of what you have done.

bring in

If you know the work of a professional and get used to it, you can acquire mid-level skills at the start!

Professional
A basic practice → professional work
B Basic practice → pseudo-professional work

3 POINTS!
1. Approach to the target company!
2. Don't give up even if you refuse!
3. Don't overdo it to keep it going!

Proposal
Genre : Action RPG
Catchphrase : "Doubt the truth. There is an answer beyond that."
Concept : Orthodox battle x Moe characters
Target : Male users in their teens to 20s
Selling point : Mystery leads to mystery! Truth revealed!
Synopsis : Synopsis of the story
Theme of work : A story of a boy and girl who seeks the real truth
Character draft : Existing image character image
Stage/Setting : Concept image
System : Pseudo 3D battle from a 2D angled perspective
Staff : Key animation, scenario, theme song, production

Purchase order (PDF or EXCEL)
Specifications : An overview of the work itself. Notes on overall drawing, etc.
Instructions : An overview about creating characters.
Materials : Materials from the ordering side for production.
※ Sometimes they come separately, and sometimes they come together.

※ Plans and purchase orders are basically confidential. Many companies sign a non-disclosure agreement before starting work. = say NDA.

⑥ Summary
• Create your own proposal and order form
• Determine delivery date
• Creating a production schedule
• Creation of character concept design
• Basic practice during the return
• Collect what you have done into a portfolio
• Once completed, create a delivery note and invoice
• Send a portfolio to a company
• Repeat the above

[example]

The 90th day has finally come! Draw a picture using what you have learned so far and compare it with the first day. You should be able to see your growth.

Published by Tuttle Publishing, an imprint of Periplus Editions (HK) Ltd.

www.tuttlepublishing.com

DATE-SHIKI OEKAKIJUKU 90-NICHE DE
KAWARU GARYOKU KOJO KOZA
© 2021 Naoto Date, edited by Remic
English translation rights arranged with Mynavi
Publishing Corportion
through Japan UNI Agency, Inc., Tokyo

English Translation © 2023 by Periplus Editions
(HK) Ltd

ISBN 978-4-8053-1766-2
Library of Congress Cataloging-in-Publication
Data in process

26 25 24 23 10 9 8 7 6 5 4 3 2 1

Printed in China 2307EP

Distributed by
North America, Latin America & Europe
Tuttle Publishing
364 Innovation Drive
North Clarendon, VT 05759-9436 U.S.A.
Tel: 1 (802) 773-8930; Fax: 1 (802) 773-6993
info@tuttlepublishing.com
www.tuttlepublishing.com

Japan
Tuttle Publishing
Yaekari Building, 3rd Floor
5-4-12 Osaki
Shinagawa-ku
Tokyo 141 0032
Tel: (81) 3 5437-0171; Fax: (81) 3 5437-0755
sales@tuttle.co.jp
www.tuttle.co.jp

Asia Pacific
Berkeley Books Pte. Ltd.
3 Kallang Sector, #04-01
Singapore 349278
Tel: (65) 67412178; Fax: (65) 67412179
inquiries@periplus.com.sg
www.tuttlepublishing.com